BACKROADS OF
TEXAS

ALONG THE BYWAYS TO BREATHTAKING LANDSCAPES AND QUIRKY SMALL TOWNS

TEXT BY GARY CLARK
PHOTOGRAPHS BY KATHY ADAMS CLARK

VOYAGEUR
PRESS

Quarto is the authority on a wide range of topics.

Quarto educates, entertains and enriches the lives of our readers—enthusiasts and lovers of hands-on living.

www.quartoknows.com

First published in 2016 by Voyageur Press, an imprint of The Quarto Group, 401 Second Avenue North, Suite 310, Minneapolis, MN 55401 USA. Telephone: (612) 344-8100 Fax: (612) 344-8692

quartoknows.com
Visit our blogs at quartoknows.com

Voyageur Press titles are also available at discount for retail, wholesale, promotional, and bulk purchase. For details, contact the Special Sales Manager by email at specialsales@quarto.com or by mail at The Quarto Group, Attn: Special Sales Manager, 401 Second Avenue North, Suite 310, Minneapolis, MN 55401 USA.

10 9 8 7 6 5 4

ISBN: 978-0-7603-5053-9

Library of Congress Cataloging-in-Publication Data

Names: Clark, Gary, 1943- author. | Clark, Kathy Adams, 1955- photographer.
Title: Backroads of Texas : along the byways to breathtaking landscapes and quirky small towns / by Gary Clark ; photographs by Kathy Adams Clark.
Description: Minneapolis, MN : Voyageur Press, 2016.
Identifiers: LCCN 2016018214 | ISBN 9780760350539 (softcover)
Subjects: LCSH: Texas--Tours. | Scenic byways--Texas--Guidebooks. | Automobile travel--Texas--Guidebooks. | BISAC: TRAVEL / United States / South / West South Central (AR, LA, OK, TX). | TRAVEL / Pictorials (see also PHOTOGRAPHY / Subjects & Themes / Regional). | PHOTOGRAPHY / Subjects & Themes / Regional (see also TRAVEL / Pictorials).
Classification: LCC F384.3 .C55 2016 | DDC 917.64--dc23
LC record available at https://lccn.loc.gov/2016018214

Printed in China

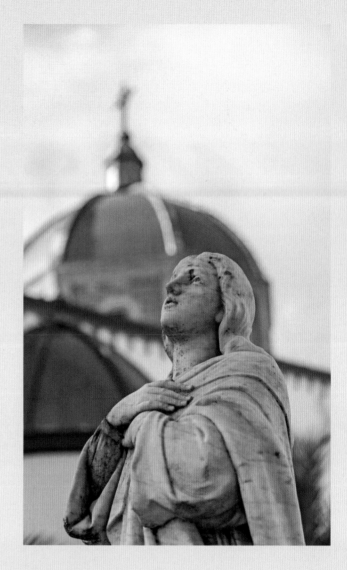

Acquiring Editor: Todd R. Berger
Project Manager: Caitlin Fultz
Art Director: James Kegley
Cover Design and Layout: Diana Boger

On the front cover: Ross Maxwell Drive is one of the most scenic drives in Big Bend National Park.
On the back cover: A replica of the cabin that served as the first capitol of the Republic of Texas from September 1836 to December 1836, located in West Columbia.
On the frontis: The History Center in Diboll, Texas, is a museum dedicated to the history of the timber industry as well as local history.
On the title page: The peak of Casa Grande at sunset through the Window from Ross Maxwell Drive at Big Bend National Park.
On the contents page: Our Lady of Guadalupe Church in Hebbronville.

In memory of our Texan fathers:

James David Clark

Ben Eugene Adams

CONTENTS

ACKNOWLEDGMENTS

THIS BOOK DERIVES from the cooperation and unmatched friendliness of countless Texans. To every shop owner, café owner, family restaurant owner, museum guide, park volunteer, park ranger, and townsperson who shared with us information about their communities and recommendations for places to see, we tip our hats to say, "Thanks, partner." Many good friends around the state offered suggestions for locations in their communities.

We owe thanks beyond words to Barbara Burkhart, Karen Copeland, Sean Fitzgerald, Justine Henley, Sharron Jay, Karen McCormick, Crystal Mead, Mike Sloat, Tom Taroni, and Dr. Josie Williams for telling us about special places where they live.

Our daughter-in-law Kellie Hopkins mined a mountain of material about each region of the state to prepare us for producing the book and then carefully edited the manuscript for accuracy. Our son Michael Clark and his wife, Robin, who are experts on Texas wineries, gave us detailed information about Texas vineyards. Our longtime friend and colleague Patti Edens combed the manuscript to ensure accuracy of facts, figures, and for coherent descriptions about each location. Our cousin, Forrest Hines Clark Jr.—who is by far the most informed Texas history buff we know—has always enlightened us; his late father, Forrest Hines Clark Sr., wrote a book detailing family history called *The Crosswinds of Duval County*, which enhanced our knowledge of South Texas. All these people wrought the grist for this book, and our gratitude to them is bigger than our big state.

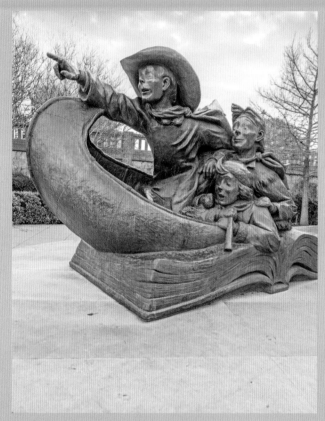

The Abilene Storybook Sculpture Project

Kathy and I are seventh- and sixth-generation Texans. Our family roots gave us the perspective for discussing and photographing backroad communities with clear eyes to distinguish fact from fancy and show you Texas in a loving, but realistic, light. To our forebears, this book is your legacy.

INTRODUCTION

THINK HOW OFTEN restaurants in states other than Texas have menu items such as Texas-sized steak, Texas-sized hamburger, or Texas-sized margarita. Even Texas eateries boast "Texas-sized" food and drink. In common parlance, Texas is always synonymous with "big." While Alaska is slightly bigger, Texas got the "big" moniker first.

Lay a Texas map over Europe, and it covers France, parts of Germany, Italy, England, and a significant section of the Atlantic Ocean. Flip the map over west toward California and it extends into Los Angeles, or flip it to the east toward Georgia and it extends into Savannah. The 856-mile distance on Interstate 10 west across Texas from Orange to El Paso roughly equals the driving distance north from Dallas to Sioux City, South Dakota.

Small wonder people traveling across the northern part of Texas on Interstate 20 or across the heart of Texas on I-10 are prone to say, "Texas is nothing but miles and miles of nothing except miles and miles."

We, however, want you off the interstates. We want you on a road American poet Robert Frost called "the one less traveled by" so that you may discover that Texas is more

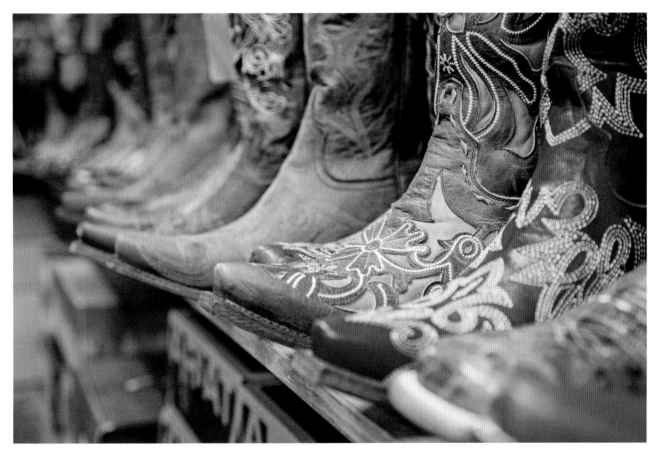

Texans love their cowboy boots. Ornate to practical boots can be found at Sassy Pantz in Stockyard Station at the Fort Worth Stockyards.

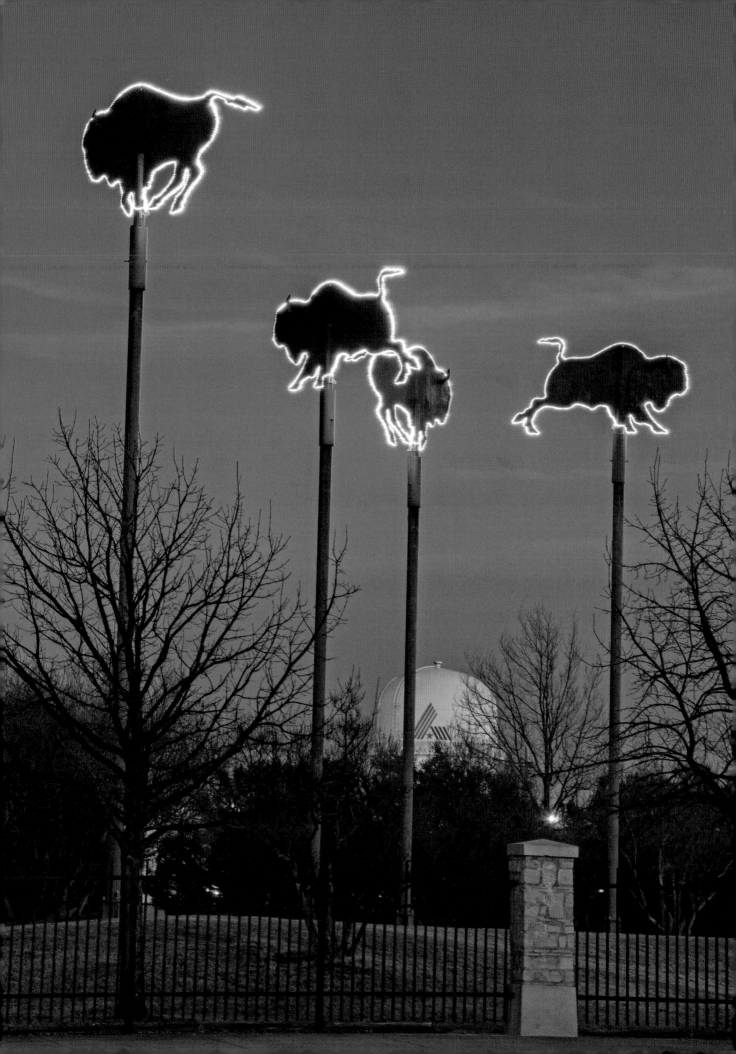

than the sum of its miles. Oh, yes, we'll have to move you along interstates from time to time just to get you to the best of the backroads because, well, Texas is a big state of daunting distances admittedly eased by direct interstate routes . . . occasionally. We'll get you off soon. Also, we may put you on US highways because in Texas, most such roadways are like seldom-traveled backroads that wind through picturesque countryside and into historic towns you'd be shortchanged to bypass.

You'll discover a state of startling geographic contrasts, including a 367-mile coastline from the border with Louisiana to the Mexican border; a seemingly endless and dense pine forest where early Anglo settlers often got lost; verdant hills with valleys cut by spring-fed, clear-water streams; thirty-seven mountains over a mile high; desert terrain astonishingly filled with flowering plants, grasses, and immense ranch lands; high plains where millions of bison once roamed; eye-popping canyons with one second in size only to the Grand Canyon of Arizona; and a sweeping, lush tropical paradise along the Rio Grande River. Texas is a place of Spanish missions dating back to the 1600s and historic lands first claimed by American Indians such as the Teya, Querecho, Caguate, Aranama, Coca, Karankawa, and Nasoni peoples. The state's name derives from a Caddo word translated by the Spanish as "Tejas," basically meaning "friends." Texas boasts towns dating back to the 1700s filled with extraordinary histories; a wine country rivaling California's Napa Valley; and big cities teeming with businesses, top-tier colleges and universities, cutting-edge medical research centers and hospitals, highly rated art museums, music halls, theater companies, and, of course, restaurants and hotels.

Wildlife—from deer to mountain lions, bears, jackrabbits, armadillos, foxes, and birds—abounds. Perhaps no wildlife is more abundant and readily seen than birds, more than 620 species in all. You will not miss them. From meadowlarks in the Texas prairies to waterfowl in lakes, coastal wading birds, eagles, hawks, hosts of songbirds, and even tropical birds such as the resplendent green jay seen nowhere else in the United States but in the Texas Rio Grande Valley, birds will light up your life in Texas.

The people of Texas are as diverse as the land. European heritage, Hispanic heritage, African heritage, Pacific Asian and Chinese American heritage, and Middle Eastern American heritage are woven into many other cultural traditions to create a tapestry both beautiful and life-affirming. And yes, Texas has a big cowboy heritage, a proud heritage, and a heritage inclusive of all brands of ethnicity. Don't be surprised to see a Chinese American alongside an African American, both wearing cowboy boots.

Are Texans full of pride? Yes. But it's pride in the land more than pride in themselves, the kind of pride you find among people in all fifty states of our great nation. Regardless of the caricatures of Texans as swashbucklers, they are no different from citizens in other states—friendly, hardworking, giving, interesting, quick to laugh, quick to give you a hand, and even quicker to share winsome stories with you about their towns.

Enjoy Texas. Enjoy the land. Enjoy the people.

Buffalo weathervanes stand on poles on the grounds of Frontier Texas! in Abilene.

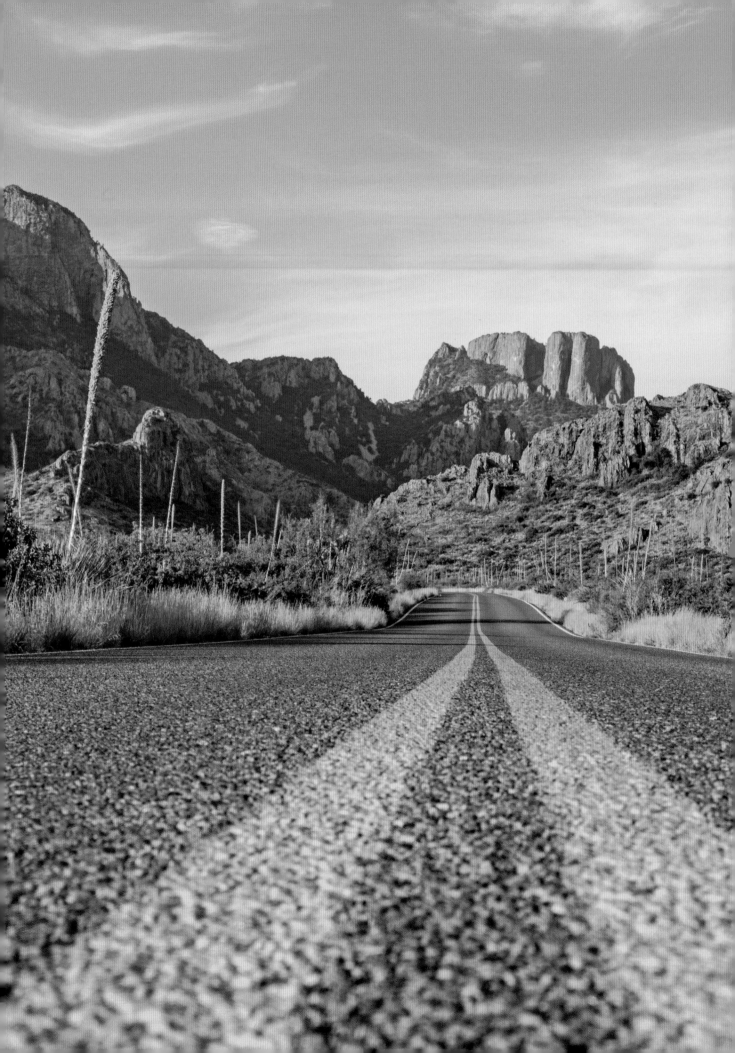

BIG BEND COUNTRY

Big Bend National Park offers visitors a chance to experience high mountains and low deserts.

DRIVING INTO THE MOUNTAINOUS REGION of West Texas from the Big Bend to El Paso is like arriving in a different country, let alone a different part of the state. Distances are daunting. One hundred miles from the city of Alpine to the famous Big Bend National Park. At least 220 miles from Alpine to the nearest major city, El Paso. The 6,193-square-mile Brewster County could contain the state of Connecticut and the whole of New York City with plenty of room to spare. But fewer than ten thousand people reside in the county, a low-density population characteristic of the entire region. Ranch houses are in view, if at all, at distant horizons. Communities are small, historic, and lively.

With a small population spread over a huge area and with towns smaller than a typical big city suburb, the sky at night is far darker than most other places in North America—so dark, in fact, that visitors may see the Milky Way as they have never before seen it, a true resemblance of a milky white band across the sky but full of countless beads of light.

Overlaying the land is a portion of the roughly two-hundred-thousand-square-mile Chihuahuan Desert, the largest desert of North America that extends into Mexico and over parts of New Mexico and Arizona. It's a startlingly green shrub desert of white-thorn acacia, lechuguilla, ocotillo, yuccas, and grasslands, the latter making it prized ranching territory. Average elevation of the desert is about 2,500 feet, not including mountain peaks over 6,000 feet. The mountains well up from the desert to form a collage of "sky islands," derived from cataclysmic volcanoes beginning some forty-two million years ago and ending perhaps thirty-two million years ago. The imposingly tangled,

rugged, igneous rock mountains rise in a stunningly artful dimension as though designed by Pablo Picasso. Other mountains began as part of earth's Rocky Mountain building processes some sixty-five million years ago, making the entire region one of the more geologically and ecologically complex features in North America. Embracing the mountains are lush forests with spring-fed streams and grassy meadows. Mountain lions and black bears dwell in the mountains, but you will not likely see them—you are far more likely to encounter Carmen Mountain white-tailed deer. In both mountains and desert, you will see coyotes, jackrabbits, greater roadrunners, scaled quail, and a surprising array of songbirds that are among the most colorful in North America.

The area's human history is as complex as the land. It was first inhabited by prehistoric Indians who likely fished the Rio Grande, hunted large game, and farmed fertile fields along the river floodplain. Beginning in the early 1500s, the nomadic Chisos arrived but were displaced by Mescalero Apaches in the 1700s. Comanches, whose Great Comanche Trail passed through Big Bend in the 1800s, were among the last American Indians using the land. By the 1600s, Spanish settlers arrived, and in the 1800s Anglo settlers came mostly for ranching. A short-lived spate of quicksilver mining brought more people in the early twentieth century. Although oil would become the mainstay industry of twentieth-century Texas, it bypassed the Big Bend mountainous regions. But grass above formed abundant grazing land for cattle, grassland that until the late twentieth century was so rapaciously overgrazed it became virtually barren until modern ranching practices took hold.

La Grange

San Marcos

Boerne

New Braunfels

Schule

Roswell

WHITE SANDS NATIONAL MONUMENT

SAN ANDRES NATIONAL WILDLIFE REFUGE

NEW MEXICO

CARLSBAD CAVERNS NATIONAL PARK

Carlsbad

EL PASO

GUADALUPE MOUNTAINS NATIONAL PARK

2

Orla

Monahans Sandhills State Park

Monahans

Pecos

54

Aransas Wildlife

10

20

Balmorhea

Fort Stockton

Rockpor

Balmorhea State Park

118

Port Ara

17

118

Fort Davis National Historic Park

3

FORT DAVIS

90

166

118

Mustang Isla

Marfa

17

118

Alpine

67
90

67

Marathon

90

MEXICO

1

118

385

67

SLAND

Presidio

Terlingua

170

BIG BEND NATIONAL PARK

RE

0 100 Miles
0 100 Kilometers

MEXICO

Rio Grande City

Laguna Acosta

Wildlife Refug

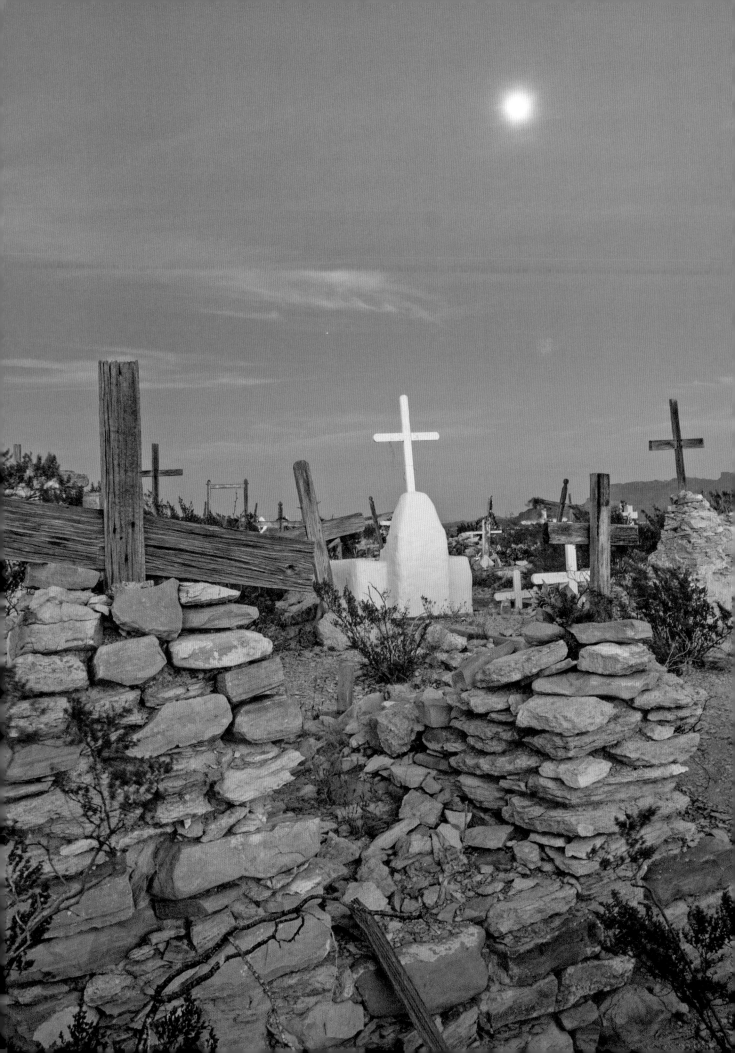

FARM to MARKET ROAD 170

FROM MARATHON TO PRESIDIO AND BACK

From Marathon on US Highway 90, follow US Highway 385 south 68 miles to Big Bend National Park. The speed limit changes to 45 miles per hour once you reach the park boundary. Study Butte is on the western boundary of the park. Turn on Farm to Market Road 170 west from Study Butte and drive 64 miles to Presidio. Drive on US Highway 67 north 58 miles to Marfa. Drive 26 miles east on US Highway 90 to Alpine. Approximately 250 total miles.

You'd hardly guess that the present-day garden spot on an otherwise desert plain adjacent to the Glass Mountains was part of a region the early settlers called Hell's Half Acre. But in 1882, when former seafaring captain Albion E. Shepard (working as a surveyor for the Galveston, Harrisburg & San Antonio Railway) saw the sweeping vista around the community then called Camp Pena Colorado, he was reminded of the landscape at Marathon, Greece. Shepard subsequently purchased land in the area for a ranch and applied for a post office in a town he not surprisingly named Marathon.

The peaceful city has no high-rise buildings, no bright lights, and no crowded thoroughfares. Even US Highway 90 seems like a country road passing in front of a few cafés and restaurants, a few shops, and fewer hotels, yet all with welcoming hosts. Sit inside a coffee shop, read a magazine on one of the stands, chat with the locals, and listen to the occasional rumbling sound of a train barreling down the

Opposite: **Wooden crosses and stacked stone grave markers under a full moon at Terlingua Cemetery, Texas.**
Below: **Cow skulls decorate a wall at the Gage Hotel in Marathon. The hotel is known for style, comfort, and hospitality.**

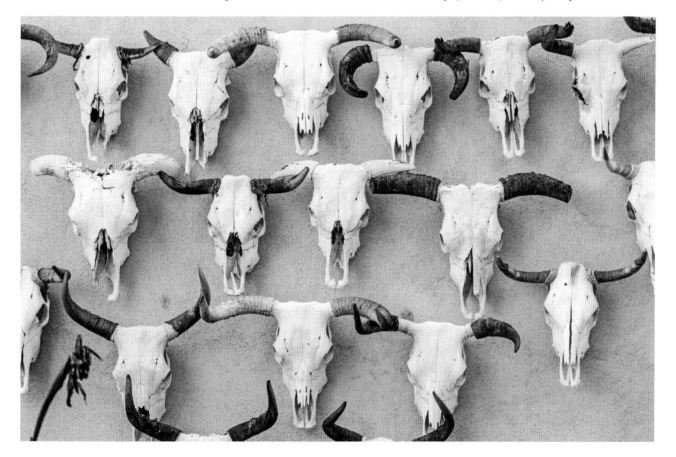

tracks that all of a sudden blares its thunderous horn. The locals will laconically intone, "There's the train."

For most of the twentieth century, Marathon was a dusty, unremarkable town with a gasoline station that was maybe open if you needed to stop before heading south to Big Bend National Park. Few travelers knew, and few yet know, of its history as the passageway for raiding nineteenth-century Comanches heading into Mexico, or that an army captain named Douglas MacArthur brought troops to the town in 1911 to assist local authorities against potential raids by Mexican revolutionaries under the leadership of Pancho Villa. MacArthur's troops were later replaced by troops under the command of a young lieutenant named George Patton.

In 1927, Marathon businessman Alfred Gage built a hotel across the highway from the railway depot in the architectural style of a Spanish mission and appropriately named it for himself. The hotel fell into disrepair when Gage passed away, and the town became a dusty spot on the highway. Not until 1978 did the town gain new life when Houston businessman J. P. Bryan bought the Gage Hotel and began restoring it. The restoration attracted other businesses, giving the community a new birth of life that continues to blossom like a desert rose.

Park along US 90 and walk down the sidewalk bordering the north side of the highway. Have breakfast or lunch at a café, then stop at the gift shops and maybe duck in to the grocery store. Spend a night at the Gage Hotel with its spacious cowboy-themed rooms encompassing a serene courtyard. Amenities include the White Buffalo Bar, 12 Gage Restaurant, swimming pool, spa, gardens, walking and running trails, gym, and game lot with soccer ball and sand volleyball. Visit the twenty-six-acre Gage Gardens across the railroad tracks. Interpretive signs describe the wide variety of drought-tolerant native plants and trees such as desert willow,

Star Trail, or light left behind by the stars as the earth rotates at night. Big Bend National Park has some of the darkest skies in the lower forty-eight states thanks to efforts to reduce light pollution.

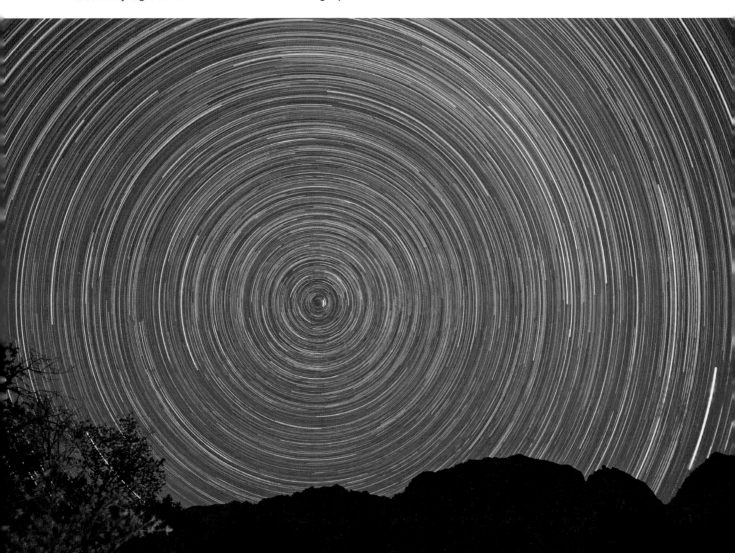

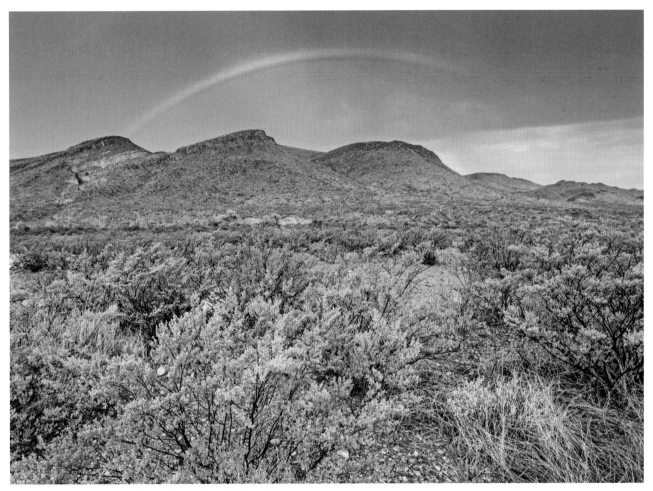

Late summer rains bring rainbows to Big Bend National Park.

blue sage, red yucca, smoketree, and pinyon pine. The gardens include an orchard with trees such as pecan and walnut, plus a mile-long trail through native grasslands of bluestem, nettle, and pigweed.

The entrance to Big Bend National Park is thirty-six miles south of Marathon on US Highway 385. A short trip down the road, right? Wrong. You'll be entering America's last frontier where distances are more than the sum of miles. Fill up your gasoline-powered vehicle before striking out on a Big Bend adventure.

You'll cross the park's boundary at Persimmon Gap where eighteenth-century Comanches once raced through on horseback to raid Mexican villages another one hundred miles south. Persimmon Gap holds rock dating back five hundred million years, so stop at the ranger station and look around. You will drive another forty-four miles into spectacular scenery on the way to the main headquarters at Panther Junction. The park is vast, covering more than

eight hundred thousand acres. Speed limits on the paved roads are forty-five miles per hour. Gravel roads to interesting locations force a slow, slow drive. You could start early in the morning at one end of the park and not wind up at the other end until late afternoon.

Two must-see places are the Chisos Basin and Rio Grande Village. The Chisos Basin, at an elevation of 5,400 feet in the Chisos Mountains, rests on a plateau in a sky island born from a cycle of catastrophic volcanoes some thirty to thirty-two million years ago, which left startlingly sculpted mountains. The basin is full of wildlife along mountain trails and around the lodges and campground. Birds such as Say's phoebes, canyon towhees, cactus wrens, and rufous-crowned sparrows are common throughout the year. Beautiful Scott's orioles and varied buntings are less common but present in all seasons except winter, and white-winged doves commonly coo mornings and evenings in every season.

You could spend a whole morning chasing butterflies that abound around the lodge from spring through autumn. The show-stopper of mammals is the Carmen Mountains white-tailed deer, one of the smallest races of white-tailed deer in North America that you will see only in the Chisos Mountains. Look for its V-shaped tracks, wide in the back and narrow in the front. Mammals such as the handsome gray fox and not-so-handsome collared peccary (a.k.a. javelina) wander around the basin. Black bears are not seen too often in the basin, but they forage in the surrounding mountains. Mountain lions, though rather common, stay mostly out of human sight, so much so that people who've lived in the park for twenty years have never laid eyes on one.

Rio Grande Village on the east end of the park rests in a low floodplain along the Rio Grande River. The large cottonwood trees in the picnic areas and campground hold a large variety of birds, particularly in fall and spring migration. A nature trail begins with a boardwalk over a marsh where you can find butterflies such as the fatal metalmark, mourning cloak, and small checkered skipper. But don't miss the dragonflies, such as the thornbush dashers with emerald-green eyes or the slough amberwings. Early mornings and late afternoons are times to sit quietly and look for a bobcat strolling along the edge of the salt cedars by the river, or watch jackrabbits scampering among creosote bushes in the nearby desert, or coyotes running along the campground roads.

Study Butte (pronounced "stewty beaut") is a small community just north of the western entrance to Big Bend National Park. You'll find lodging, convenience stores, auto mechanics, banks, and an unmatched charm among the people in this desert community.

Turn onto Farm to Market (FM) Road 170 in the heart of Study Butte and travel west to Terlingua. Built on mercury mining, Terlingua seems limited but is filled with charm. Follow the signs to the Terlingua Ghost Town where you'll find the Terlingua Trading Company, a store with a wide, shaded veranda in front. Once inside the store, you'll get lost in the eclectic merchandise, including candy, hot sauce, cold drinks, folk art, textile crafts, books, and much, much more. Allocate an hour or more for shopping.

When you've done enough shopping, walk down the road to the Terlingua Cemetery. Piles of stones cover each grave with wooden crosses displaying the names of long-deceased luminaries, rascals, and ordinary folks. Candles burn in glass containers on many graves. Some graves mark recently deceased persons, but many date to a bygone time of a thriving mining town.

Walk back up the hill and have a meal at the Starlight Theatre. This old theatre has been turned into an amazingly exciting place to enjoy a meal and sometimes listen to music. The ambiance is fun, laid back, and always welcoming to strangers.

Continue along FM 170 to Lajitas. On your way, you'll find information on Big Bend National Park and Big Bend Ranch State Park in the Barton Warnock Center, an enthralling educational facility with a gift shop, museum displays, restrooms, and garden.

The community of Lajitas is anchored by the Lajitas Golf Resort and the Badlands Hotel, with adjacent gift shops having an Old West look.

The drive west from Lajitas to Presidio along FM 170 is beyond question among the most scenic drives in the United States. Yet because it lines the southern boundary of America's last frontier, the breathtaking road rarely gets mentioned in travel magazines. The two-lane road skirts the Rio Grande as it winds and twists through towering cliffs. Luckily, pullouts are well spaced along the road. You'll want to get out and take photos or enjoy the view. Several parking areas also allow access to a small bit of the massive three-hundred-thousand-acre Big Bend Ranch State Park. A few of the short hikes into the slot canyons are well worth the small effort. Approximately ten miles west of Lajitas is the remnant of a ghost town called Contrabando, better known for a movie set where at least nine movies or parts of movies, including *Streets of Laredo*, have been filmed. However, a recent river flood damaged all the buildings except the one called La Casita.

For an adventure to see what it was really like in the legendary frontier of the Old West, visit Big Bend Ranch State Park that stretches inland along the highway from the Rio Grande. Its more than three hundred thousand acres are formed of rugged mountains, plateaus, and canyons, but minus the amenities people expect in national and state parks. Trails in the park make a hiker feel what it was like for pioneers to follow animal trails in the once-untamed western wilderness. Campers see a nighttime sky lit up with countless stars as bright and clear as seen by

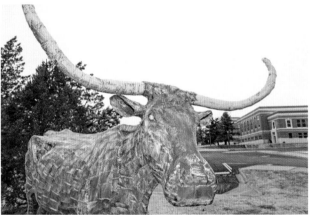
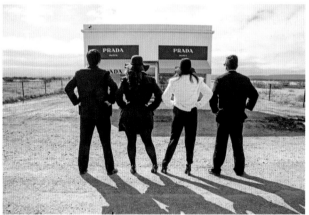

Top: **Sunrise on a clear morning illuminates the mountains around Alpine, Texas.**

Below left: **Statue of a Texas longhorn on the campus of Sul Ross State University, Alpine, Texas.**

Below right: **Prada Marfa is a mock-up of a Prada store created by Scandinavian artists Elmgreen & Dragset. It's located on US 90 between Valentine and Van Horn, Texas.**

Paleo-Indians. Hikers will find two of the largest waterfalls in Texas. It's a wilderness like none other in the lower forty-eight states, a true frontier, a true remnant of the Old West, and a true challenge to the adventurous.

Camping permits are available at Fort Leaton State Historic Site at Sauceda or at the park headquarters situated on Casa Piedra Road, twenty-seven miles off FM 170.

Continue driving along FM 170 to Presidio, an area continuously inhabited for at least three thousand years. Spaniards came here in 1535 when Álvar Núñez Cabeza de Vaca and his companions, being quite literally lost in the desert, stumbled into the community and claimed it for Spain. The town sits at the junction of the Rio Conchos flowing out of Mexico and the Rio Grande that begins in

the Rocky Mountains of the United States. Presidio is hot in summer, with Fahrenheit temperatures on the town's bank clock reading 123°F. But it's a town with people warmly welcoming visitors, as you will discover in any local restaurant while scarfing down a plate of delicious barbecue or a plate of homemade Tex-Mex food.

The Presidio area and nearby Big Bend Ranch State Park has one of the darkest skies in the United States with a Class 1 or "absolute darkest sky" designation as measured on the Bortle light pollution scale. In October, the town hosts the Texas Dark Sky Festival, and maybe it's the dark sky that inspires Presidio's high school students to build model rockets and become so good at it that they won fourth place in the nation for model rocket building in 2014 and earned a visit to the White House and an appearance on national television. Presidio may be small and sometimes dusty, but it is no intellectual backwater.

Leave Presidio on US Highway 67 and travel across the rocky landscape that gradually turns into expansive grasslands.

You'll reach the town of Marfa at the intersection of US 90. At an elevation of 4,830 feet and surrounded by mountains, the town was merely a water stop on the Galveston, Harrisburg & San Antonio Railway back in 1883. But Marfa hit the big time in 1955 when acclaimed Hollywood actors James Dean, Rock Hudson, Elizabeth Taylor, and Dennis Hopper arrived in town to film the now classic movie *Giant*. You'll see references to this movie all over town.

The Marfa Lights appearing as some kind of ghost lights—maybe signals from space aliens?—have been a big tourist attraction for decades. A viewing area east of town is where people claim to see bouncing balls of light out in the desert at night, like something from the 1977 sci-fi movie *Close Encounters of the Third Kind*. Studies have shown the lights to be bouncing from car headlight beams, but don't tell that to onlookers anticipating desert ghosts or space aliens.

Marfa is filled with restaurants, museums, and a couple of hotels. The vintage Hotel Paisano near the courthouse is always a treat and a national historic landmark. Recently, the town has become an art community with the Chinati Foundation and Contemporary Art Museum, founded by the artist Donald Judd, at its core.

Continue east along US 90 to Alpine, in the high country at an elevation of 4,600 feet with an exceedingly pleasant year-round climate and encompassed by high mountain ranges and sprawling grasslands. Sul Ross State University sits in the middle of town and provides a college feel to the community. The town has plenty of restaurants, hotels, and places to shop. Spend some time at the excellent and informative Museum of the Big Bend on the campus of Sul Ross.

The city is a mixture of real-life cowboys, university scholars, poets, and theater performers. Maybe the pleasant climate and clean fresh air are what draw an eclectic citizenry.

2

US HIGHWAY 62 from EL PASO to PECOS

From El Paso, follow US Highway 180 east 105 miles to Guadalupe Mountains National Park. Continue on US Highway 180 east 19 miles and turn south on Ranch to Market Road 652. Drive 41 miles on Ranch to Market Road 652 to US Highway 285 south. Drive 38 miles south to Pecos. Drive 45 miles on Interstate 20 east to Monahans Sandhills State Park. Approximately 250 total miles.

El Paso sits on the western edge of the state as a modern metropolitan city of 650,000 residents. It is among the safest cities in the United States and the site of the first Thanksgiving Feast in 1598, twenty-three years before the

Pilgrims ate their famous meal. Places to visit include Fort Bliss, a massive military base in operation since 1848; the University of Texas at El Paso with buildings resembling Bhutan monasteries; and the Ysleta del Sur Pueblo on the

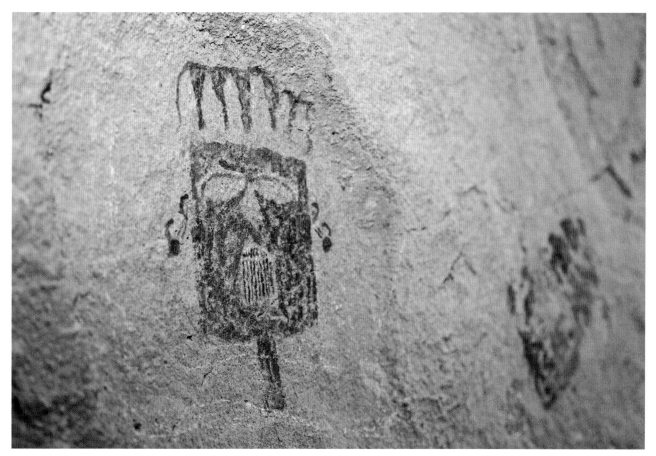

These pictographs, or painting on rocks, by the Jornada Mogollon date from 600 AD to 1400 AD in a solid mask design. They're located at Hueco Tanks State Historical Park outside of El Paso, Texas.

Tigua Indian Reservation offering lovely churches dating back to the 1650s. Sample scrumptious Tex-Mex food at any of the local eateries and visit a local festival for a delightful memory of your visit.

The Franklin Mountains dominate the landscape from any part of the city with stunning views and opportunities for outdoor activities. Enjoy the spectacular sunset from Skyline Drive and ride the Wyler Aerial Tramway to the top of Ranger Peak.

Texas Highway Loop 375 Express Southwest runs along the border fence designed to keep out illegal immigrants crossing the Rio Grande from Mexico. The efficacy of the fence is a subject of hot debate in our nation.

This route will leave El Paso on US Highway 62 heading east. Turn north after the community of Butterfield on Texas Highway 2775 and drive to Hueco Tanks State Park and Historic Site. As you enter the park, you'll notice a large pile of red boulders to the east. The rocky outcrop in an otherwise flat desert has been sheltering humans

and offering them life-giving water for a thousand years. Natural depressions in the rocks hold rainwater throughout the year. In a dry, parched environment such as West Texas, these pools called huecos (whey-coes) can be the only water for miles. Modern visitors come to the park to enjoy the history and recreation. It's a popular place with hikers, rock climbers, and bird-watchers.

Take a self-guided walk to see the historic cave drawings and climb on the rocks. But be aware that only seventy people are allowed on the trails at a time. Guided tours are offered Wednesday through Sunday.

After leaving the park, return to US 62 east. The highway merges with US Highway 180 through a flat, open desert toward Guadalupe Mountains National Park.

Two notable food stops are along the highway. Just west of the ghost town of Salt Flat is the Cornudas Café that offers the "World Famous Cornudas Hamburger," which lives up to its reputation. The Salt Flat Café, twenty-three miles east and right before the intersection of Ranch Road

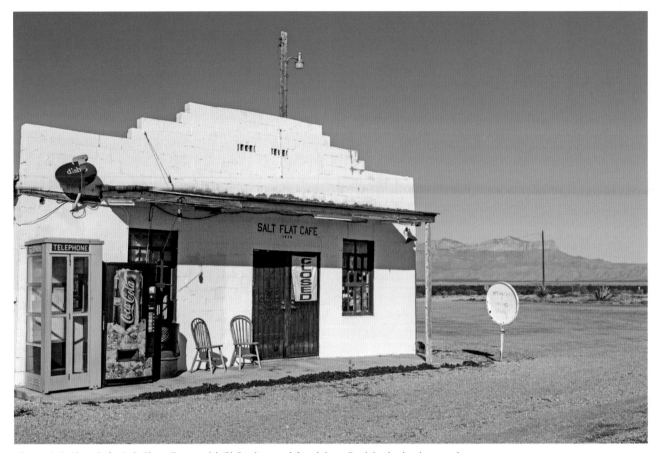

Above: **Salt Flats Cafe, Salt Flats, Texas, with El Capitan and Guadalupe Peak in the background.**

Opposite: **El Capitan, at 8,078 feet, dominates the landscape of Guadalupe Mountains National Park in far west Texas.**

1576, is a renowned outpost that has been serving travelers between Carlsbad, New Mexico, and El Paso since 1929. In the 1950s, it was a mandatory stop for cars with overheated radiators under summer's hot desert sun.

Past the Salt Flat Café, you'll notice that the highway descends to a flat, lifeless plain where a shallow lake spread over the area a million years ago. Once the lake dried up, it left a bed of salt that people have been harvesting for hundreds of years.

Stop at one of the pullouts along the salt bed, touch the salt, taste it if you dare, but do enjoy the sight of the Guadalupe Mountains in the distance.

The first mountain peak you may see is the 8,078-foot El Capitan towering above the flat desert landscape and virtually hiding Guadalupe Peak to the left, which stands as Texas's highest mountain at 8,749 feet. Both peaks form the apex of the Guadalupe Mountains. During the Permian period between about 251 and 299 million years ago, the present-day surrounding desert and mountains formed a

shallow sea with the peaks being part of a massive reef. Stop at one of several picnic areas along the highway as it forms a tight bend around the peaks and enjoy the grandeur of the area.

El Capitan has served as a marker in the desert for Mescalero Apaches, Spanish explorers, and early settlers. Today the peak is part of Guadalupe Mountains National Park. Backpackers, hikers, campers, and nature lovers enjoy the park throughout the year. Amenities inside the park are few, with no lodges and only campgrounds. The visitor's center offers an overview of the park, so stop in to enjoy the displays, friendly staff, and restrooms. A short hike along the nature trail is a nice way to take a break from driving.

After visiting the park, continue along US 62/180 to Ranch Road 652. Turn south toward Pecos, Texas. RR 652 is a two-lane local road cutting across the desert in twists and turns. At the intersection with Ranch Road 2119, you have two routes to choose for the journey to Pecos. You may

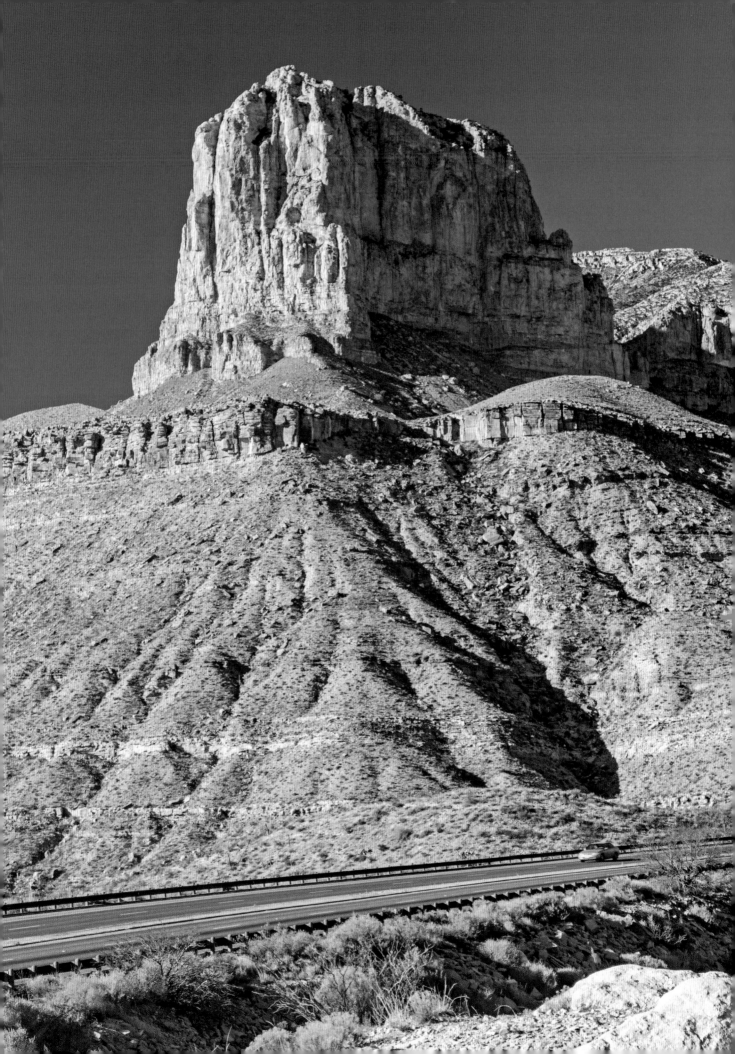

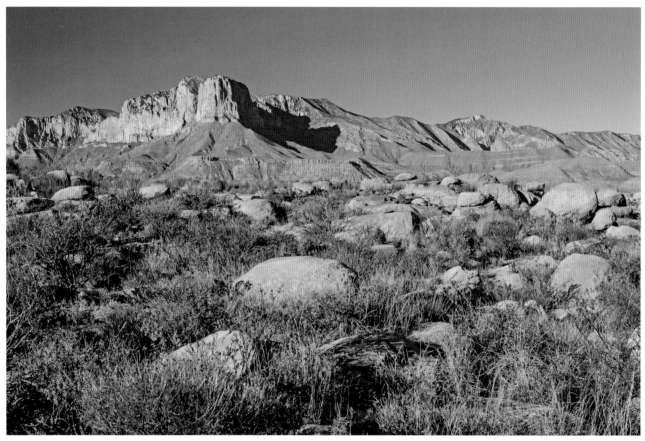

Guadalupe Peak, behind El Capitan, is the highest peak in Texas at 8,749 feet.

continue on RR 652 and drive to Pecos on US Highway 285. Or you may drive into Pecos on RR 2119. Both routes will have traffic from oil field vehicles and might be a bit crowded.

RR 652 and US 285 cross the Pecos River that begins in New Mexico and winds for 926 miles until it meets the Rio Grande near Langtry with a watershed of 44,402 square miles. Pictographs in caves and on rocks show that Paleo-Indians lived along the river. Diary entries from Spanish explorer Antonio de Espejo in 1583 explain that the Jumano lived near the river just west of the town of modern-day Toyah. When this area was part of Mexico, settlers came for the rich farmland. Anglo settlers arrived in 1871. The community of Pecos became a crossroads for their travels thanks to good river crossings.

In Pecos, navigate to First Street and US 285. Here, you'll find a finely restored historic area. The West of the Pecos Museum has been open since 1963. It originally housed a saloon dating back to 1896, and an adjacent hotel

was built in 1904. Three floors and more than fifty rooms of the hotel building now offer a museum of West Texas history. The gift shop lures you with interesting items.

Walk the streets around the museum. The Texas Rodeo Hall of Fame is across the street in the restored train depot. A replica of Judge Roy Bean's courthouse sits nearby, as do other attractions.

Monahans Sandhills State Park is forty-five miles east of Pecos along Interstate 20. The park opened in 1957 and preserves 3,840 acres of dunes and desert scrub.

Most people visit the park to slide down the dunes on plastic sleds. Rent sleds at the park headquarters where you can also learn a bit about the dunes and how they were formed. The displays at the headquarters are outstanding for small children.

Drive the park roads, reserve a campsite, or simply stay for a picnic and sit on the dunes. Be sure to check out one of the many ranger programs.

BALMORHEA to FORT DAVIS

From Balmorhea, follow County Road 319 or Houston Street east to Lake Balmorhea. Return to Texas Highway 17 south and drive 5 miles to Balmorhea State Park. Drive 49 miles south to Texas Highway 118 in Fort Davis. Drive 25 miles west on Texas Highway 118 to Texas Highway 166. Drive 42 miles west on Texas Highway 166 connecting with Texas Highway 17 outside Fort Davis. Approximately 125 total miles.

The small West Texas community of Balmorhea sits a mile south of busy Interstate 10 on Texas Highway 17. Mescalero Apaches were the first inhabitants of this area due to the abundant water flowing from San Solomon Spring. In 1906, three land promoters with the last names Balcom, Morrow, and Rhea established the town of Balmorhea.

Balmorhea is a charming little community. Park along Main Street near Dallas and Austin Streets to start your visit. The Main Canal runs beside the road with the soothing sounds of running water. Cottonwoods offer shade, making the town cool and refreshing even in the middle of summer.

Lake Balmorhea sits east of town via County Road 319 or Houston Street. The 556-acre lake is a reservoir created by Sandia and Toyah Creeks. The lake is a mecca for anglers hoping to catch largemouth bass or sunfish. Canoes and kayaks are more common on the lake than motor-powered boats. Bird-watchers love the lake for its abundant supply of ducks, grebes, egrets, herons, and shorebirds. Because the lake rests in the middle of a desert, the water level often fluctuates summer to winter as a result of, or lack of, rain.

The lake is open daily with a modest fee required.

Balmorhea State Park is the next stop along Highway 17 southwest in the town of Toyahvale. The state park was built by the Civilian Conservation Corps (CCC) and holds the world's largest man-made swimming pool. The waters of the pool come from the natural San Solomon Springs. Temperatures in the pool are a steady 72 to 76°F all year.

Park activities include geocaching, bird-watching, picnicking, camping, and motel-style lodging. The park fills fast in the summer, so prepare for your visit ahead of time.

Continue along Highway 17 to Fort Davis. Enjoy the drive as the highway crosses through farm fields and then winds through low mountains.

The town of Fort Davis sits at the intersection of Highway 17 and Texas Highway 118. Situated at 4,892 feet above sea level, the town enjoys a moderate climate year-round. The Jeff Davis County Courthouse sits in the middle of town, and the historic Hotel Limpia stands across the street. The hotel was built in 1912 and is named for the creek that runs nearby. The Blue Mountain Bistro inside the hotel serves excellent food and even caters to vegetarians. You'll find that same attention to dietary habits at other local restaurants and grocery stores in town.

Historic Fort Davis on Highway 188 is nestled against Sleeping Lion Mountain and Hospital Canyon. The site is

The town of Fort Davis has modern conveniences mixed with historic Texas charm.

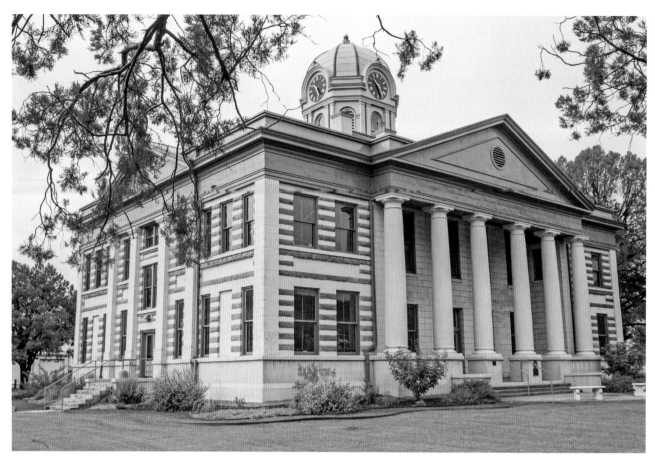

Above: **The Jeff Davis County Courthouse, in Fort Davis, Texas, dates to 1910 and was constructed in the Classical Revival style with a Beaux-Arts clock tower.**

Right: **A shop window in the beautiful town of Fort Davis.**

impressive with well-preserved officers' quarters, barracks, and storage buildings. Friendly, helpful volunteers staff a museum and bookstore there. The National Park Service manages the fort.

Head to Davis Mountains State Park, located on Highway 118. The park encompasses 2,709 acres in a lush, scenic terrain of soft mountain slopes. It rests within Texas's most sweeping mountain range formed by volcanic activity some sixty-five million years ago. What was thus formed by a cataclysm now eases the senses with gentle slopes and tranquil bird songs, including the lively song of a spotted towhee sounding like the words "drink-your-tea-hee-hee."

From the 'park headquarters, you'll descend into a mountain-ringed, pastoral valley that makes up the major portion of the park. Because the park's elevation averages about a mile high, you'll be comforted in warm seasons by soft breezes.

Among the more sought-after wildlife attractions for park visitors are the rare Montezuma's quail that come down the grassy, rocky mountain slopes to feed at a public observation location during the late afternoon (park staff will tell you the most current location). The birds, with their desert-brown coloring offset by striking black-and-white harlequin faces, can be surprisingly difficult to see. The park's interpretive center building has a bird feeding station with a birdbath at the back, all bordered by a

wooden wall with viewing and photo portals. The quail often come to that location.

Drive the winding Skyline Drive to the highest point in the park and enjoy a serene mountaintop vista with cool winds caressing your face as you watch scrub jays hassle rock squirrels.

Don't miss the spectacular adobe-style Indian Lodge that resembles an old Pueblo village. In summer, cliff swallows, the famed "Swallows of Capistrano," nest prolifically around the lodge and are easy to see and photograph. You may have breakfast, lunch, or dinner at the lodge's Black Bear Restaurant whether or not you are staying there. Be sure to check out the adjacent gift shop.

Enjoy the drive to McDonald Observatory. Highway 118 twists and turns over some of the best mountain scenery in West Texas. You'll find the Frank N. Bash Visitors Center for the observatory in the main parking area. Enjoy the informative exhibits about planets, stars, and deep space galaxies and treat yourself or your children to a "toy" in the gift shop.

McDonald Observatory offers guided tours of the large telescopes crowning the mountains above the visitor's center. Star parties are offered throughout the year. Solar viewing programs are offered during the day, depending on weather. If visiting during a busy time of the year, such as spring break, you should make reservations in advance.

After leaving the observatory, continue on Highway 118 to Texas Highway 166. This open two-lane road cuts through some of the most isolated land in Texas. As you drive, enjoy the view of grasslands with mountains in the distance, windmills standing like lone sentinels along the

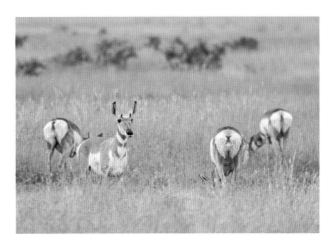

Right: **Pronghorn antelope graze in a grassy field near Fort Davis.**
Below: **A windmill is silhouetted against the morning sun near Alpine, Texas.**

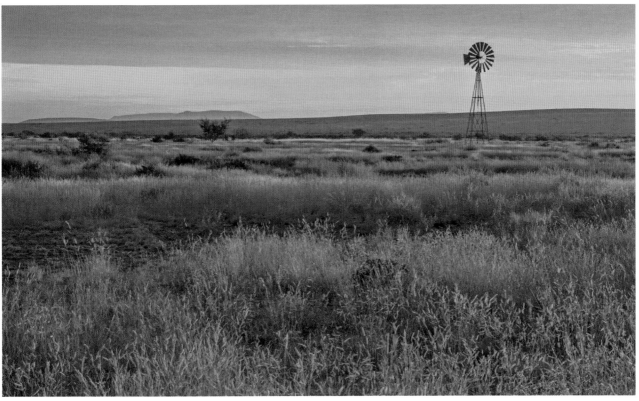

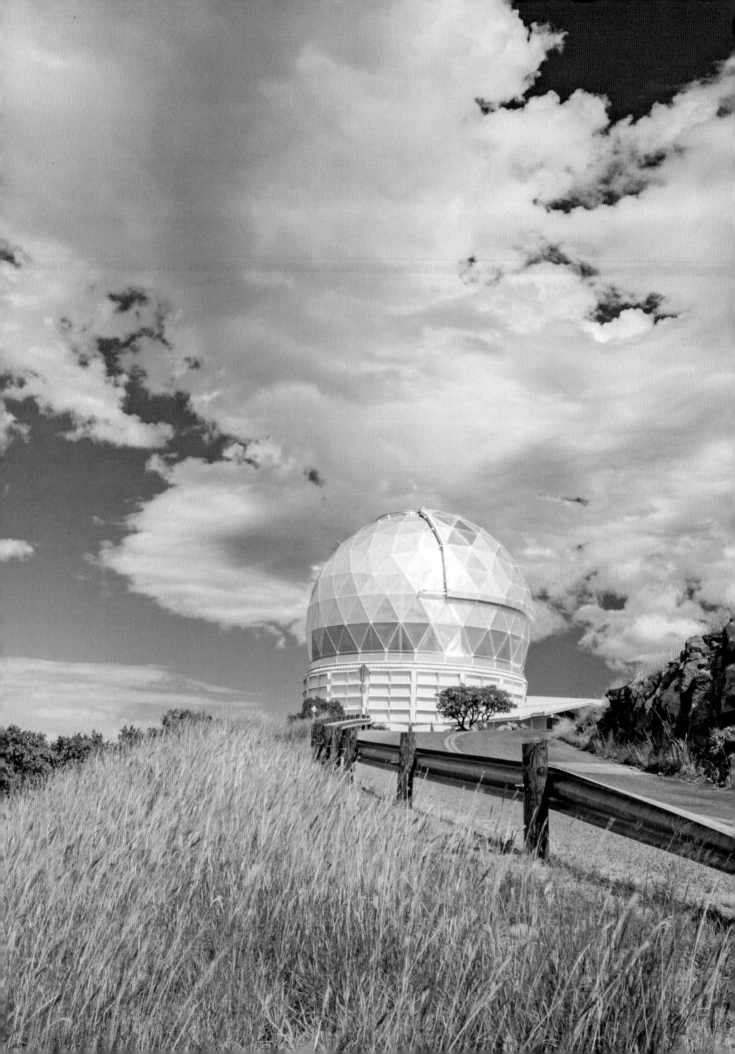

highway, and be sure not to miss pronghorn antelope grazing in the grasses.

Highway 166 returns to Highway 17 south of Fort Davis.

Head to the Chihuahuan Desert Research Institute (CDRI) that will confound any notion you have of a desert being desolate and barren of life. Spread over 507 acres in the Davis Mountains, the institute shows that the Chihuahuan Desert is one of the most biologically diverse regions of the world. It is the largest North American desert, stretching 250 miles wide and 800 miles long from West Texas across southern New Mexico to southeast Arizona and extending south into Mexico to San Luis Potosi.

CDRI was founded thirty-one years ago by a group of professors from Sul Ross University in Alpine, Texas. At first, the institute worked out of the university to coordinate desert research. But in the 1980s, it bought acreage off Highway 118 near Fort Davis so that students from around the world could study the ecology of the Chihuahuan Desert.

Today, CDRI is open to the public as well as scientists and students. It has a beautiful visitor's center with a gift shop, exhibit area, meeting rooms, and offices. Nearby is a greenhouse with three hundred species of native desert cacti being propagated, a surprisingly lush arboretum full of native plants and trees such as Apache plume and desert willow, and a hiking trail winding through a canyon of stunning rock formations.

But the first thing visitors notice is the green landscape, not the desolate brown ground often associated with deserts. Situated five thousand feet above sea level, the property has verdant grasslands dotted with junipers and chollas. Wildflowers such as thistle and Mexican hat decorate the dirt road leading from the main highway to the institute. The road winds over rolling hills and stops in the parking lot of the visitor's center, an adobe building with a red tin roof. A wide porch wraps around the building, providing shade from the desert sun and a nice summertime vantage point from which to watch black-chinned hummingbirds coming to the hummingbird feeders, an ash-throated flycatcher feeding young in a nest box, and

Indian Lodge, a hotel run by Texas Parks and Wildlife, was built in the 1930s by the CCC, in Davis Mountains State Park near Fort Davis, Texas.

INDIAN LODGE

Indian Lodge is a full-service hotel located inside Davis Mountains State Park. The lodge was built in the 1930s by the Civilian Conservation Corps and has been renovated to accommodate the modern traveler. There are thirty-nine rooms, a swimming pool, and the Black Bear Restaurant. Natural plantings around the lodge usually attract numerous birds that may be particularly enjoyed in the courtyard. Being an extremely popular hostelry for tourists means that should you plan to spend a night or two there; be sure to make advanced reservations.

Opposite: **McDonald Observatory's Hobby-Eberly Telescope near Fort Davis, Texas, is designed to gather a very large amount of light for spectroscopy.**

a strikingly colorful Scott's oriole with elegant yellow and black plumes singing atop a juniper tree. An added treat is a stroll through the arboretum where you will see diverse plants such as the multiple varieties of ceniza with silvery leaves accented by purple, blue, and pink flowers.

PART II

PANHANDLE

M. L. Leddy's has made quality boots, saddles, and leather goods since 1922.

Call it the Llano Estacado (Spanish for "staked plains") or call it the High Plains, the Texas Panhandle holds wonders as dramatic and enlivening to the spirit as any in the country. No question it's a rugged land—but no question it's a land of splendid red-rock canyons second only to those in Arizona and Utah. The region gets its moniker "panhandle" because it thrusts upward from the Central Plains like the handle of a giant pan. A mostly high, flat, treeless plateau forms the Panhandle and seems to touch the sky from horizon to horizon. Its deep and splendidly beautiful steep canyons are like upside-down mountains etched in eons of earth's geological history. Nowhere is the canyon feature better exemplified than at Palo Duro Canyon.

People whizzing across the Panhandle on Interstate 20 might not notice its intricate beauty and might instead see the land as a sort of moonscape. Until they drive the backroads. That's when they will discover capacious grasslands with pronghorn antelope, meadowlarks, and wildflowers. Further afield are lands where Comanche, Kiowa, and Cheyenne held sway during much of the nineteenth century after they had displaced the Pueblo and Apache. The Red River Indian War led by General Tecumseh Sherman in 1874 wiped out the last of the American Indian strongholds in the Panhandle and removed remaining Indians to reservations.

But this is also a land of many a western cowboy legend, including the famed Charles Goodnight whose accomplishments included the invention of the chuck wagon to supply meals on long cattle drives, the creation of the million-acre JA Ranch, and the preservation of the genetically pure breed of Southern Plains bison that we still have today.

For all its imposing landscapes and rugged cowboy traditions, Panhandle communities are utterly pastoral with calming rivers and fresh-scented air. Its people define the word hospitable. Towns such as Canadian offer beautiful scenic walkways, scrumptious eateries, and some of the best music festivals in America, where you may hear a tune written in the 1880s called "Red River Valley" and made famous by twentieth-century country-western singer Marty Robbins singing these lyrics:

> *Come and sit by my side, if you love me*
> *Do not hasten to bid me adieu*
> *Just remember the Red River Valley*
> *And the cowboy who loved you so true.*

Dalhart

Rita Blanca River

LAKE MEREDITH
NATIONAL
RECREATION AREA

Lake Meredith

Canadian River

Canadian

Borger

Pampa

McLean

Shamrock

Texola

Sayre

OKLAHOMA

AMARILLO

Conway

Stanley Marsh's
Cadillac Ranch
Canyon

6

Palo Duro Canyon
State Park

Buffalo Lake

Red River

Caprock Canyons State Park and Trailway

Quitaque

Plainview

Paducah

LUBBOCK

Post

4

Lamesa

Sweetwater

ABILENE

Big Spring

Tuscola

5

Midland

Odessa

Monahans

Fort
Chadbourne

Bronte

Echo

Coleman

Lake
Brownwood
State Park

7

Brownwood

San Angelo State Park

San Angelo

Aransas
Wildlife

Rockport

Port Aran

stang Isla

ISLAND

RE

100 Miles

100 Kilometers

La Grange

San Marcos

Boerne

Schule

ALT
90

Rio Grande City

Laguna Acosta
Wildlife Refuge

MEXICO

A lone live oak tree in a field of red dirt on US 277 between San Angelo and Abilene, Texas.

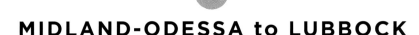

MIDLAND-ODESSA to LUBBOCK

From Odessa, follow Interstate 20 and take Exit 108. Return to Interstate 20 and drive 28 miles east on Interstate 20 to Midland. Drive 36 miles east on Interstate 20 to Big Spring. Drive 106 miles north on US Highway 87 to Lubbock. Approximately 175 total miles.

Midland and Odessa function like the two chambers of a heart pumping economic blood into the body of the Permian Basin. In common Texas parlance, the two cities are named as one entity, "Midland-Odessa," in the same way Minnesotans say "Minneapolis–St. Paul." Begin your route on the west side of Odessa at Exit 108 off Interstate 20 with a journey south on Meteor Crater Road. The Meteor Crater Museum sits next to the second-largest meteor crater in the United States. Measuring 600 feet in diameter with a depth of 15 feet, the crater may not compete for awesomeness with Arizona's Meteor Crater at

2.4 miles in diameter and at least 550 feet deep. Still, the Texas crater inspires awe. Scientists estimate that a spectacular meteor shower rained down on the area around fifty thousand years ago, with most meteors burning up in earth's atmosphere or pelting the ground like burning pebbles or meteorites (about 1,500 have been found.) The big meteor struck the land with such astounding force that it blew out one hundred thousand cubic yards of crushed rock and gouged a crater one hundred feet deep. Over succeeding centuries, the crater was filled in with soil that raised the crater bowl to its current shallow depth, which is

actually a benefit for tourists with children who can easily tromp the earthen bowl of an ancient catastrophe brought from outer space.

Just outside the Meteor Crater Museum are a picnic area, informational displays, and trails around and through the crater. When leaving the parking area, watch for bright green signs. Each sign displays the name of a planet in our solar system and is spaced out from the museum to represent proportionate distances of the planets to the sun, Mercury being closest to the museum and Pluto the farthest.

Head to the Permian Basin Petroleum Museum twenty-eight miles east on I-20. Any number of meandering byways could get you there, but you'd need a good map and lots of time to take them. Community leaders founded the museum in 1975, and it is the largest in the United States dedicated to the history of the petroleum industry. Dotting the expansive grassy entrance is oil drilling equipment, including a wooden oil derrick, black pump jacks, and towering drilling platforms. Detailed informational signs on the equipment will enliven equipment geeks.

Inside the museum, you'll see a variety of informative and interactive displays explaining the growth of the oil industry and the people and machinery that made it possible. The Petroleum Hall of Fame honors pioneering men and women of the industry.

The museum puts Midland-Odessa in context because beyond the museum along nearly every road in the Permian Basin is evidence, like pump jacks and drilling platforms, of the oil and gas industry that gave rise to the twin cities out of a veritable moonscape.

Midland-Odessa's basin terrain of flat land with blanched-looking rocks and soil dramatically changes as you drive east toward Big Spring. Whether traveling along I-20 or Texas Highway 158 to Farm to Market Road 33, you'll begin to see fertile, earthy soil with green vegetation such as redberry juniper, shin oak, and native grasses.

Note that the town name Big Spring is singular "spring." Locals are sure to very politely correct anyone saying, "Big Springs." Towering above the city is a large plateau rising 2,811 feet above sea level and offering a panoramic view of the city, the surrounding countryside, and even the imposing wind turbines on a neighboring plateau. Big Spring State Park sits on top of the plateau overlooking the city. Workers with the Civilian Conservation Corps during the Great Depression constructed most of the buildings and trails in the park. They used limestone quarried from the plateau to construct the winding road up the hill, as well as the park superintendent's residence, concession buildings, pavilions, and a footpath that circles the plateau. Local residents enjoy a spectacular fireworks display from the park every Fourth of July.

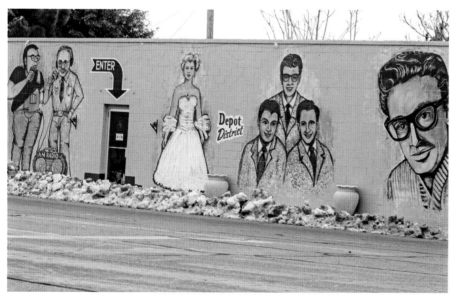

Left: **Mural with the face of Buddy Holly and others across from the Buddy Holly Center in Lubbock, Texas.**
Right: **The Meteor Crater Museum sits next to the site of the Odessa Meteor Crater. The crater is the second largest in the United States and sixth largest in the world.**

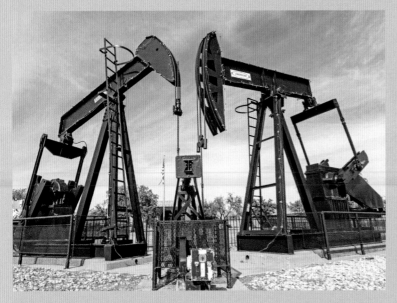

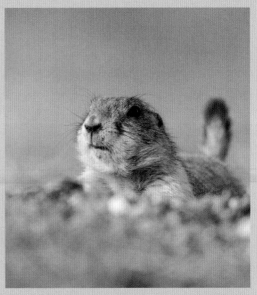

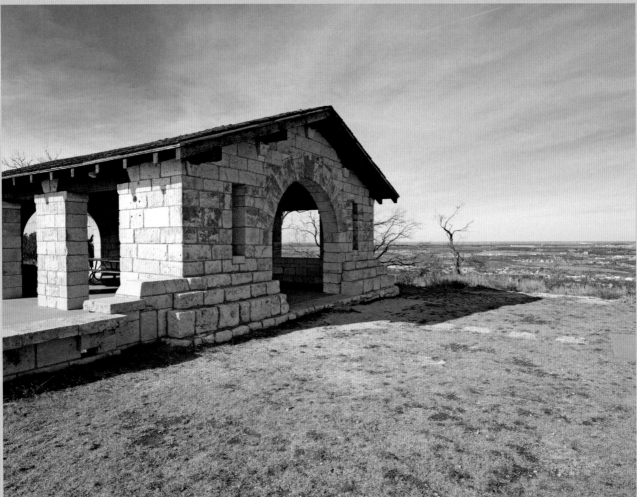

Above: Big Spring State Park sits on a plateau overlooking the city of Big Spring. Buildings in the park were constructed by the Civilian Conservation Corps during the Great Depression.

Top left: The Permian Basin Petroleum Museum in Midland is a great place to learn about the history of the oil industry. Displays on the grounds of the museum allow an up-close view of many common machines used in the oil patch.

Top right: A colony of black-tailed prairie dogs is protected and free to live at MacKenzie Park in Lubbock, Texas.

Comanche Trail Park is a city park a bit south of the state park and it marks the site of the original Big Spring. You may reach the city park from the state park by traveling on Wasson Road or US Highway 87. The park includes a lake for fishing, a hike and bike trail, a golf course, and a picnic area.

This route leaves Big Spring on US 87 heading north to Lubbock. Enjoy the wide-open spaces along the way. Farm fields line the highway and traffic is sparse. For a deep rural experience, travel to Lubbock via Texas Highway 669 east of Big Spring and connect with US Highway 84 in Post.

Lubbock is a bustling and surprisingly metropolitan city that's home to the prestigious Texas Tech University and, as locals would say, "home of the Red Raiders" in reference to the university's football team.

Your first stop will be Mackenzie Park at the intersection of Interstate 27 and US Highway 82. Follow the signs to the park, and once inside the park, follow the signs to the prairie dog town. Here, a quiet, protected home for black-tailed prairie dogs sits inside the thriving, modern city. Back in the 1930s, local resident Kennedy Clapp established the colony with only four prairie dogs during a time when ranchers despised the little mammals that ate grass and grass roots in competition with cattle herds. Fortunately, Clapp was wise enough to know that prairie

dogs were an essential part of the land and needed to be protected. Today, the City of Lubbock embraces the colony's home in the park as a major tourist attraction.

Park at the main area of the colony. Informative signs explain the life cycle of prairie dogs, including a display of a cross section of their tunnel "towns." Prairie dogs pop out of their burrows to feed and bask in the sunshine. Several burrows are even in the parking area for close views of the animals. Adults, children, and pets are forbidden from harassing or disturbing the prairie dogs that should be viewed from a distance to fully enjoy their winsome, playful antics. Viewing the colony is free and available from dawn to dusk year-round.

Leave Mackenzie Park on I-27 and drive south to Nineteenth Street or Buddy Holly Drive.

The Buddy Holly Center sits at the corner of Nineteenth and Crickets Avenue as a tribute to the famous and much-beloved 1950s rock-'n'-roll singer Buddy Holly. Holly was born in Lubbock in 1936 and died along with popular singers Ritchie Valens and J. P. "The Big Bopper" Richardson and their pilot Roger Peterson in a plane crash in Iowa on February 3, 1959. Across Crickets Avenue is a statue of Holly, whose hit songs "That'll Be the Day" and "Peggy Sue" still make people young and old tap their feet and swivel their hips.

5

ABILENE AREA

From Abilene, follow Farm to Market Road 89 south to Buffalo Gap and Abilene State Park. Backtrack to County Road 275. Drive 1.5 miles south on Country Road 275 to County Road 274. Drive east 1 mile on County Road 274 to Farm to Market Road 613. Turn south to Tuscola. Connect with US Highway 83 north in Tuscola then US Highway 84 south in 3 miles. Drive 35 miles south to Texas Highway 206 outside Coleman. Drive 12 miles northeast on Texas Highway 206 to Farm to Market Road 585 and continue another 13 miles east to Farm to Market Road 1850. Drive on Farm to Market Road 1850 east for 3 miles to Texas Highway 279. Drive south on Texas Highway 279 to for less than a mile to Park Road 15. Drive 6 miles east to Lake Brownwood State Park. Approximately 70 total miles.

Abilene's roots as a city of commerce began when the Texas & Pacific Railway reached the town in January 1881. Railroad officials opened a railroad station, platted the area, and auctioned 178 lots to businesses and people. Abilene quickly became a hub of commerce in Central

Texas and remains a center of commerce, as well as a center of healthcare, education, and culture. The Grace Museum at the corner of First Street and Cypress Street allows you to learn about the history of Abilene. In addition to a historical collection of clothing, furnishings, and

Left: **Well-known characters in illustrated children's books are depicted in the Abilene Storybook Sculpture Project. The sculptures can be found on the streets around North First Street in Abilene, Texas.**

Right: **Lake Brownwood State Park, in the Rolling Plains near Abilene, offers water sports, fishing, camping, and other outdoor activities. Several buildings in the park were built by the Civilian Conservation Corps during the Great Depression.**

machinery, the museum's second floor provides a children's discovery zone filled with interactive displays and exhibits, including a large replica of an ambulance for kids to sit in, a replica of a human skeleton they can touch, and a model of the human eye in cross-section with words explaining how the eye functions.

Across the street from the museum is the National Center for Children's Illustrated Literature. Local and national foundations help fund traveling exhibits, book signings, educational activities, and a permanent collection of original pictures from children's illustrated books. Sculptures and artwork along the sidewalks and green space surrounding the two museums are from children's books, including characters from Dr. Seuss books. Park across from the Grace Museum and notice the dinosaur sculpture on a parking garage depicting Dinosaur Bob from the children's book, *Dinosaur Bob and His Adventures with the Family Lazardo*, by William Joyce. A flamingo sculpture wearing glasses is on the front of the main entrance to the Texas State Technical College Building at First and Pine Street.

Frontier Texas!, located nearby at 625 North First Street, is the official welcoming center for Abilene. You'll notice eight giant metal bison weathervanes towering above the grounds of the center. The bison weathervanes rotate with the wind to resemble a herd of the mighty beasts running across the prairie.

Head inside the Frontier Texas! building to see impressive interactive displays about the history of the Texas rolling plains. Learn about the great bison herds that once roamed the area as well as how the seemingly endless herds attracted Comanches for hunting. Visit the general store to purchase souvenirs and gifts.

Leave Abilene on Farm to Market Road 89 west for about thirteen miles to the small community of Buffalo Gap, which as its name implies, sits in a gap at the Callahan Divide formed by a ridge of hills separating the Brazos and Colorado River Basins.

Bison once crossed the gap as they moved through the area. Early settlement roads crisscrossed the gap because of reliable water in Elm Creek and abundant bison for food and trading. The town of Buffalo Gap

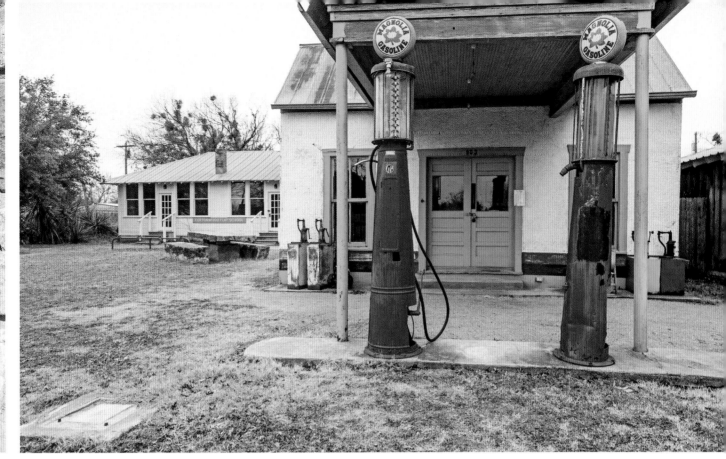

The Buffalo Gap Historic Village is a project of the McWhiney History Education Group. The village has several historic buildings, including a Magnolia gas station and a schoolhouse.

became the county seat of Taylor County in 1878. Presbyterians opened Buffalo Gap College in 1885, the same year the town had a weekly newspaper. Abilene eventually became the county seat when the Texas & Pacific Railway opened offices in that community. The population of Buffalo Gap has dropped precipitously in recent years, and today we see only a small community yet with a rich history.

Buffalo Gap Historic Village is located on North Street two blocks off of FM 89. The historic village contains a number of buildings, including a blacksmith shop, stone houses, a schoolhouse, and gas station.

Return to FM 89 and slowly drive through town. Small homes, restaurants, and businesses sit under a canopy of oak trees. FM 89 makes a sharp turn near the edge of town where you'll see a little cluster of historic buildings. Look for the cowboy boots nailed to the railing along the sidewalk in front of the shops. Plastic flowers fill the boots, making them hard to miss.

Abilene State Park is sixteen miles from Buffalo Gap on FM 89 west. Turn on Park Road 32. The park includes 529

acres of rolling hills covered in a thick forest of red oak, pecan, mixed hardwoods, and cedar.

Drive to the park swimming pool to see a large red sandstone building in front that was built by the Civilian Conservation Corps during the Great Depression. After the city of Abilene donated the land for the park in the 1930s, the federal government sent CCC Company 1823 composed of World War I veterans to construct the community building and swimming pool. Notice the commemorative carved rock made by the men of Company 1823 in a protected space of the parking lot. A CCC company of African American veterans came later to build the restrooms, roads, and tall water tower behind the swimming pool.

The park offers activities including camping, picnicking, hiking, and bird-watching. An excellent bird blind providing protection from weather comes equipped with bird identification books so that visitors can learn the names of birds attracted to seeds that have been scattered around the blind by local volunteers and staff.

Leave Abilene State Park on FM 89 and enjoy a journey to Lake Brownwood State Park through the towns

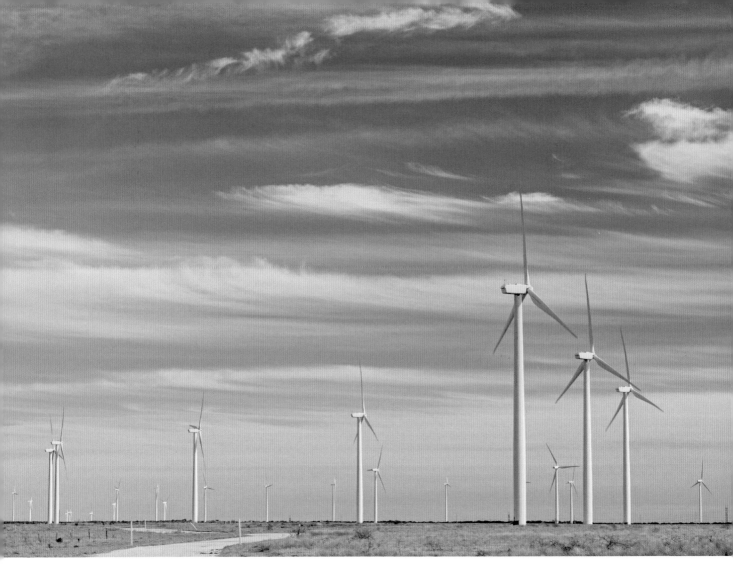

One of the largest wind energy projects in the world sits atop the Callahan Divide, south of Abilene and Sweetwater, Texas.

of Tuscola, Coleman, and Grosvenor. The journey might take an hour or two, but it's worth it to see farm fields, horse pastures, grasslands with red-tailed hawks perched on fence posts, and roads that seem to go on forever. A few miles after Grosvenor, head south at the intersection with Texas Highway 279 and then turn east on Park Road 15. Stop at the Parkway Drive-In, a small grocery store at the intersection, for picnic supplies before driving to the park.

Lake Brownwood State Park is located on the shores of Lake Brownwood. A thick woodland consisting of black-jack oak, red oak, and other woody brush provides shade as well as a home for fox squirrel, deer, and raccoons. Northern cardinals sing from the branches and ducks paddle on the lake.

The Group Recreation Hall is an extraordinary example of the work done by CCC workers in the 1930s. The one-story sandstone building has a beautiful arched window in the front, another in the back, and a tower on one side. The CCC used the building as a blacksmith shop. Iron lanterns that adorn the structure were made in the shop, as was the sundial on the building's tower. Climb the stair-way inside the two-story tower for a stunning view of Lake Brownwood and the surrounding countryside.

CAPROCK CANYON/PALO DURO to CANADIAN

From Quitaque, follow Texas Highway 86/County Highway 1053 west for 15 miles until it turns into US Highway 87 north. Drive 31 miles north on US Highway 87 to Canyon. Drive 13 miles east on Texas Highway 217 to Park Road 5. Return to Texas Highway 217 and connect with Interstate 27 north. Drive Interstate 27 north and then Loop 335 west for 16 miles to Interstate 40 west. Cadillac Ranch is 3 miles west. Return to Interstate 40 and drive east for 81 miles to McLean. Drive 33 miles north on Texas Highway 273 to Pampa. Drive 47 miles northeast on US Highway 60 to Canadian. Approximately 290 total miles.

Caprock Canyons State Park and Palo Duro Canyon State Park near Amarillo are two canyons with eye-popping landscapes and enough birds, mammals, wildflowers, hiking trails, and breathtaking vistas to captivate your interest for days on end.

The more than 1,500 acres of Caprock Canyons State Park is one hundred miles southeast of Amarillo and two miles north of the little town of Quitaque (pronounced "kitty-quay"). It's also fourteen miles west of Turkey, the birthplace of country music legend Bob Wills. The park marks a deeply etched escarpment in the caprock between the High Plains to the west and the Rolling Plains to the east. Caprock refers to the hardened, impenetrable substrate of earth that makes up the High Plains. Rolling grasslands and red rock canyons furnish the landscape of the nearly fourteen-thousand-acre park. As an ecotone (a transitional biologic zone) between the Rolling Plains and High Plains, the park hosts a diversity of both eastern and western plant and animal life. You can see mixed-grass prairies typical of the Rolling Plains to the east and scrub oak and juniper typical of the High Plains to the west. A trail at the interpretive center leads to a ridge offering a panoramic view of the canyon with its wind- and water-sculpted rock spires of pink, gold, and red. The park has an abundance of scenic vistas plus twenty-seven miles of hiking trails, including trails along an old railway line that includes a trestle bridge and tunnel.

Although not common, golden eagles nest on the steep red cliffs of the park. The best place to look for mammals is at the bottom of the canyon around the cottonwood trees and wild plum bushes along the Little Red River. You'll see both white-tailed and mule deer grazing in the park; if you're lucky, you'll see a coyote, gray fox, or bobcat. Pronghorn are easy to see as they graze in the early morning and late afternoon in the upper canyon grasslands. Be sure

Cadillac Ranch is a public art installation on Interstate 40 west of Amarillo. An art group called Ant Farm, consisting of Chip Lord, Hudson Marquez, and Doug Michels, created the installation in 1974.

to ask at the park headquarters where to look for the remnant of genetically pure bison from the historic Southern Plains bison herd that once numbered sixty million bovines on the Texas High Plains.

The twenty-eight thousand acres of Palo Duro Canyon State Park are located twenty-five miles southeast of

The Texas Panhandle is expansive grassland under a seemingly endless sky. US 60 runs between the towns of Pampa and Canadian.

Amarillo. The heart of the park rests in a portion of an eight-hundred-foot gorge that's 120 miles long and 20 miles wide. Nature has designed few canyons on earth with such exquisite colors and contours as Palo Duro. The Prairie Dog Town Fork of the Red River gouged out the huge canyon with scenery so heart-stirring that it inspired the famed American artist Georgia O'Keeffe.

The cliffs of the canyon walls reach down 250 million years into geologic time with color-coded keys of reds, whites, purples, grays, pinks, and yellows. For example, red sandstones are a key to the oxidation of iron in the sediments of ancient shallow seas, and white gypsum laced in the cliffs show periods when the seas evaporated. Accenting the colorful canyon walls in spring and early summer are brightly colored wildflowers such as star thistle, Indian blanket, and plains zinnia. Not surprisingly, butterflies sail over the wildflowers and along the streams. The canyon is also lined with trees, resulting in the name Palo Duro that means "hard wood" in Spanish. Beautiful trees such as juniper, cottonwood, soapberry, and hackberry abound, and the trees are home to an array of woodpeckers, including golden-fronted, ladder-backed, and red-headed woodpeckers. Big mammals such as white-tailed and mule deer live in the canyon as do smaller mammals such as raccoons, squirrels, and the tiny Palo Duro mouse. Mexican pocket gophers tunnel beneath the ground and

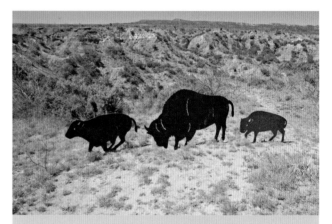

Bison exhibit, Caprock Canyons State Park Visitor Center, Texas panhandle. *Photograph by Larry Ditto*

HUMAN HISTORY IN THE CANYON

Human history in Caprock Canyons dates back to the ice age and the wooly mammoths. But one man's history bears a brief mention. Charles Goodnight, a nineteenth-century rancher and Texas Ranger, created the famous JA Ranch, of which the canyon was a part. His original dugout home is on display in the park. Goodnight's enduring legacy was saving the Southern Plains bison from extinction, the same bison you can see at Caprock Canyons State Park.

aerate the soil, leaving behind little mounds of red dirt in the campgrounds.

Travel through Amarillo and take exit 60 off Interstate 40 just west of the city to the Cadillac Ranch art installation. Travelers along this stretch of highway have been stopping at Cadillac Ranch for years to gape at ten Cadillacs with their noses buried in Panhandle dirt. A group of local artists calling themselves Ant Farm created the art installation in 1974. Development necessitated moving the original installation six miles west to its current spot.

The cars are buried in order from oldest to newest and span models from 1949 to 1964. Each car is covered in a thick layer of graffiti paint, and all visitors are welcome to add their own spray paint graffiti. Just take your spray paint with you when you leave.

Heading the opposite direction on I-40 leads you to the small town of McLean on historic Route 66, authorized by the US Congress in 1927 as a coast-to-coast highway. The tiny gasoline station that opened in 1928 here was the first Phillips 66 station outside of Oklahoma and still stands as a memorial in the town. Spend time observing the historic buildings in town before heading north on Texas Highway 273 to Pampa.

Born in Oklahoma in 1912, legendary folk singer Woody Guthrie went to live with family in Pampa in 1929, where he married a local woman and developed his skills as a poet, lyricist, and folk singer. The devastating, human-caused Dust Bowl of the 1930s drove Guthrie to leave Pampa in 1937 for Los Angeles, where he wrote the time-honored song, "This Land Is Your Land." Guthrie died in 1967 after a long bout with Huntington's disease.

Pampa has never forgotten Guthrie and is home to the Woody Guthrie Folk Music Center at 320 South Cuyler. In 1992, residents held a tribute to Woody Guthrie and

GEORGIA O'KEEFFE'S TEXAS CONNECTION

On your way out of Palo Duro Canyon, take a side trip into the town of Canyon. It's where famed artist Georgia O'Keeffe lived from 1916 to 1918 while creating a series of watercolor paintings she called "Light Coming on the Plains," now in the permanent collection at the Amon Carter Museum of American Art in Fort Worth. O'Keeffe also taught art at West Texas State Normal College, now West Texas A&M University.

On the campus of the university, you'll find the Panhandle-Plains Museum in an art-deco building of the era of the Great Depression. Notice that more than seventy brands from local ranches are carved in stone above the doorway. On the sides of the main entrance are reliefs depicting historic scenes carved in the building blocks. Look up and see stone heads of jackrabbits and other local animals that resemble gargoyles. The interior of the museum is impressive and well worth the time to visit.

More than seventy-five brands from ranches in the Texas Panhandle decorate the entrance to the Panhandle-Plains Historical Museum in Canyon.

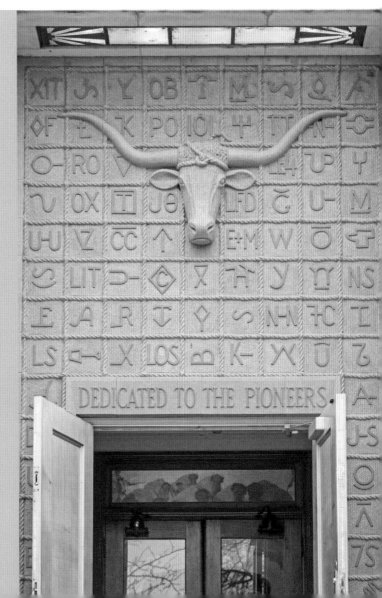

Above: **At the Citadelle Art Foundation in Canadian, a statue called Coming of Winter: The Forerunner by William Pochial is the focal point in one of the formal gardens.**

Top: **The Cattle Exchange Restaurant, on South Second and Main Streets, in Canadian, Texas, is known for its quality food and classy decor.**

LAKE MEREDITH

Lake Meredith National Recreation Area includes a ten-thousand-acre lake created by a dam on the Canadian River and located about forty miles north of Amarillo on Texas Highway 136 just west of the town of Fritch. The national recreation area covers fifty thousand acres with recreational opportunities that include fishing, boating, swimming, camping, and bird-watching.

As you approach Canadian, watch the hillsides next to the highway for a statue of a huge green dinosaur sitting atop a hill. Local folk artist Gene Cockrell built the concrete statue with his own money. He wanted local children to know that they were close to home when they saw the dinosaur from the highway.

dedicated a sculpture in his honor. The 150-foot-long iron sculpture along North Hobart Street in East Coronado Park depicts a musical line and staff with notes to the song, "This Land Is Your Land." Also, the stretch of US Highway 60 through the Texas Panhandle is called the Woody Guthrie Memorial Highway.

Head east out of Pampa on US 60 toward Canadian, Texas. The highway along this stretch is an easy drive through grasslands and high plains but then changes to include small canyons with tree-lined streams. US 60 intersects with US Highway 83 for the last stretch into Canadian.

Canadian is a charming town of unexpected beauty in the far northeastern corner of the Texas Panhandle. From as far back as the 1100s, Apache, Kiowa, and Comanche lived along the river that cuts through town. The area proved to be a perfect place for military encampments during an Anglo settlement in the 1800s. Wagon trains stopped here on the way to the California gold rush in the 1850s, the first cattle ranches were established in the 1860s, and the town of Canadian was thriving by the late 1880s with a railroad and well-established main street.

When you enter Canadian on US 83, take a right on Nelson Avenue, which leads to a historic part of town

where large homes date back to the turn of the last century. The Citadelle Art Foundation sits at 520 Nelson Avenue. The building housing a world-class art collection has an interesting heritage itself. It was originally the home of The First Baptist Church but was later purchased by Malouf and Therese Abraham and remodeled into a family dwelling.

The Hemphill County Courthouse sits a few blocks away on Main Street. The plain red brick building was constructed in 1909 in the Classical architectural style, and the central tower of the courthouse has a silver dome that's visible for blocks. Restored buildings line Main Street and give the center of town a welcoming, prosperous ambience. Walk down to the Cattle Exchange Restaurant, at South Second and Main Street, for amazing food in a classic setting. The old Moody Building was built in 1910 and today houses one of the best steak restaurants in the area.

A little exercise might be in order after a steak dinner so head north on Second Street toward Canadian River Wagon Bridge near the edge of town. The people of Canadian converted an iron wagon bridge, originally built in 1915, into a walking bridge. When the original bridge was constructed, it was the largest steel structure west of the Mississippi. The bridge had to be rebuilt after a flood in 1923 and then it became the longest pin-connected bridge in the state. Today visitors can walk the entire 3,255-foot length of the bridge, making it a round-trip 1.23-mile walk. The surface is covered with wooden planking and decking for smooth, easy walking. Guardrails make it a safe place for children. The bridge is also part of the scenic hiking and biking trail that crisscrosses the Canadian River Valley.

In a large park at the south end of Wagon Bridge is a giant arrow stuck in the ground, marking part of the Quanah Parker Trail. Quanah Parker was the last chief of the Comanches, and the son of a Comanche warrior and an Anglo woman. Points of interest are noted with a large roadside arrow. A map of the Quanah Parker Trail can be downloaded from the Internet.

The Canadian River Wagon Bridge opened in 2000. The bridge structure dates back to 1916 and was once the longest pin-connected bridge in Texas. Today, the bridge is part of a scenic hiking and biking trail in Canadian, Texas.

SAN ANGELO to FORT CHADBOURNE

From San Angelo, drive west on US Highway 67 to Farm to Market Road 2288 for the South Shore and North Shore entrance of the state park. Drive 8 miles to US Highway 277 north. Drive 28 miles north on US Highway 277 to Bronte. Drive 12 miles north to Fort Chadbourne. Approximately 41 total miles.

San Angelo sits under a wide-open sky in West Texas. The Concho River flowing through town provided early residents of the late 1800s with an ample water supply, which in turn led people to cultivate fertile farmlands and a thriving community. Today the city is a showcase for successful small-town living that lures tourists, companies, and new residents.

Opposite and below: **The Railway Museum of San Angelo is housed in the historic Orient-Santa Fe Depot.**

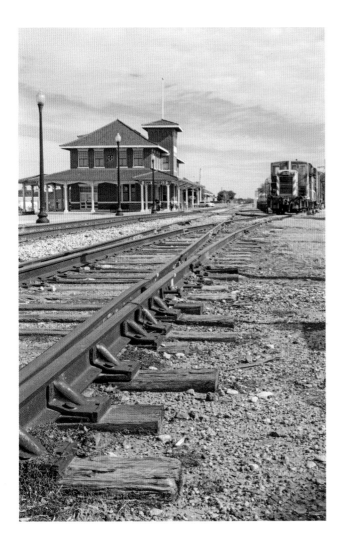

Begin your exploration at the Chamber of Commerce and Visitor Center building (on Avenue B and US Highway 87), where friendly volunteers can direct you to places for dining, lodging, and sightseeing. But take a few minutes to enjoy the grounds of the visitor's center with terraced water gardens leading down to the banks of the Concho River. A series of walking trails lead you through parks lining the river and enhance San Angelo as one of the top river walk destinations in Texas.

Nearby, on Park and Harris Streets, is the International Water Lily Collection, which is a terraced garden, built around seven large rectangular and square tanks containing water lilies. Each water lily species is named and many may be viewed at eye level. The plants bloom during every season of the year, but January and February might have the fewest blooms. The lily collection is part of Civic League Park that covers an entire city block with an impressive rose garden and open grassy spaces.

Next, drive to the Santa Fe Depot Railway Museum along the railroad tracks at the intersection of Avenue C West and Chadbourne Street South. The museum is housed in the historic Orient-Santa Fe Depot built in 1909 and contains railroad artifacts along with a model train layout and historic photographs.

Fort Concho National Historic Landmark is two blocks east at Oakes Street South. The fort was established in 1867 as settlers came to the area and ran into territorial disputes with the Comanches. The famed (some say infamous) military officer of the nineteenth century William "Pecos Bill" Shafter was a fort commander. Regiments of "Buffalo Soldiers," the term then used for African American soldiers, were stationed at the fort. Nowadays, you will notice the twelve buildings made of native limestone surrounding a vast parade ground. Friendly staff and volunteers at the visitor's center and gift shop will provide information about the fort and

Conrad Hilton built his fourth hotel in San Angelo, Texas, in 1929. The hotel still stands and is home to several civic groups.

explain the guided tours being offered. But you are free to walk and explore on your own.

In the historic downtown, you'll find the fourteen-story Cactus Hotel at the corner of Oakes Street and Twohig Avenue that Conrad Hilton built as his fourth hotel in 1929. No sleeping rooms are open today, but the lower levels are used by civic organizations. Around the hotel is a pedestrian-friendly district, home to shops and restaurants. Be sure to stop at one of the many historic murals along these streets that are a civic project sponsored by Historic Murals of San Angelo. All the murals are funded through private donations and depict the history of San Angelo from prehistory to the twenty-first century.

San Angelo State Park offers you a chance to escape the city and enjoy outdoor activities. The park has two entrances, both reached from Farm to Market Road 2288. The South Entrance leads to camping, picnicking, RV pullouts, hiking trails, fishing areas, and boat ramps. The park surrounds the

O. C. Fisher Lake, formed when the North Concho River was dammed in 1947. Lake levels fluctuate due to drought, but that doesn't keep people from enjoying the equestrian, biking, and hiking trails. Access to the popular walking trail along the top of the dam is off Mercedes Street. The North Entrance leads to a quieter and smaller portion of the park and is situated among cottonwoods and mesquite along grasslands that border the North Concho River.

Leave San Angelo State Park and head north on US Highway 277 to the town of Bronte. Through Bronte, continue for another twelve miles to Fort Chadbourne. You'll know you're there when you see a thirty-foot cavalry spur by the front gate. Established in 1852, the fort offered a safe way station for stagecoaches along the Butterfield Overland Mail route. The fort was left in ruins in the late 1800s when it was no longer needed to keep the area secure. Buildings were allowed to weather, deteriorate, and collapse.

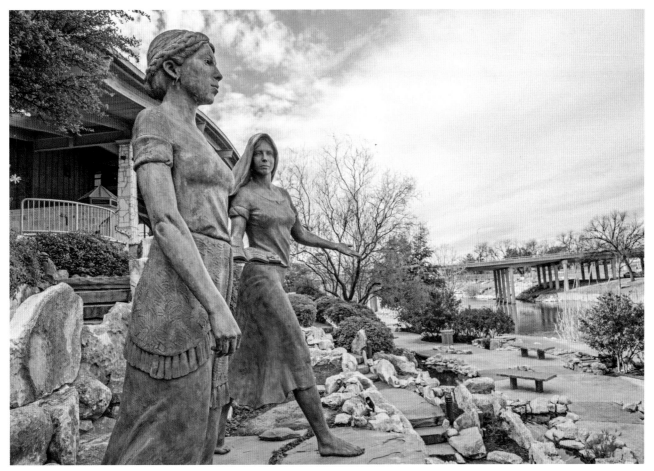

The Princess Falls Dream Gardens are behind the San Angelo Visitor Center. The gardens overlook the Concho River. Statues in the garden are by John Noelke.

The buildings at historic Fort Chadbourne near Bronte, Texas, have been restored through the efforts of the Fort Chadbourne Foundation.

Fortunately, the Fort Chadbourne Foundation is working to stabilize and restore the buildings. Stop at the visitor's center to learn about the project and examine the exhibits of historic firearms, tools, and American Indian artifacts. Walk outside to see the restored officer's quarters, barracks, and Butterfield Stagecoach Station.

Abilene is down the road along US 277. Enjoy the view of the giant wind turbines as the road crosses the ridges we call the Callahan Divide. You will not find any official pullouts as the highway passes through the turbines, but you will find service areas where it's safe to park.

PART III

PRAIRIES AND LAKES

The state flower of Texas is the bluebonnet, which blooms in eastern Texas from mid-March to early April.

U P UNTIL THE early 1800s, Texas was primarily a prairie state with a sea of grassland stretching across the northern, central, coastal, and southern regions, being principally interrupted by an expansive pine forest in the northeastern half of the state. Even the western half of the state, dominated by the Chihuahuan Desert but upwelled with high mountains, still held vast stretches of grasslands, some reaching from horizon to horizon.

Central and north central Texas exemplified the once-great prairies, with grasses growing to the height of a horse's belly. To the region's north lies the Oklahoma border, to its west the Panhandle plains and Hill Country, to its east the dense pine forests, and to the south the Gulf Coast and South Texas plains. Anglo settlers called the region "Cross Timbers" due to woodland patches abruptly crossing through open prairies in a north to south direction. In 1856, a surveyor named W. B. Parker with the US Government described the woods as "not growing in a continuous forest, but interspersed with open glades, plateaus, and vistas of prairie scenery. . . ." (Notes taken during the expedition commanded by Capt. R. B. Marcy, through unexplored Texas, in the summer and fall of 1854.)

Long before European settlers, the land was home to the Wichita and the Waco, who farmed the fertile black soil, growing corn and melons. They built villages with thatched-grass homes; hunted quail, deer, and bison; and formed trading alliances with other tribes as well as with the early French and Spanish setters to the east and south. The Wichita and the Waco were ultimately re-settled on reservations, and Parker surveyed the land for potential reservations.

European hunter-traders eventually wiped out the bison, settlers later farmed the rich black soil, and ranchers grazed cattle in the lush grasslands. Farming and ranching boomed, and with the boom came towns, roads, railroads, and more recently exurbia communities as havens for people from the big cities of Dallas and Fort Worth. Accordingly, the vast prairies have vanished but remnants still exist between the small towns and along the backroads between them. The towns harken back to a pastoral period of Texas history with its people still possessing the pioneering self-reliant spirit of their forefathers.

Lakes abound in the region, all formed by dams on rivers, and all supporting sport fishing and boating. Anglers from across the United States head to the lakes for year-round fishing. State parks rest near or by the lakes. What's interesting to remember, though, is that the lakes were unimaginable to the Wichita, the Waco, and Anglo American settlers who, instead of casting an eye over a big lake, cast an eye over a wide sea of tall grasses waving in the breeze like water waving across a lake.

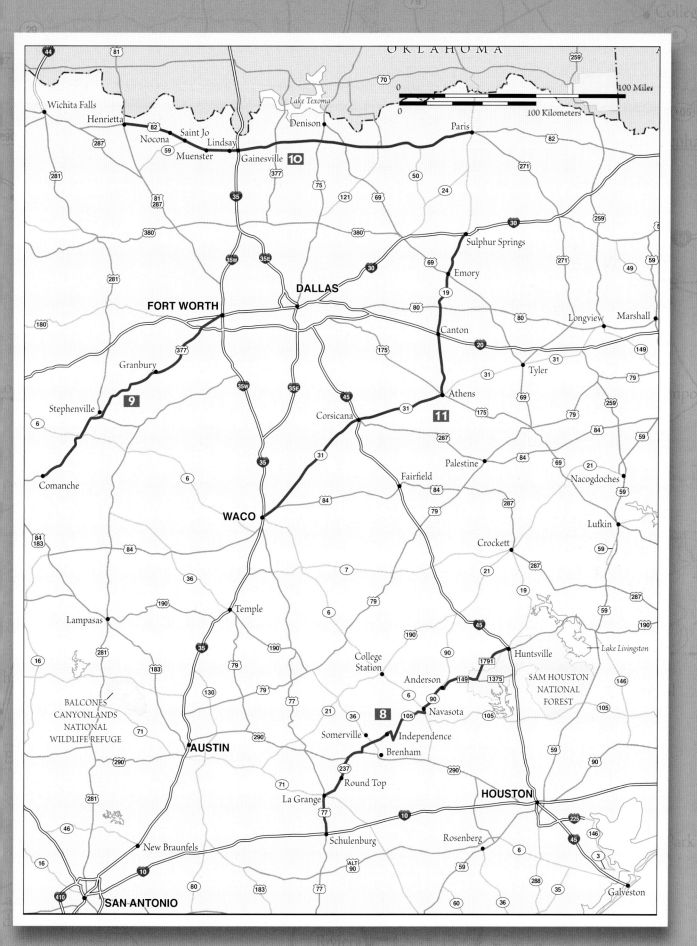

Sculptor David Adickes's sixty-seven-foot-tall statue of Sam Houston stands outside Huntsville, Texas.

8

HUNTSVILLE to ROUND TOP

From Huntsville, follow Texas Highway 75 north until it turns into Texas Highway 30 west then Texas Highway 90 south to Anderson. Drive on Texas Highway 90 south to Texas Highway 105 east for 8 miles to Washington-on-the-Brazos. Continue east on Texas Highway 105 for 9 miles to Farm to Market Road 390. Drive north on Farm to Market Road 390 to Independence. Drive south on Farm to Market Road 50 and turn on Airport Road to reach the diner. Return to Farm to Market Road 50 and drive south of Texas Highway 105. Drive west through Brenham to Texas Highway 237. Drive 8 miles east to Round Top. Drive south on US Highway 237 to US Highway 77. Drive 17 miles south on US Highway 77 to US Highway 90. Approximately 140 total miles.

A sixty-seven-foot white statue of Sam Houston stands along Interstate 45 just south of Huntsville. The statue by artist David Adickes is made of thirty tons of concrete and steel. Follow the signs to the visitor's center, where you'll find plenty of parking, restrooms, friendly staff, a gift shop, and access to the statue.

The city of Huntsville is north along Texas Highway 75. The Gibbs-Powell Historic Museum on Eleventh Street lets visitors see a historic home built in 1862, plus furnishings and artifacts. The Texas Prison Museum at 491 State Highway 75 North gives a safe glimpse of the Texas prison system, including death row. Exhibits show both sides of the death penalty argument with examples of hanging, the electric chair, and modern lethal injection. Weapons confiscated from prisoners are on display as are pieces of incredible artwork produced by people behind bars.

After visiting the prison museum, you may want to return south to Huntsville State Park for a chance to clear your mind and enjoy the great outdoors. The beautiful two-thousand-acre park situated around Lake Raven offers hiking, fishing, camping, and swimming. Follow the signs to the park from I-45.

Anderson is a pleasant drive from Huntsville on Texas Highway 30 west and then connecting with Texas Highway 90. You'll see the Grimes County Courthouse towering above the trees before you get to Anderson. The 1893 building stands on a hill and looks a bit like a caricature of a haunted house from a children's book. Joe Palmer, one of the gangsters led by Clyde Barrow of "Bonnie and Clyde" fame, was found guilty in this courthouse of killing a prison guard. Fanthorp Inn State Historic Site is nearby at 579 South Main. The lovely two-story white inn was a stop on the stagecoach line. The park has a replica of an 1850 Concord stagecoach.

More history awaits you at the Washington-on-the-Brazos State Park off Farm to Market Road 105 near the town of Washington. Texas was born at this location when brave men declared their independence from Mexico in 1836. The park has a replica of Independence Hall. The Star of the Republic Museum is a just a few feet away and filled with displays and artifacts.

The Barrington Living History Farm is behind the museum. Watch volunteers in period dress make butter or

Old Blush is a favorite antique rose in many parts of Texas.

Above: **Holiday candlelight celebration, Fanthorp Inn State Historic Site, Anderson, Texas.**

Right: **Texas bluebonnets in the spring in Washington County, Texas.**

plum preserves. Talk to the volunteers as they tend to gardens as settlers would have done in the early days of Texas.

The roads along this route are famous for springtime wildflowers. Bluebonnets carpet entire fields in blue from mid-March to mid-April. Indian paintbrush and coreopsis add splashes of red and yellow into the summer.

Independence at the intersection of Farm to Market Road 50 and Farm to Market Road 390 offers interesting sights such as the brick columns of the first Baylor University that still stand at Old Baylor Park.

Antique Rose Emporium on FM 50 south of Independence is filled with antique roses and display gardens with plantings that change through the seasons. Historic houses are ringed with beds brimming with a variety of blooming plants. Roses climb over arbors and trellis as they might have done back in the 1850s, or as we hope they will do today in our gardens.

Four columns on the grounds of old Baylor University near Independence, Texas.

Lunch at the Southern Flyer Diner at Brenham Airport is something that should not be missed. The diner is a step back in time to when waitresses wore poodle skirts as rock-'n'-roll played on the jukebox. Order a hamburger and shake, forget about the calories, and enjoy the atmosphere.

Round Top is home to antique shops, music venues, and lodging. Antique Week in late March each year is a popular event that dates back to 1968. In June and July, the International Festival Institute showcases some of the best classical music concerts anywhere. Something is going on throughout the year at Round Top.

Painted churches are scattered through communities near Schulenburg. German and Czech immigrants built the churches in the mid-1800s with lovely painted interiors. Stop at the Chamber of Commerce at 618 North Main Street in Schulenburg to start your tour. The Chamber has a map to each church and will tell you which churches are open for viewing.

9

FORT WORTH to COMANCHE

From Fort Worth, follow US Highway 377 southwest to Granbury. Drive 39 miles west on US Highway 377 to Stephenville. Drive west on US Highway 377 Business through Stephenville. Drive on US Highway 377 west for 32 miles to Comanche. Approximately 105 total miles.

Real cowboys are a common sight at the Fort Worth Stockyards.

Fort Worth is the fifth-largest city in Texas and often overshadowed by the larger Dallas or lost in a mumble when locals say "DallasFtWrth." Yet, Fort Worth has done an excellent job maintaining its identity as "Cow Town."

The city's history goes back to a treaty that the Republic of Texas negotiated with the Delaware, Chikasaw, Waco, Tawakani, Keechi, Caddo, Anadahkah, Ionie, Biloxi, and Cherokee peoples in 1843 in which the tribes agreed to remain west of Birdville, a community northeast of Fort Worth and along the north Trinity River. Protection stations were set up along the negotiated line or "where the West begins." The US military took up the task of protecting the border when Texas joined the Union in 1846. When Fort Worth was in operation as a military fort in 1849, civilian settlement soon followed. Birdville later became today's Haltom City.

The famous Chisholm Trail passed through Fort Worth in the 1800s as herds of longhorn cattle were driven from Texas to the railheads in Kansas after the Civil War. The Texas & Pacific Railway reached Fort Worth in 1876, and the city became a terminus versus a way station for the cattle market. Other railroad lines were built into the city in the following years, and the cattle business branched into meat-packing plants and leather-working shops. The ranching and mercantile trade attracted bankers, lawyers,

Above: **Sassy Pantz in Stockyard Station at the Fort Worth Stockyards carries a wide variety of cowboy boots.**

Left: **Jewelry and accessories with a Texan flair can be found at the Stockyard Station in the Fort Worth Stockyards historic district.**

and store clerks. In the early twentieth century, the oil boom in Texas further enhanced Fort Worth's wealth and status. Today, the dynamic city of culture and trendy establishments still holds on to its "Cow Town" roots.

Head to the Stockyards National Historic District where activities center around Stockyards Station at 130 East Exchange Avenue. The former rail station has been converted into a shopping and entertainment area where you can walk along the old train tracks and brick streets, tasting, shopping, and exploring.

A team of cowboys drives a small herd of Texas longhorns twice a day down Exchange Avenue outside Stockyards Station. Cowboys occasionally ride their horses along the street and bring docile longhorns out so tourists can take a picture or two.

The Fort Worth Stockyards National Historic District also has entertainment, shopping, museums, lodging, and year-round events.

Above: **Texas longhorn cattle were brought to the state by early Spanish settlers. The breed originated in Spain and can have horns that span seven feet.**

Right: **Stockyards Station houses a variety of shops and entertainment venues at the Fort Worth Stockyards, Fort Worth, Texas.**

Opposite: **The Hood County Courthouse in Granbury, Texas, was built in 1890 in the Second Empire Style.**

Granbury is southwest of Fort Worth on US Highway 377. The highway is wide and modern in Fort Worth but settles into a two-lane divided highway with a wide shoulder. Granbury's early settlers included Davy Crockett's widow Elizabeth Patton Crockett.

You will see the Hood County Courthouse in the historic center of town. The white limestone building has elongated windows that light the two-story courtroom on the second floor, and a gray, two-story bell tower adds to the grandeur of the building.

The Granbury Theatre Company sits across from the courthouse in the old opera house and offers productions of Broadway musicals throughout the year. Stop at

Ketzler's Schnitzel Haus and Biergarten on the same block for tasty food.

Stephenville is the next stop along US 377. Exit the main highway and take Business 377 or Washington Street into town.

The Stephenville Historical House Museum is at 525 East Washington Street. The museum site has twelve nineteenth-century structures spread around three acres.

The old Comanche train depot houses the Comanche Chamber of Commerce and Agriculture.

A wooden white Presbyterian church stands in the center of the complex. Several primitive, split-rail buildings held together with mud chinking stand nearby.

Antique shops and cafés stand along Washington Street up to the center of town where the Erath County Courthouse dominates the landscape. The white and russet-colored sandstone structure stands three stories high and is adorned with a pointed clock tower. The buildings around the courthouse square are nicely preserved and contain antique shops, law offices, hair salons, and places to eat. The Bosque River Trail is a nice exercise path with an entrance off North Vine and North Floral.

The campus of Tarleton State University, part of the Texas A&M University System, is at 1333 West Washington. You'll know you're close when you see the purple and white banners waving in the breeze. The university is one of the reasons Stephenville was voted one of the best small towns in America in Norman Crompton's 1996 book, *The 100 Best Small Towns in America*.

The West End Cemetery sits adjacent to the university at West Washington and South Lillian. Graves date back to the late 1800s, and many have ornate markers.

Reconnect with US 377 and drive to Comanche. The highway is a two-lane road with periodic passing lanes and cuts through pastureland, grasslands, and pecan orchards. Buy some of those pecans at the Durham Pecan store on the outskirts of Comanche. The pecans are also available at Things Remembered, one of many businesses in the restored historic buildings around the Comanche County Courthouse.

HENRIETTA to PARIS

From Henrietta, follow US Highway 82 east for 28 miles to Nocona. Drive 13 miles east to Saint Jo on US Highway 82 and then another 10 miles to Muenster. Continue on US Highway 82 east for 10 miles to Lindsay. Drive on US Highway 82 east for 32 miles to Texas Highway 289. Drive 7 miles north on Texas Highway 289 to Farm to Market Road 996 and 5 miles west to Lake Texoma. Turn west off Texas Highway 209 onto Refuge Road and travel 4 miles to Hagerman Wildlife Refuge. Return to US Highway 82 and drive east for 65 miles to Paris. Approximately 200 total miles.

Start in the small town of Henrietta at the intersection of US Highway 287 and US Highway 82. Traffic from Amarillo, Wichita Falls, and Fort Worth speeds by on the outskirts of Henrietta, yet the town seems locked peacefully away from the hubbub of the highways.

In 1860, when the US settlements were new to the area, Henrietta was the only town in Clay County. Local residents confronting hostilities from the Kiowa had to abandon the area during the Civil War for lack of military protection. A major battle took place in 1870 between the US Army and the Kiowa, with Chief White Horse as the leader, the latter being defeated and settlers being able to return. (The entire area was home to American Indians and their ancestors thousands of years before the arrival of Anglo settlers.)

You can learn about the history of Henrietta by visiting the Jail Museum and Heritage Center at 116 Graham Street. The museum is housed in the jail built in 1890. It's a tan two-story building that still has bars on some of the windows. Inside are examples of 1890s décor, western artifacts, displays about ranching in the area, and photos of the original settlers.

Two blocks away is the Clay County Courthouse, a three-story red brick building with tan stone trim anchoring the town around Main Street. Stewart's Sweet Shop across from the courthouse is a place to grab a pastry or to have lunch. Jefe's Mexican Restaurant is nearby and offers tasty Tex-Mex cuisine.

Heading east out of Henrietta on US 82 offers a chance to drive through the undulating low hills of the Texas prairies to reach Nocona. This is the town where the Nocona brand of cowboy boots originated, and the old factory is visible on US 82 at the eastern edge of town.

H. J. "Daddy Joe" Justin moved his boot repair business to Nocona in 1887 when the railroad was built. Justin's

St. Peter's Catholic Church was built in 1918 in Lindsay, Texas. The interior of the church is stately and ornate.

knack for repairing boots had led him to making his own special cowboy boots to meet the demand of cattlemen both on ranches and on the Chisholm Trail. Young cowboys riding mustang horses herded cattle along the trail to market in Abilene, Kansas, from as far away as Laredo. Daddy Joe died in 1918 and his sons moved the company to Fort Worth.

The daughter of Daddy Joe, Enid Justin, had learned the boot-making business from her father and decided to

Above: **A dickcissel sings while perched on a branch at Hagerman National Wildlife Refuge in spring.**

Opposite: **A plaque in front of the Clay County Courthouse in Henrietta, Texas, honors the location where the first registered Hereford cattle set "the hooves" in Texas back in 1876.**

stay in Nocona. She convinced locals that her work was as good as her father's, and her business thrived as it met the demands of a new breed of plainsmen called "wildcatters," who began setting up drilling rigs to pump oil out of the ground. The Nocona Boot Company ultimately merged with the Justin Boot Company in 1981, bringing the two family companies back together.

Learn more about leather making and Nocona boots at the Tales 'N' Trails Museum at 1522 East US 82. Nocona boots are tastefully arranged on display cases. Touch them and feel the quality of the workmanship. Other displays illustrate the importance of leather to the town as well as how American Indians such as the Kiowa and Wichita tribes, in addition to oil and agriculture, shaped the entire region. Outside the Tales 'N' Trails Museum are old farm implements such as a Case Peanut Special machine.

Visitors can tour an old prairie house and touch hand tools from a bygone era.

St. Jo is the next community on this route heading east on US 82. Cattle drives along the Chisholm Trail brought life to this area in the 1870s, and a railroad came through in 1886. Since that time, the town has had a relatively stable population of about one thousand people. The town's main square has a historic hotel, a custom boot maker, and coffee shops. Stop and enjoy the yellow and black mural off the main square that celebrates the Chisholm Trail.

Muenster is the next community along US 82 east. The German heritage of this community is noticeable at the first stoplight where Fischer's Meat Market bids visitors "Willkommen" and invites everyone in for sausage and German-style meats. The Fischer's Thriftway on North Main offers groceries as well as meats.

THE CHISHOLM TRAIL

The legendary Chisholm Trail actually had its beginning not as a cattle trail but as a wagon trail north of the Canadian River made by Jesse Chisholm, of Scottish-Cherokee descent, who in 1864 traded goods with Kiowa, Apache, Ute, and Comanche as far as 220 miles south. Texas cattle drivers finding the trail by the river named it after Chisholm and extended the trail's name all the way to the Rio Grande. Cattle drives along the trail lasted from about 1867 to 1884 and are a story of how Texas recovered from an economic collapse following the Civil War. Cowboys who drove the cattle herds along the long, hard miles of the trail became the stuff of legend and myth, as told countless times in Hollywood movies that glorified and romanticized the American cowboy. But the lives of cowboys on the trail were hardly romantic. Their work was a matter of long, grueling, dirty days buffeted by endless hardships.

Jesse Chisholm, circa 1865. *Photograph courtesy of KansasMemory.org, Kansas State Historical Society*

Continuing along the wide-open roadway, US 82 makes it fun to pass through little towns, with nearly each one holding historic treasures. For example, as you slow down to enter Lindsay, you'll notice a tall steeple towering among the trees in the community. That's St. Peter's Catholic Church on Ash Street. The church we see today was rebuilt in 1918, one year after a tornado destroyed the original structure. A restoration in 2009 brought the church into the twenty-first century. The ornate interior is as astonishingly beautiful as many historic churches in Europe. In 1913, the town's founding families built four small chapels around the church grounds that not only add to the beauty of the church grounds but also enhance the beauty of the community. US 82 gets much wider as it crosses Interstate 35 in Gainesville.

Continue to exits for Lake Texoma or Hagerman National Wildlife Refuge, both well worth the diversion.

Opposite: Area cattle brands are on display at the Tales 'N' Trails Museum in Nocona, Texas. The museum celebrates leather, agriculture, ranching, and Native American history.

Lake Texoma's surface water covers eighty-nine thousand acres, straddling the Red River and the Texas-Oklahoma border. Lodging includes cottages and conference centers that make the lake a destination for as many as six million people a year. Activities such as camping, fishing, and water sports abound.

Hagerman National Wildlife Refuge on the southern edge of the lake draws birds and bird watchers year-round. Spring is a best time to see migratory water birds such as phalaropes and ducks. Summer is enhanced by beautiful grassland birds, such as scissor-tailed flycatchers. Refuge personnel and volunteers offer a variety of programs throughout the year.

Next stop is Paris, which anchors this route on the eastern end. The town is filled with so much history that you could spend a day to a week covering all the attractions. Settlers arrived in the area between 1824 and 1826, and a store merchant named George Wright founded the town in 1844 along the Central National Railroad of the then-Republic of Texas. Thomas Poteet, working for Wright, either named Wright's store Paris or named the town Paris, depending on which historical account you read. No one knows precisely why Poteet chose the name.

In 1916, a major fire devastated the town. Townsfolk adopted the attitude of "smile and we'll get through this." One year later, in 1917, the majority of the community was rebuilt and Paris was back in business. Today "Smile!" is the town's motto. The Eiffel Tower in Paris will make

anyone smile. The Boiler Makers Local No. 902 built the scale model of the Eiffel Tower that stands sixty-five feet tall on Collegiate Drive. In 1998, a red cowboy hat was added to the top of the tower to make it one of the best dressed of the fifteen Eiffel Tower replicas in America.

Next to the Eiffel Tower is the Red River Veterans Memorial. A towering gate, wide walkways, American flags, and black granite memorials combine to make this an outstanding tribute to America's veterans.

The Evergreen Cemetery is a tribute to community leaders and located on Business Highway 19/24 and Evergreen with a convenient entrance between Fourth and Fifth Streets along Evergreen. Two rows down in the cemetery and to the left is the famous grave of Willet Babcock with an ornate marble tombstone supporting a mysterious statue on top that some say is the figure of Jesus carrying a cross, while others say it's Jesus leaning on a cross. Still others say it's an angel in mourning leaning on a cross and even others claim it's a character out of Shakespeare—a bit of a stretch but proffered because of Babcock's love of Shakespearian drama. No matter what the statue represents, one thing is for sure. It's wearing cowboy boots!

When leaving the cemetery on Evergreen Street, turn right on Business Highway 19/24 or Church Street. Ornate homes and churches sit along the street near downtown. Stop at the Sam Bell Maxey House on 812 South Church Street, a home built in 1868 in High Victorian Italianate style. The front is adorned with two porches, one on the first floor and another on the second floor. Large windows draw abundant light into rooms with towering ceilings. The Texas Historical Commission has preserved the house, and guided tours are available twice daily. Historic furniture and accessories decorate the home built by Maxey as he moved through life as a soldier, lawyer, and state and US Senator. His body rests at the Evergreen Cemetery.

Continue along Church Street to Paris's historic center around Business Highway 82. The town has maintained a large number of historic buildings that today house antique shops, restaurants, theaters, and offices. The Paris Bakery is located at 120 North Main Street across from the Lamar County Courthouse. Drop in for breakfast or lunch or just a cup of coffee where the food in this Paris, Texas, town really does recall food in the cafés of Paris, France.

Above: **The Paris Bakery on Main Street is open for breakfast, lunch, and dinner. The bakery is housed in a historic building across from the courthouse in Paris, Texas.**

Opposite: **The Eiffel Tower replica in Paris, Texas, is one of many in the United States. Local citizens put a red cowboy hat on the top of their tower to set it apart from all the rest.**

The sun comes up over Lake Texoma, one of the most popular lakes in north Texas.

—— 11 ——

SULPHUR SPRINGS to WACO

From Sulphur Springs, follow Texas Highway 19 south for 20 miles to Emory. Drive 23 miles south on Texas Highway 19 to Canton. Continue on Texas Highway 19 south for 24 miles to Athens. Drive on Texas Highway 31 west for 24 miles to Corsicana. Continue on Texas Highway 31 east for 38 miles to Waco. Approximately 165 total miles.

This route begins in Sulphur Springs on Interstate 30. The area around Sulphur Springs is dotted with farm fields and pastures. Dairy farming is important to the economy of the area, and the Southwest Dairy Museum preserves its history and educates future generations. The ten-thousand-square-foot facility is built in the style of a dairy farm building. The history of dairy farming is on display, as are the practical operations of separating cream and then making cheese, butter, or ice cream.

Leave Sulphur Springs on Texas Highway 19 south toward Emory. Emory is situated between two large reservoirs: Lake Tawakoni and Lake Fork. Both reservoirs attract some of the migratory bald eagles that spend the winter in Texas. In 1995, then-Texas governor George W. Bush signed a resolution declaring Rains County "The Eagle Capital of Texas." Bald eagles feed primarily on fish and roost in tall trees. Both lakes have jagged coastlines with tall pine and hardwood trees along the shoreline, an

ideal setting for eagles. Lake Fork is known as an outstanding lake for bass.

The Rains County Courthouse is located at 167 East Quitman in the center of town. Across the street is the Big Mouth Burger Company. A sign out front reads, "We do not have cholesterol free. We have FREE cholesterol."

Continue along Highway 19 to Canton. Canton is famous for First Monday Marketplace, which draws visitors from surrounding cities and states. The tradition began in the 1850s when people came to town on the first Monday of every month when the circuit judge arrived. The event was a chance to transact business, sell produce or livestock, swap stories, and see neighbors. First Monday Marketplace is now so popular that selling takes place starting the first Thursday of the month and continues all

Opposite: **Rains County is "The Eagle Capital of Texas."**
Bald eagles can be seen in other parts of the state as well.

Top: **Texas Freshwater Fisheries Center, in Athens, Texas, celebrates fishing and the importance of fish in the environment.**

Bottom: **An alligator gar swims in a display at the Texas Freshwater Fisheries Center, in Athens, Texas.**

Left: **Collin Street Bakery's tasty pecan pie.**

Right: **Roses and a variety of other plants are on display at the East Texas Arboretum and Botanical Gardens in Athens, Texas.**

weekend through Sunday. Mondays are out. The crowds had grown so big by 1965 that the city had to buy six acres of land north of the courthouse for the event. Crowds continue to grow.

All around Canton are indications of a market town. Antique shops are common as are bed-and-breakfasts and gift shops. Take time away from shopping and enjoy a walk through the historic homes near the courthouse. "Artsy" is in full swing when it comes to decorating the homes. Two concrete temple lion statues like you might see in Thailand guard the entrance to one home. In front of another house are concrete greyhound statues guarding the doors.

Drive along Highway 19 to Athens. Many small antique and gift shops line the highway.

Athens is home to the Texas Parks & Wildlife Fisheries Center at 5550 Farm to Market Road 2495. The center is an amazing facility with living displays showing a woodland pond, saltwater environment, a lake, and a reservoir habitat. Displays are housed in water-filled outdoor tanks nestled into the environment. Plants and trees around each tank are appropriate for the environment that's illustrated. Each display has a thick, glass panel so that fish are visible. All of the glass panels are at eye level for the many school children who visit the center. Inside the center is a movie about the fish hatchery on the 107-acre site. Trophy fish and a fishing hall of fame are on display. Visitors can

see beautiful examples of lures and a display showing how artificial worms are made.

The gift shop stocks T-shirts, gift items, and books. Outside are picnic tables set among native plants that attract butterflies and hummingbirds. The East Texas Arboretum and Botanical Gardens are located at 1601 Patterson Road. It's a quality, first-rate facility covering one hundred acres with two miles of walking trails. Magnolias and pines shade the formal gardens. Crepe myrtles and azaleas add color to roses and native plants. Near the parking area is a replica of an old-time schoolhouse with an adjacent playground for children. A large dollhouse also stands nearby for children to play in. Adults will enjoy the old barn filled with tools and many an old-timer will smile at the old-fashioned outhouse nearby.

A short walk away is the historic Wofford House, originally built in 1850. The home gives visitors a chance to tour a home as it would have looked 150 years ago.

Leave Athens on Loop 7 and connect with Texas Highway 31 west heading toward Corsicana.

Corsicana was founded in 1848 as the county seat of Navarro County. A hero of the Texas Revolution, Jose Antonio Navarro named the town after Corsica, an island between France and Italy that was the birthplace of his parents. The town grew because of oil fields, agriculture, and its location on the railroad.

The Cook Education Center, on the grounds of Navarro College in Corsicana, Texas, houses a planetarium and the Pearce Collections, an assortment of western art and Civil War documents.

The Pearce Museum in the Cook Center on the campus of Navarro College, at 3100 West Collin Street, shows Texas history from the Civil War to the twentieth century. Western art, sculpture, artifacts, and historic papers are on display. While you're in the Cook Center, check the schedule for the planetarium programs that are open to the public.

Collin Street Bakery is located at 401 West Seventh Street. Step inside and buy a famous pecan pie, or buy and ship one of their famous fruitcakes to anyone anywhere in the world, or select a delicious pastry to eat right away. The shop offers fresh sandwiches, soups, and salads. A small dining area gives you a chance to slow down and enjoy great food.

Finish this route by continuing along Highway 31 to Waco.

Waco was named for the Waco tribe who were dispersed by the more aggressive Cherokee tribes. The Texas Rangers established an outpost in the area in 1837 and an Anglo settlement followed. The town grew after the Civil War thanks to a spur off the Chisholm Trail.

Begin your visit at the Texas Ranger Hall of Fame at University Park Drive. The museum has displays about the legendary Texas Rangers, as well as individual Rangers who became legends in their own right. A movie illustrates the history of the Rangers and their current role in law enforcement. Displays contain memorabilia illustrating famous cases, including the ambush of notorious gangsters Bonnie and Clyde in 1934 by a posse led by retired Texas Ranger Captain Frank Hamer.

The campus of Baylor University is nearby. Find a public parking spot and walk the campus. Buildings on the tree-shaded campus date back to the 1880s. The campus covers one thousand acres and is home to a student population of fifteen thousand.

Step back in time by visiting the Waco Mammoth National Monument at 6220 Steinbeck Bend Drive. Tour guides will lead you to a location where you can see mammoth bones still sitting in their rocky matrix. Displays inform about the ice age and how the fossils were discovered at this location.

Neff Hall has become the iconic structure on the Baylor University campus in Waco, Texas. Pat Neff was the twenty-eighth governor of Texas and ninth president of Baylor.

PINEY WOODS

Caddo Lake State Park is a great place to see stands of cypress trees on Caddo Lake.
The park offers hiking, boating, camping, and bird-watching.

E AST TEXAS IS a great and magnificent forest, interrupted by an occasional town, farm, or man-made lake. As part of the once-expansive and contiguous southern pine forest of antebellum America, it is reminiscent of a wilderness seen by the likes of Daniel Boone. Although the wilderness forest yielded long ago to the axe, tall pine tree forests still line backroads that seem to tunnel through the woods. But the pine forests are also home to multiple other trees, such as oaks, hickory, ash, and sweetgum. The forest understory supports abundant shrubs like yaupon and wax myrtle. Wildlife is abundant with rabbits, squirrels, foxes, bobcats, wild turkeys, and deer.

The forest is moist, with rainfall exceeding forty inches yearly. Rolling terrain rarely exceeding an elevation of five hundred feet of slight hills and valleys, and sectioned by rivers and creeks, contains surprising sandy beaches and woodland marshes. In the midst of the sprawling forest with its mostly small communities, many of which were borne in an era of extensive logging, rests the invaluable Big Thicket National Preserve consisting of 105,684 acres of one of the most diverse and extraordinary ecosystems in North America. Its diversity includes plant communities and wildlife species indicative of coastal plains to the south, central plains to the west, and dense pine forests to the east.

Often called "Deep East Texas," the region was historically the land of Caddo, who were mostly farmers growing crops such as corn and beans in forest clearings. They also hunted deer and turkey and gathered acorns, berries, and other plant foods from the rich forest floor. Hardwood trees enabled them to fashion some of the strongest of bows and arrows known among American Indians, and they not only used these weapons for hunting, but also traded them as prized weapons for goods from other tribes. Caddo huts would seem like a comfortable kind of cabin for modern-day campers, being constructed of wood, cane, and grass. Caddo Lake, named for the tribe, was the state's only natural lake formed by a logjam on the Red River until an artificial dam was constructed in the early twentieth century.

Spanish settlers entered the region in the 1600s and established the town of Nacogdoches in 1779. Later, Anglo settlers arrived to take advantage of Mexican land grants. By the late 1800s and early 1900s, the town and surrounding areas became centers for commerce in the logging and oil industries. Nowadays, the town hosts a major research university, Stephen F. Austin State University, ranked in 2016 by *US News & World Report* in a tie with California State University as among America's best universities.

DALLAS

Sulphur Springs

Emory

Avinger
49
Jefferson
134
2198
Uncertain
12
Karnack
43
Marshall

Canton

Longview

Tyler

Athens

Corsicana

Palestine

Fairfield

Ratcliff

Crockett

Nacogdoches
59
Sam Rayburn Reservoir
103

Lufkin
13
59
Diboll

Toledo Bend Reservoir

LOUISIANA

George Histori

Lake Livingston

Huntsville

College Station

SAM HOUSTON NATIONAL FOREST

Navasota

Lake Conroe

Brenham

La Grange

Port Neches
Beaumont
366
Orange
14
Port Arthur

HOUSTON

Schulenburg

Rosenberg

San Jacinto Battleground State Historic Site

Sabine Pass

Texas City

Galveston
15

El Campo

Brazoria

San Luis Pass
257
BRAZORIA NATIONAL WILDLIFE REFUGE

GULF OF MEXICO

0 50 Miles
0 50 Kilometers

MARSHALL to AVINGER

From Marshall, follow Texas Highway 43 east for 15 miles to Karnack. Drive 4 miles east along Farm to Market Road 134 and Farm to Market Road 2198 to Uncertain. Backtrack along Farm to Market Road 2198 and Farm to Market Road 134 for 17 miles west to Jefferson. Drive on Texas Highway 49 west for 16 miles to Avinger. Approximately 53 total miles.

Marshall is a modern town with deep, historical roots located on Interstate 20 in northeastern Texas. The Caddo lived here long before Spanish explorers came this way. African American and Anglo settlers put down roots from 1820 to 1830.

The Buard History Trail links locations made famous by African Americans, including Wiley College, the first black college west of the Mississippi. Contact the Marshall Convention and Visitors Bureau at 213 West Austin for more information.

Marshall played a large role supporting the confederacy during the Civil War. Munitions and manufactured items needed by the soldiers were made in Marshall. After Vicksburg fell in the war, Marshall was the capital of the confederacy west of the Mississippi.

The Texas & Pacific train depot, built in 1912 at 800 North Washington Street, was restored to its original elegance in the 1990s. Amtrak passenger trains regularly stop at the station to ferry passengers to Dallas, San Antonio, Los Angeles, and Chicago. Walk the grounds of the station to see an old train engine, then go inside to tour the Texas & Pacific Railway Museum.

The Harrison County Courthouse is located in downtown Marshall on Houston Street. Across the street is

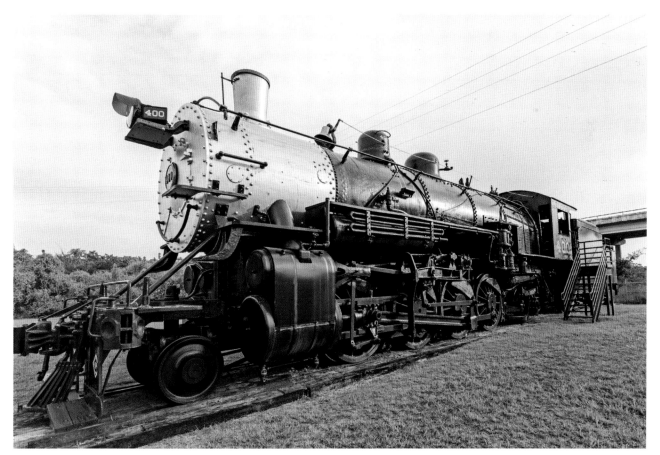

Above: **Texas & Pacific engine #400 is a Mikado-type steam locomotive. It sits on the grounds of Marshall's restored train depot.**

Opposite: **The Shady Glade Cafe in Uncertain, Texas, is a great place to grab a hamburger or some fried catfish.**

Telegraph Park on the site of the first telegraph office in the state of Texas, and it has an interesting statue depicting telegraph operators. A performance stage stands nearby where local concerts and events are held. Restaurants abound in the area so enjoy a meal day or night.

Leave Marshall and drive to Karnack on Texas Highway 43. Lady Bird Johnson, wife of President Lyndon Johnson, was born in Karnack. Her family home built in a Southern plantation style is now a private residence.

Continue along Highway 43 to the community of Uncertain. Yes, that's the name of the town with an uncertain history behind its name. You'll find that the community spreads throughout the area with no recognizable . . . certain? . . . boundaries on the edge of Caddo Lake.

Caddo Lake is a sprawling series of bayous and lakes that stretches across the Texas-Louisiana border. The lake originally formed from a series of natural logjams on the Red River and surrounding bayous. Paddle wheelers and steamboats ferried people and goods around the lake as far back as the 1830s. The US government bought the land and lake from the Caddo people in 1835 for $80,000. Today, the lake covers 26,800 acres with countless small resorts and fishing camps.

Shady Glade Resort at 449 Cypress Drive in Uncertain offers cabins, RV sites, and a boat launch. Eating at the Shady Glade Café is a must. The café's fried catfish lunch is simply not to be missed. Nor is its "Not-Your-Grandmother's" banana pudding.

Caddo Lake State Park is a serene wilderness park along Caddo Lake. The entrance to the park is on Farm to Market Road 2198 off Highway 43. Stop at the interpretive center to get a map and pay your entrance fee. Displays in the center give a history of Caddo Lake and illustrate the wildlife you might see. The park has campsites, cabins,

Opposite: **Jefferson, Texas, has a charming historic downtown. Many buildings have been restored and now house shops and restaurants.**

Below: **The Old Harrison County Courthouse, in Marshall, Texas, is an example of Renaissance Revival, Beaux Arts, and Classical architecture. The courthouse was in use from 1900 to 1964. Today, the Harrison County Historical Museum is housed on the first and second floors.**

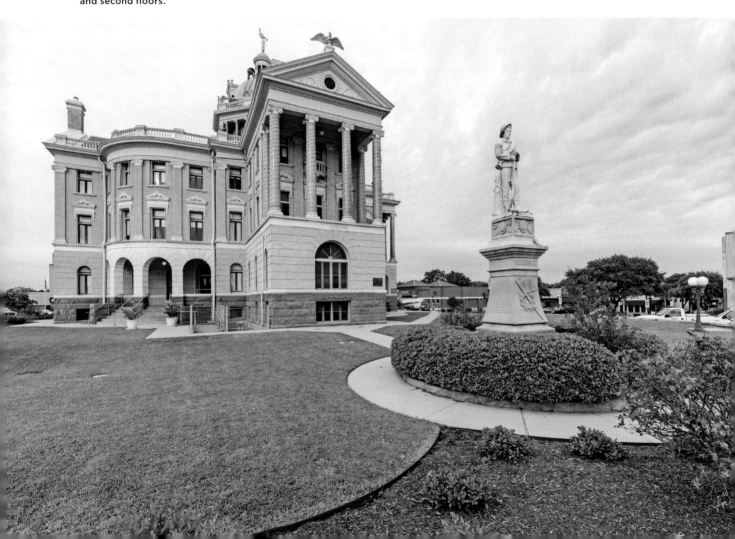

The Church of Uncertain in Uncertain, Texas. The small community sits on the banks of Caddo Lake.

fishing areas, a boat launch, and hiking trails. Hiking the trails through the rolling hills covered in pines and mixed hardwoods is a pleasure. Overlooks provide stunning views of inland ponds and waterways lined with bald cypress trees. Each tree seems to be covered with Spanish moss that looks like men's gray beards wafting in the breeze.

Jefferson is a short drive away to the east along Farm to Market Road 134. Jefferson was a port of entry for the Republic of Texas and major shipping point for cotton and agricultural products.

In 1874 the Southern Baptist Convention was held in Jefferson. Delegates from all over the United States attended, including Pastor Joshua Stradly of Oxford, North Carolina. Pastor Stradly wrote accounts of his trip to the Baptist newspaper back home remarking, "This city, numbering one thousand inhabitants, is at the head of navigation on the Cyprus [sic] Bayou. It now enjoys the advantages of the railroad."

Jefferson Railway Tours offers journeys on an antique locomotive much like the one that delivered Pastor Stradly to Jefferson. The railway takes riders on an hour tour through wetlands and woods while guides pass along history, legends, and ghost stories. Catch the train at 400 East Austin.

The historic center of Jefferson is lovingly restored. No visit is complete without a stop at the Jefferson General Store at 113 East Austin. You'll know you're in the right place by the old blue pickup truck out front.

Avinger is the next stop along Texas Highway 49. The Harris Mercantile and Trading Company is a nice place for people interested in hardware or antiques. The award-winning Five D Cattle Company Steakhouse and Meat Market shouldn't be missed for a great steak dinner.

DIBOLL to LUFKIN to NACOGDOCHES

From Diboll, follow US 59 north and then Texas Highway 287 Loop around Lufkin. Drive 11 miles west on Texas Highway 103 and then another 11 miles west on Texas Highway 7 to Ratcliff. Backtrack along Texas Highway 103 to Lufkin. Drive 20 miles north on US Highway 59 to Nacogdoches. Approximately 85 total miles.

Start in the small city of Diboll on US Highway 59. The town was named for a J. J. Diboll, who sold seven thousand acres of timberland to Thomas L. L. Temple, and he in turn built a sawmill there that began operation in 1894. Head to The History Center on 102 North Temple. The modern facility is built in the Craftsman architectural style with exposed wood on the floor, walls, and ceiling. First-rate displays show how native pine forests were developed into the booming timber industry of the nineteenth and twentieth century. Tools that the lumberjacks used to fell mighty trees are on display. Railroad workers transported those trees to the mills, and their tools are also on display.

Another room in the museum is devoted to a library. Staff can help with genealogy searches and newspaper archival searches. Friendly staff members are knowledgeable about the area, so strike up a conversation. Outside is a steam engine used in the local timber industry. Climb aboard and blow the steam whistle. Walk through the train cars, including a caboose. You'll find photos from the days when the rail cars brought timber to market.

The Durst-Taylor House, built in 1835 in Nacogdoches, is an example of a traditional house that early settlers might have built.

Left: **Fig trees were a common tree planted by early settlers in Texas. The fruit is still a favorite in many areas of the state.**

Middle: **The original Old Stone Fort was built from 1788 to 1791 on the El Camino Real. It was torn down in 1902, sparking a preservation movement throughout the state. In 1936, a replica of the Old Stone Fort was built on the campus of Stephen F. Austin State Teachers College (now Stephen F. Austin State University.)**

Right: **Traditional tools sit in the blacksmith shop behind the Durst-Taylor House in Nacogdoches, Texas.**

Opposite below: **The History Center in Diboll, Texas, is a museum dedicated to the history of the timber industry as well as local history.**

Davy Crockett National Forest spreads west of Lufkin. President Franklin Roosevelt proclaimed this land a national forest in 1936. The forest is named for legendary Texas hero of the Alamo, Davy Crockett, who was born in the woods of Tennessee. Crockett served as a Tennessee US Congressman from 1827 to 1835 when he was defeated in a reelection bid. A colorful figure even in his lifetime, he is alleged to have said after his defeat for reelection, "I told the people of my district that I would serve them as faithfully as I had done; but if not, they might go to hell, and I would go to Texas." Crockett was killed at the Battle of the Alamo in 1836 at the age of forty-nine.

Stop at the National Forest Ranger Station on Texas Highway 7 near Ratcliff about one-quarter mile west of Farm to Market Road 227. The Civilian Conservation Corps built the Ratcliff Lake Recreation Area in 1936. The recreation area offers places to camp, picnic, swim, or hike. Drive to Lufkin on Texas Highway 103 but even better, chart your own course along forest roads and farm-to-market roads.

Lufkin is a bustling city and home to Angelina College. The city was founded in 1882 as a stop on the Houston, East & West Railway line and named for a cotton merchant in Galveston named Abraham P. Lufkin. Timber, sawmills, and paper mills built the community. Beautiful murals illustrating the history of Lufkin by the artist Lance Hunter decorate buildings in downtown.

Continue to Nacogdoches along US 59. Settled by Spanish missionaries in 1716, Nacogdoches is the oldest town in Texas. The mission was abandoned around 1773. Prior to Spanish settlement, the town was Caddo territory. Legend says that a Caddo chief had two sons. One of the sons had light hair and complexion and the other son dark hair and complexion. The Caddo chief sent one son to the east and one to the west with instructions to settle and become leaders of their own tribes. The light-haired son traveled three days to the west and created the settlement we call Nacogdoches. The dark-haired son traveled to the east and created the settlement we call Natchitoches in Louisiana.

Antonio Gil Y'Barbo officially founded Nacogdoches in 1779. Y'Barbo was born in 1729 at the eastern terminus of the Camino Real in Los Adaes in the area of current-day Louisiana. In 1779, Y'Barbo led a group of settlers to Nacogdoches and housed them in the abandoned 1716 mission.

Y'Barbo's Old Stone Fort is preserved on the campus of Stephen F. Austin State University. The Texas Centennial Commission built the replica you see today in 1936. The museum, located at the corner of Griffith and Clark Boulevard, is filled with displays that illustrate the times of Y'Barbo and the settlement.

Take time to walk the campus of Stephen F. Austin State University, shaded by towering pine trees and lined with beautiful gardens of azaleas, roses, and other flowers.

Durst Taylor House and Gardens are located at 304 North Street. The home is an example of a residence in the 1830s, and it is the second-oldest original structure in Nacogdoches. Staff in the visitor's center will unlock the doors of the house and offer you a tour. The grounds contain a blacksmith shop, smokehouse, and gardens. Fig trees stand in the garden much as they did in the 1830s.

— 14 —

ORANGE to BEAUMONT

From Orange, follow Texas Highway 87 west for 15 miles until it turns into Farm to Market Road 366 and drive 5 miles west to Port Neches. Return to Texas Highway 87 and drive south to Port Arthur. Drive 14 miles south to Sabine Pass along Texas Highway 87. Backtrack to Port Arthur and connect with US Highway 287 North. Drive 10 miles to Beaumont. Approximately 77 total miles.

Founded in 1836, the city of Orange not surprisingly got its name from native orange trees that once grew along the Sabine River. We call the trees bitter orange or trifoliate orange for the lemony sour-tasting fruit on stems with three leaves. Today, the city is a thriving hub of commerce thanks to shipping, petrochemicals, shipbuilding, and other industries.

Head to Shangri La Botanical Gardens at 2111 West Park Avenue in the heart of Orange. H. J. Lutcher Stark started working on these gardens in the 1940s. An ice storm in 1958 devastated the lovely azalea bushes and other vegetation, but as every gardener knows, plants come back with a little love and attention. That's what revived Shangri La Botanical Gardens not only after ice storms, but after hurricanes and floods. The gardens are magnificent and arranged into sections or "rooms" covering 252 acres. Visitors can also explore an expansive cypress marsh. Visit the nature discovery center, go to the greenhouse, eat in the café, and shop in the gift store.

H. J. Lutcher Stark's father, W. H. Stark, began life in a simple family in rural Texas. He worked hard and eventually became president of Texas's biggest sawmill, later investing in timber and paper companies, banking institutions, and other enterprises. He built an expansive family home in 1894 at the corner of Green Avenue and Sixth Street. The architecture was in Queen Anne style, and the restored home now called the Stark House showcases the wealth and privilege that dominated Orange from the Gilded Age of the late 1800s into the early 1900s.

The Stark House motto is "take a stroll through history." Each of its fifteen rooms is decorated as it would have been at the turn of the twentieth century. Works of art in the home include a death mask of Napoleon Bonaparte from 1821, a Hupmobile roadster from 1909, and many pieces of jewelry from the Art Nouveau era.

Next, head to the Old Orange Café & Catering Company at 914 West Division. This restaurant in the heart of Orange is a favorite with locals from the nearby courthouse and Lamar State College.

Opposite: **The Buu Mon Buddhist Temple in Port Arthur, Texas, serves a community from all over Texas and Louisiana.**

Above: **First Presbyterian Church Lutcher Memorial Building in Orange has an opalescent glass dome by J&R Lamb Studios.**

Opposite: **The grounds of Shangri La Botanical Gardens and Nature Center in Orange hold a bit of something for everyone. Several large bottle trees are a marvel to see.**

Next page: **Re-creation of the town that grew around the discovery of oil at Spindletop in 1901 at the Spindletop-Gladys City Boomtown on the grounds of Lamar University in Beaumont, Texas.**

The First Presbyterian Church in the Lutcher Memorial Building at 902 West Green Avenue is an impressive edifice built in 1912 in the Classical Revival style. It has a granite exterior with towering cut-glass windows and is topped with a green dome. Enter the building if it is open for a public tour and step back to another era. This was the first air-conditioned public building west of the Mississippi. Stand in the middle of the second-story sanctuary and marvel at the opalescent or milky glass dome creating a stunning overhead effect.

Leaded-glass windows adorn most of the walls of the church. Many of them present one image inside the church and another image outside the church. For example, from inside the church, one window shows an image of the Virgin Mary on a donkey facing toward the viewer. From outside the church, the window shows the Virgin Mary on a donkey heading away from the viewer.

Please remember that this building is an active church. Services are held on a regular schedule, as are public events. Contact the church to see if it will be open for public viewing.

Take Texas Highway 87 out of Orange and head southwest to Port Neches on the Neches River. This area was home to an Atakapa village and later became an important riverboat landing point called Grigsby's Bluff. The town's name was changed to Port Neches in 1901.

A great restaurant, the Port Neches River Wheelhouse, is located at 720 Lee Avenue in Port Neches. The large metal building is open on three sides to the Neches River. Diners have a view of the river and can watch as guests arrive via personal boat to enjoy a bowl of sausage gumbo, rib-eye steak, or a shrimp po' boy. Helicopters can land in the field nearby for those wanting to fly over for a lunch or dinner.

The Port Neches Park sits nearby, if you need a little exercise or rest after dining.

Return to Highway 87 and drive a short distance to Port Arthur. Port Arthur sits on the marshy banks of Sabine Lake on the Texas-Louisiana border. An industrial city with three major refineries, it sits on the Intercoastal Waterway that allows boat traffic to flow smoothly from Florida to South Texas.

The city is also home to the Buu Mon Buddhist Temple at 2701 Procter Street. The temple started in 1980 in Beaumont but moved to its present location in 1987. The temple is housed in a building that started as a Baptist church, then was home to a Vietnamese Catholic congregation. The temple is surrounded by gardens that are filled with lotus, water lilies, and bamboo. A seven-foot statue of Buddha stands in the middle of the garden.

Take Highway 87 out of Port Arthur and head south along the western bank of the industrial channel toward Sabine Pass. At the four-way stop in Sabine Pass, turn west and enjoy the drive through some of Texas's most well-preserved marshes. Look for the pullout into the Texas Point National Wildlife Refuge for bird-watching, nature viewing, and outdoor photography. Sea Rim State Park is a

bit farther along Highway 87 and offers camping, outdoor activities, and access to the shoreline.

Turn around on Highway 87 and return to Beaumont. Beaumont became a town in 1838 and prospered thanks to its location on the Neches River and then next to railroad lines. After the Civil War, rice joined timber and cattle as the major industries in the area.

Beaumont really hit the map, though, on January 10, 1901, when oil was discovered at Spindletop Hill. A gusher of oil shot hundreds of feet into the air and still shot two hundred feet into the air nine days later. Records show that the well was producing one hundred thousand barrels of oil a day. The town's population grew from nine thousand to thirty thousand in three months.

Visit a re-creation of Spindletop at the Spindletop-Gladys City Boomtown on the grounds of Lamar University at 5550 Jimmy Simmons Boulevard. The wooden oil rig on the grounds periodically shoots water two hundred feet into the air. The site has a museum, a gift shop, and a replica of a village as it would have looked in 1901. Guided tours are available or you can walk and explore on your own.

The people of Beaumont have preserved many of the homes built by prominent citizens of the nineteenth and

JANIS JOPLIN

The 1960s blues and rock singer Janis Joplin (1943–1970) was born and raised in Port Arthur in a middle-class family. A major tourist attraction is the Joplin area on the second floor of the Museum of the Gulf Coast at 700 Procter. An exhibit displays her artwork, music, and a replica of her painted Porsche. Despite her tumultuous and tragic life, she has often been hailed as "the best white blues singer in American musical history." She was inducted posthumously into the Rock and Roll Hall of Fame in 1995 and given a Grammy Lifetime Achievement Award in 2005.

Port Arthur native Janis Joplin. *Photo by GAB Archive/ Referns/Getty Images*

Above: **Old Blush China Rose at the Beaumont Botanical Gardens, Beaumont, Texas.**

Top: **The Neches River Wheelhouse Restaurant sits on the banks of the Neches River in Port Neches. Diners can dock their boats at the restaurant, fly in on a helicopter, or drive up in their cars.**

twentieth centuries. Visit the John Jay French Museum at 3025 French Road to see a home restored to the way it looked in the mid-1800s. French was a successful tanner and merchant.

The McFaddin-Ward House at 1906 Calder Avenue is much larger and shows the Beaux-Arts Colonial style. At the time the home was built in 1905, it had the latest in heating, plumbing, and electricity. The McFaddins lived in the house for seventy-five years. Guided tours are available. The gardens and carriage house can be toured on your own.

Finish your visit to Beaumont with a stop at the Beaumont Botanical Gardens in Tyrrell Park. The gardens are open daylight to dark every day. Walk through the grounds looking at plants in bloom throughout the year. Spring and summer are particularly spectacular, but the grounds are well maintained during any season.

SAN JACINTO to SAN BERNARD REFUGE

From San Jacinto Battleground State Historic Site, follow Park Road 186 until it turns onto US Highway 225 or Pasadena Freeway east until it merges with Texas Highway 146. Drive south 28 miles to the Texas City Dike. Drive on Texas Highway 197 to Texas Highway 3 merging to Interstate 45 south. Drive for 10 miles to Galveston on Interstate 45. Take Seawall Boulevard west in Galveston as it becomes Farm to Market Road 3005 for 27 miles to San Luis Pass. Continue on Farm to Market Road 3005 as it becomes County Road 257 for 13 miles. Turn right on Texas Highway 332, right on Farm to Market Road 523, and then right again on Farm to Market Road 2004 to the entrance for the Brazoria National Wildlife Refuge. Approximately 106 total miles.

San Jacinto Battleground State Historic Site is where the beauty of nature and the glory of human history shine with equal splendor. The San Jacinto Monument rises 570 feet above a landscape of marshlands, woodlands, and grasslands. Birds such as herons, egrets, ducks, hawks, sparrows, and songbirds abound. Squirrels and rabbits scamper on the ground where General Sam Houston's rag-tag army fought and won the battle for Texas independence in 1836.

Located twenty-two miles from downtown Houston, the park is an ideal place for people of all ages. Human history hovers around you with every step.

You will enter the park heading southeast on Park Road 1836. The park is a one-thousand-acre peninsula that pushes northward into the confluence of the Houston Ship Channel (once Buffalo Bayou) and the San Jacinto River. As a result, three hundred acres of marshland border the

Opposite: **Texas City Dike extends nearly five miles into Galveston Bay. The dike is a popular fishing spot.**

Below: **San Jacinto Monument, with reflecting pool, at San Jacinto Battleground State Historic Site, Pasadena, Texas. Light pollution comes from Baytown on the left and Pasadena on the right.**

Texas City Dike is a popular place to photograph the sunrise and moonrise and watch ships passing by.

north and east end of the park. Along the park road to the southeast, you'll notice grasslands dotted with live oaks.

A grassland restoration project is returning the area to its original coastal prairie landscape. Grasses such as bluestem, Indiangrass, and switchgrass, along with grassland birds, will soon predominate the area as they did when Sam Houston fought his battle.

Proceeding on Park Road 1836, you'll drive over a short causeway that crosses a tidal marsh. Park on either side of the causeway and look for waterfowl that lived here when Texas won its independence from Mexico. Continue past the causeway to the end of the road at Adams Point. Look toward the northeast at the vast San Jacinto Marsh. Texas Parks and Wildlife initiated a plan in 1995 to restore the San Jacinto Marsh and adjacent wetlands in the park. Since the 1940s, erosion and land subsidence have degraded the marshes, and natural bluffs that had

historically protected the marsh from erosion have consequently vanished.

Ultimately, the area will look much the way it did when Sam Houston's army chased the Mexican soldiers to their deaths in the muddy marsh. But beyond its historical significance, the marsh is regaining its crucial role as a spawning ground for Galveston Bay fish, shrimp, and crabs and also bringing back wildlife such as river otters, muskrats, alligators, wood storks, brown pelicans, peregrine falcons, and the majestic osprey.

Drive back from Adams Point across the causeway to the crest of a small hill where the road veers to the right. Park your car and wander around beneath the live oaks. Be sure to read the small monuments posted in the area. After all, you're standing on the ground where Santa Ana and his Mexican army camped the night before they lost the decisive battle against the "Texians" on April 21, 1836.

The battle was fought during the peak of the spring migration of neotropical songbirds. The trees were probably full of migrating birds. I've often wondered if any of the Texan or Mexican soldiers noticed the singing of warblers, tanagers, and orioles that day. But I don't suppose they had migratory songbirds particularly on their minds. Drive to the parking area for the San Jacinto Monument and visit the museum replete with displays and treasured artifacts from Texas revolutionary days. Take the elevator to the observation room at the top. Look north and east from the observation room to see the expanse of the marsh and its interaction with the San Jacinto River. Look south and east to survey the historic battlefield. You'll be looking down on a unique area where biological diversity merges with historical legacy.

Across Independence Parkway from the monument is the battleship *Texas*. Officially called the USS *Texas*, it is the only remaining battleship that played a role in both World War I and World War II. Guided or self-guided tours give visitors a chance to see above- and below-deck. Take a look at the guns topside and then drop below for a tour of the engine room. Walk through the ship and be rather startled at the living conditions of sailors during a different era.

Exit the park on Road 1836 headed toward Texas Highway 225. Take Texas 225 east and merge onto Texas Highway 146 south toward La Porte. Travel about twenty miles and then turn left onto Farm to Market Road 1765. Stay straight and continue along Fifth Avenue South as it changes to Fourth Avenue South, then turn right onto Sixth Street South. Turn left on Dock Road to Texas City Dike.

The Texas City Dike is a nearly five-mile-long dike that extends out into Galveston Bay. A two-lane road runs along the dike that includes several pullouts for fishing,

Above: **A family enjoys a walk along the shore at Galveston Island State Park in Galveston.**

Next page: **Night scene of the historic buildings along the Strand in Galveston.**

Brazoria National Wildlife Refuge is a popular place with anglers, bird-watchers, and nature lovers.

bird-watching, water sports, and sightseeing. The dike was built in 1935 to reduce sediments in lower Galveston Bay. Anglers love the dike so much they've named it the "world's longest man-made fishing pier."

Stop at Boyd's Onestop if you'd like a little fresh seafood to eat at one of the picnic tables on the dike.

Drive to Galveston. It would be a shame to drive through here for beaches and seafood restaurants and not stop for an hour or more on the Strand. Park your car near the corner of Twenty-Fifth and Strand to begin a walking tour.

The Galveston Island Railroad Museum is housed in the old Santa Fe Railway Station. Inside are interesting displays, but the real treasures are out back. Vintage engines and railway cars stand on the tracks just as they might have been seen in the 1940s or 1950s. Walk through dining cars and mail cars.

If you can, pull yourself away from this gem and walk along the Strand. The Strand is filled with history but also has outstanding restaurants, gift shops, and hotels. Many of the historic buildings that line the Strand survived the catastrophic hurricane of 1900, among the worst natural

disasters in US history. Everything you see still standing also survived the devastation of Hurricanes Ike and Rita in the twenty-first century. Notice the high-water marks on many of the buildings.

Leave the Strand and drive to Seawall Boulevard. The entire island of Galveston is a mere three miles wide at its widest point and twenty-seven miles long. Spanish explorers surveyed the island in 1519, and Cabeza de Vaca was shipwrecked on the island in 1528. The Mexican government established a port of entry here in 1825. Shipping commerce dominated the economy after the Texas war of independence in 1836, and thirty-seven thousand people inhabited the island in 1900.

When a huge hurricane hit the island on September 8, 1900, it covered the island with a 15.7-foot high wall of water. The devastation was horrendous, beyond anything we've seen in the United States except perhaps for the catastrophe of Hurricane Katrina hitting New Orleans. A long-range plan was implemented to protect the city from future storms. By 1904, houses had been raised to protect them from flooding, and a

three-mile-long seawall that stood seventeen feet above the mean low tide line had been constructed. The seawall is now ten miles long.

Seawall Boulevard changes into Farm to Market 3005 that runs the length of the island. Stop at Galveston Island State Park for access to the Gulf of Mexico. The two-thousand-acre park sweeps over both sides of FM 3005 on the west end of the island, bordered by the Gulf of Mexico to the south and Galveston Bay to the north. Diverse habitats from beaches to marshes, ponds, prairies, and trees yield diverse birds such as water birds, hawks, and songbirds.

From the park headquarters, head east along a short road running parallel to the coastline and looping like a lasso as it borders a marsh. You might see a skinny, chicken-sized, brownish-gray bird called a "clapper rail" skulking in and out of marsh grasses. A bird you're bound to see is the common gallinule with its slate-hued body and red beak scooting like a duck over shallow water while maneuvering through aquatic vegetation.

Along the road west near the campsites, stop and walk to the beach. A reddish egret will seemingly dance in the near-shore waters as it struts and flares its wings. The tall egret with shaggy auburn feathering on its head and neck spooks schools of fish under the shade of its outspread wings. Gawk at the brown pelicans flying like military squadrons over the surf before they suddenly plunge headfirst into the water to scoop up fish in expandable throat pouches.

Now to the bay side of the park across the highway. Notice coastal cord grasses and switch grasses that blanketed the island when a shipwrecked Álvar Núñez Cabeza de Vaca apparently arrived on the beach in 1528. Atop tall grass stems are eastern meadowlarks singing piccolo-like melodies resembling the words *spring-of-the-year*. In summer you'll see scissor-tailed flycatchers taking wing like aerial ballet dancers to snap up flying insects.

Continue toward the observation tower, stopping to gaze over Oak Bayou that looks like a shallow lake with herons and egrets stalking the water for fish. The observation tower provides a panoramic view of the beautiful marsh and grasslands wonderfully full of living things.

Return to FM 3005 and enjoy a drive through coastal prairies split by charming beach communities. A toll bridge crosses San Luis Pass at the end of the island. Turn into San Luis Pass County Park right after crossing the bridge.

Dunes and tidal flats are full of birds year-round as well as anglers trying to catch fish in the waters.

At the bridge, FM 3005 becomes County Road 257, better known as the Blue Water Highway. The road hugs the coast for thirteen miles. Waters from the Gulf of Mexico are a short distance away on one side with coastal marshes on the other side. Turn right on Texas Highway 332, right on Farm to Market Road 523, and then right again on Farm to Market Road 2004 to the entrance for the Brazoria National Wildlife Refuge.

A quick look around the refuge may fool you because it doesn't seem spectacular until you look closer and discover the wide diversity of plant and animal life. The refuge sprawls over forty-three thousand acres next to Bastrop, Christmas, and Drum Bays. The patchwork of coastal grasses, shrubs, marshes, lakes, and ponds camouflages the abundant birds and wildlife. It's a primary wintering ground for North American waterfowl and a major stopover point for migratory songbirds and shorebirds.

A three-mile gravel road leads you into the refuge to the information center. The road cuts through hackberry trees, baccharis shrubs, and tall coastal grasses. Look for crested caracaras perched on the fence posts. They resemble bald eagles with their white heads, tails, and wing tips, all of which give them the enduring folk name "Mexican Eagle."

At the information center, you'll find restrooms and a kiosk with maps of the refuge, a self-guided touring pamphlet, and other information. Be sure to sign in at the guest register. Entrance is free.

Adjacent to the kiosk is a short boardwalk that bridges a cattail marsh and takes you to a hiking trail. (The Friends of the Brazoria National Wildlife Refuge provided the boardwalk and many other facilities.) The hiking trail at the end of the boardwalk leads for a half mile to an observation platform over Big Slough, a wide, slow-moving stream that meanders through the refuge.

A seven-mile auto tour loop begins at the information center. Your self-guided touring pamphlet will lead you along the road to numbered signs, each sporting a handsome duck silhouette. Enjoy the birds on the tour loop, but also watch for mammals. In early morning or late afternoon, you're likely to see raccoons, deer, opossums, armadillos, and even a coyote. Feral hogs are common but not welcome because they do tremendous damage to the ecosystem.

GULF COAST

Once near extinction, whooping cranes have made an amazing comeback
thanks to the protected winter feeding grounds at Aransas National Wildlife Refuge.

THE TEXAS GULF COAST runs along an arc of approximately 367 miles, with craggy edges where rivers, bays, and estuaries indent the coastline. It marks the juncture with Louisiana at the mouth of the Sabine River and the juncture with Mexico at the mouth of the Rio Grande. Gulf waters ease into more than six bays, and eleven rivers reach their sea-bound destination along the coast.

Sitting just off the coast are seven barrier islands, the best known being Galveston Island and Padre Island, but all formed between five thousand and eight thousand years ago. Shorelines along the islands or the mainland lack rocky cliffs where sea waves crash thunderously over boulders. Instead, the coastlines are flat, sandy plains where gulf waters ease in gentle waves over beaches. Inland from the beaches are abundant marshes and estuaries filtering sediments from water draining from bayous and rivers and forming vital nurseries for shrimp, crabs, and fin fish.

Also, marshes are home to scores of beautifully plumed egrets, herons, and other birds, including the rare and endangered whooping cranes that spend every winter in the marsh at the Aransas National Wildlife Refuge on the central coast. Additionally, the coast is a harbor for the largest concentration of neotropical migratory birds in the Western Hemisphere.

Accordingly, birding is a big tourist draw that impelled the state to create a four-hundred-mile birding trail from Sabine Pass to Brownsville that included numerous towns along the way. Indeed, birds are so plentiful along the Texas coast that they attract bird-watchers from all over the world. In the spring, when Texas shores harbor the highest concentration of birds, bird-watchers descend on coastal communities in droves.

Not only birding attracts travelers to this area. Places such as Galveston, Rockport, Port Aransas, Corpus Christi, and South Padre Island rank among the top destinations for travelers because of their beach escapes.

Stretching sixty miles inland, the landscape elevates no more than five hundred feet. Coastal prairies provide a horizon-to-horizon view to form a part of the Texas heritage of wide-open spaces. Prior to the mid-nineteenth century, coastal prairies covered six million acres from Sabine Pass to Baffin Bay. But agriculture and urbanization along the coast have reduced the prairie acreage to less than 1 percent of its former coverage. Remaining prairies offering sweeping views and stunning sunset scenes may be viewed at any of the national wildlife refuges in coastal Texas.

The San Jacinto Battleground State Historic Site sits where the San Jacinto River ends its forty-two-mile journey from the Sam Houston National Forest in East Texas. It was through the once-tall grasses at this coastal spot that General Sam Houston's rag-tag army crawled unnoticed on a spring day in 1836 to make a surprise attack on a much-larger Mexican Army under the command of General Santa Ana. Mexican soldiers fleeing the surprise attack ran into an adjacent marsh, only to perish under gunfire.

The Rio Grande River is the fourth-longest river in the United States, traveling 1,885 miles from Colorado down through New Mexico and across Texas to form the border with Mexico and to languidly empty into the gulf at Brownsville. And although the river separates two nations, it does not divorce the south Texas region of its joyful Hispanic culture, nor does it stop Mother Nature from claiming it as a tropical paradise luring multitudes of tourists yearly.

SAN ANTONIO

Brady •
Lampasas •
Temple •
College Station •
Huntsville •

Fredericksburg •
Johnson City •
AUSTIN
Brenham •
HOUSTON

Kerrville •
San Marcos •
La Grange •
Rosenberg •
George Ranch Historical Park

Boerne •
New Braunfels •
Schulenburg •
West Columbia •
18
Jones Creek

SAN ANTONIO
Castroville •
El Campo •

Hondo •
Uvalde •

Kenedy •
Victoria •

Carrizo Springs •
Asherton •
Catarina •
Chapparal Wildlife Management Area
Goliad •
Refugio •
774
Aransas National Wildlife Refuge
19
Rockport

Encinal •
Port Aransas
Mustang Island State Park
16

Alice •
CORPUS CHRISTI

Lake Casa Blanca Int'l. State Park
Laredo •
Kingsville •

Hebbronville •
Riviera •
Baffin Bay
Falfurrias •

PADRE ISLAND NATIONAL SEASHORE
17

Zapata •

Raymondville •

Rio Grande City •
1420
Laguna Acosta National Wildlife Refuge
345
MEXICO
186
106
510
South Padre Island
Progreso •
100
Port Isabel
69E
48
BROWNSVILLE

0 100 Miles

0 100 Kilometers

REFUGIO to PADRE ISLAND

From Refugio, follow Farm to Market Road 774 east until it crosses Texas Highway 35. Continue on Farm to Market Road 774 east for 6 miles then turn south on Farm to Market Road 2040. Drive 6 miles to the Aransas National Wildlife Refuge. Return to Texas Highway 35 and drive south for 47 miles to Rockport. Drive south for 19 miles along Texas Highway 35 and Texas Highway 361 to the Aransas Pass Ferry and Port Aransas. Drive less than 2 miles south along Texas Highway 361 to Mustang Island State Park. Padre Island National Seashore is 13 miles south on Texas Highway 361. Approximately 130 total miles.

Refugio (pronounced "reh-FYUR-eih-oh") is a small community on US Highway 77 about halfway between Houston and the Rio Grande Valley. Convenience stores and fast food establishments line the highway serving business travelers and tourists going to and from the valley. You'd think you wouldn't see much else in the town.

Yet the stately Our Lady of Refuge Church at the southern end of town is a monument to the historic prosperity of the community. The same can be said for the opulent homes within blocks of the church. Some of the homes have fallen into disrepair, but others are being restored to their past glory.

Refugio is situated alongside the Mission River. Karankawa were the first settlers to the area. Spaniards came during the mid-1700s, and by 1795 the Nuestra Señora del Refugio Mission was established and became the community's hub. Mexican ranchers began operating cattle ranches around the mission.

Anglo settlers bought the mission and settlement in 1831. For the next one hundred years, the town's population grew and declined with the Civil War and the coming of the railroad. Oil was discovered in the area in 1928, creating a surge in population that would later fluctuate in numbers as the oil business waxed and

A yellow labrador retriever begs for a treat at the Back Porch Bar on the waterfront next to Woody's in Port Aransas.

Above: **It only takes a few minutes to cross the channel from Aransas Pass to Port Aransas by ferry.**

Next page: **Port Aransas Birding Center on Ross Avenue is a popular birding destination because the boardwalk allows visitors to see birds and wildlife that live around the freshwater pond.**

waned. Today the city is the county seat and a crossroads community.

A good local eatery is Henry's Mexican Food on 212 East Ward Street. After a lunch at the restaurant, walk along Commerce Street near the Courthouse to see the city and work off some calories. Stop at the Blue Sky Gift Shop on 102 East Purisima where women's clothing and accessories are a specialty with a tasteful emphasis on the "ranch look" often missing at shops in similar cities.

Leave Refugio on Farm to Market Road 774 and enjoy the journey among farm fields on either side of the highway. Land along this road has some of the most fertile soil in Texas. Turn south on Texas Highway 35 where the road cuts across the inlets, bays, and marshes of the Gulf of Mexico.

Head to Aransas National Wildlife Refuge off Texas Highway 35, the winter home of the highly endangered and spectacularly beautiful whooping cranes that are the bird equivalent of royalty, standing taller than any other North American bird and draped in preeminently elegant plumage.

The five-foot-tall birds with a seven- to eight-foot wingspan begin arriving mostly in November at their wintering grounds on the 22,500-acre refuge. They may migrate at an altitude of perhaps 1,600 feet, often spiraling like

migratory hawks as they follow a direct route of more than 2,400 miles from breeding grounds on the Wood Buffalo National Park in northern Alberta, Canada.

Whooping cranes are huge, sixteen-pound, flashy white birds with their black outer wings—called primary feathers—visible in flight. They have a conspicuous red crown and show red or blackish-red facial markings looking like a mask. The birds also have a bustle of white tertiary feathers on the rump that typifies cranes.

In the 1800s, whooping cranes numbered about 1,400 birds that bred around freshwater wetlands on the Great Plains of the United States and Canada and migrated to both the Mid-Atlantic coast and Gulf Coast. But overhunting of the birds for their exquisite plumes and the conversion of the Great Plains to agriculture caused the birds to decline to fewer than twenty birds in the 1940s. An exemplary cooperative effort among governmental and nongovernmental groups in the United States and Canada helped bring the majestic birds back from the edge of extinction. The current population includes a small number of wild birds in various locations, some captive breeding birds, and the approximately 250 to 300 birds at the Aransas refuge. Hopefully, the birds will reach a self-sustaining wild population of one thousand by 2033.

The birds that migrate from Alberta, Canada, to the Aransas refuge are currently the largest self-sustaining wild population. One of many reasons it has taken so long to build up the whooping crane population is that the birds don't begin reproducing until four years of age. Although a female lays two eggs, she may fledge only one chick. Parents are monogamous and will stay with their young for up to a year. Family groups of parents and young birds migrate together and occupy wintering grounds together. You can spot a juvenile by its tawny feathers. The main diet of whoopers on the Aransas refuge consists of blue crabs, but they will also feed on frogs, minnows, berries, and small birds.

Now head to the City of Rockport and Rockport Beach Park on Seabreeze Drive. The park juts like a narrow peninsula between Aransas Bay and Little Bay. Its beach is called a blue wave beach because of the uncommonly clear navy-blue gulf water. The mile-long beach also has been designated a clean beach by the Clean Beaches Council in Washington, DC. The park has sixty-one picnic sites, a fishing pier, a saltwater lagoon for swimming, and the Saltwater Pavilion by the lagoon with restrooms and showers.

Drive back south on Seabreeze, and then turn left on Veterans Memorial Drive, which becomes Navigation Circle. Look for the Rockport Center for the Arts, Texas Maritime Museum, Bay Education Center, and Rockport Aquarium. Then head for Connie Hagar Wildlife Management Area on Broadway as it hugs Little Bay. Connie Hagar was a Rockport

Above: **The sunset over Padre Island National Seashore near Corpus Christi, Texas.**

Top: **The Venetian Hot Plate restaurant in Port Aransas offers authentic Italian cuisine in a casual setting.**

Padre Island National Seashore preserves seventy miles of coastal dunes, prairies, and seashore.

resident in the mid-twentieth century who carefully documented the extraordinary birdlife of the community.

After visiting all the Rockport sites, head farther south to Port Aransas.

Barrier islands that stretch along the Texas coast from Galveston to South Padre Island near the Mexican border protect shallow inland bays from the pounding waves of the Gulf of Mexico. The bays are fed by fresh water flowing in from rivers and an influx of saltwater with the rising tides. The mixture of calm brackish water on one side and saltwater on the other side makes barrier islands a great place for fishing and bird-watching.

A good place to start a tour of the barrier islands is at Port Aransas at the tip of Mustang Island. Port A, as it is called by locals, is shaped like a triangle with the Corpus Christi Channel on the north, the Gulf of Mexico on the east, and mud flats on the west.

Paradise Pond near the ferry landing on Cut-Off Road is a famous location to see neotropical migrating songbirds in the spring. The Port Aransas Birding Center on Ross Avenue, off Avenue G, is a good place to explore the brackish water of the inland marsh. A long boardwalk allows easy access to the marsh. Climb to the top of the observation tower for a bird's-eye view of the surrounding habitat.

Fisherman's Wharf is a favorite place in Port Aransas to catch a boat. The Wharf Cat offers regularly scheduled trips from November to February to see the whooping cranes. The Scat Cat takes visitors on deep sea fishing trips. The Jetty Boat ferries passengers to St. Jo Island—also known as San Jose or Saint Joseph Island—where visitors can picnic, walk, or just enjoy a deserted island.

Port Aransas is filled with restaurants, art galleries, hotels, bed-and-breakfasts, and shops. Spend the night. Rent a golf cart and tool around the community. Enjoy the moderate climate, clean beaches, and friendly people.

Before leaving Port Aransas, grab a cup of coffee at Coffee Waves on Texas Highway 361 and check email on your smartphone. A local musician might be strumming a guitar in the corner. Enjoy a burger at the Back Porch Bar on West Cotter Street or an Italian entree at Venetian Hot Plant on Beach Street.

Mustang Island State Park is south of Port Aransas on Texas Highway 361, the road running the length of the island. The 3,954-acre park stretches from the bay to the gulf side of the island, but the entrance is on the gulf side.

Padre Island National Seashore is about thirteen miles south of the park on Highway 361. At 130,434 acres, the park protects the longest stretch of undeveloped barrier island in the world. The natural beauty is astounding, as well as the bird life with a list of more than 380 bird species. Outdoor activities include wind surfing, beachcombing, bicycling, swimming, hiking, and camping.

KINGSVILLE to BROWNSVILLE

From Kingsville, follow US 77 south and turn east on Farm to Market Road 628. Drive 9 miles to Baffin Bay. Return the 10 miles to Riviera by Farm to Market Road 628, Farm to Market Road 772 south, and Farm to Market Road 771 west. From Riviera, drive 57 miles south to Raymondville on US Highway 77. In Raymondville, turn on Farm to Market Road 186 east, then Farm to Market Road 1420 south, and Farm to Market Road 106 east, Farm to Market Road 1847 south, Farm to Market Road 510 east, then north on Buena Vista Road to the Laguna Atascosa National Wildlife Refuge. Return on Buena Vista Road to Farm to Market Road 510 then travel 5 miles to Texas Highway 100. Port Isabel is 5 miles east and South Padre Island is across the Causeway. Backtrack on Texas Highway 100 for 6 miles to Texas Highway 48. Drive on Texas Highway 48 for 23 miles to Brownsville. Approximately 186 total miles.

Start this route at the King Ranch Visitor Center at 2205 Texas Highway 141 West. Take the ninety-minute guided tour of the ranch to see Santa Gertrudis cattle along with longhorns and quarter horses. The tour includes many historic buildings and a historical overview of the ranch. Nature tours are available also.

In Kingsville, the King Ranch Museum is located at 405 North Sixth Street. A few blocks away at 201 East Kleberg Avenue is the King Ranch Saddle Shop. The shop offers saddles but is better known for clothing and home furnishings that combine contemporary lines with classic ranch style.

Baffin Bay is the next stop on this route. Farm to Market Road 628 East off of US Highway 77 South is a nice direct route with a two-lane road crossing farm fields dotted with small communities. Lunch might be in order at King's Inn on the water at 1116 South County Road 2270.

Kaufer-Hubert Memorial Park is a few blocks south along FM 628. This park is situated right on the waters of Baffin Bay and has a boat launch, picnic tables, restrooms, and a two-story viewing tower with a magnificent view over the still waters of the bay.

The shoreline of Baffin Bay is jagged and marshy, consisting of mostly private land with no direct public roads

THE KING RANCH

The King Ranch looms large in Texas history and culture. Captain Richard King made his mark in steamboating during the 1840s and 1850s, and he formed a steamboat line with his friend Mifflin Kenedy that moved cargo to ports along the Rio Grande River during the 1850s.

In 1853, Captain King bought a 15,500-acre tract of land called Rincón de Santa Gertrudis from the heirs of an 1834 Mexican land grant, and he purchased a 53,000-acre tract of land called Santa Gertrudis de la Garza from the heirs of an 1808 Spanish land grant. King's land acquisitions eventually included more than 600,000 acres. Along with business partners such as James Walworth and Mifflin Kenedy, King built a ranching empire unequaled in the United States. The ranch today covers 825,000 acres or 1,289.06 square miles, a larger landmass than the state of Rhode Island.

The ranch started with longhorn cows, a breed long used by early Mexican ranchers, but added Brahman bulls in the 1880s. Shorthorns and Herefords were later added to the herds. The prized Santa Gertrudis cattle resulted from cross-breeding between Brahman and Shorthorn cows and were officially recognized in 1940 by the Department of Agriculture.

Opposite: **The Port Isabel Lighthouse began at this location in 1853. The light guided ships in the area until 1952. Today the lighthouse is a park and landmark.**

Javelina statues grace the entrance sign at the Texas A&M campus in Kingsville, Texas.

to the next location. Make a return drive to Riviera on US 77 and drive south to Raymondville, Texas. In Kenedy County, south of the town of Sarita, the highway crosses ancient sand dunes covered in a thin layer of vegetation. The sand was blown inland from the shoreline thousands of years ago.

Take Texas Highway 186 east out of Raymondville to Rio Hondo and the Laguna Atascosa National Wildlife Refuge. A large number of wind turbines are along this route, as well as agricultural fields edged in towering palm trees.

Laguna Atascosa National Wildlife Refuge near Rio Hondo ranks among the top destinations for bird-watchers. The trees adjacent to the visitor's center shade a small waterfall and creek lined with park-style benches. Refuge volunteers constructed this bird haven. You'll find green jays, plain chachalacas, great kiskadees, and green-tailed towhees in the area.

As you drive the tour route, be on the lookout for the exceedingly rare Aplomado falcon, a bird extirpated from

South Texas by the early 1950s and reintroduced into the refuge in the 1990s. The small, colorful falcon often perches atop dagger yuccas.

When following the refuge road to the visitor's center, watch the fields for sandhill cranes in the winter and eagle-like crested caracara year-round. Watch the fence lines for the eye-catching vermilion flycatcher, with its crimson-red body draped by coal-black wings. As the tour loop goes around the Laguna Madre Lagoon, keep in mind that it's an outpost for another endangered bird, a red knot that migrates back and forth between wintering grounds in the lagoon and breeding grounds in the high Arctic.

Next stop is Port Isabel, a charming community on the south shore of Laguna Madre. The Port Isabel Lighthouse is located at East Railroad Avenue and Queen Isabella Boulevard. This is a good location to park and explore the area.

The Port Isabel Lighthouse is solid white with a black top. Construction began on the brick structure in 1851. The lighthouse was abandoned in 1905 as shipping traffic

Above: **Baffin Bay sits east of Kingsville on the Texas Coast.**

Left: **Laguna Atascosa National Wildlife Refuge on the South Texas coast is one of the few places in the United States where it is possible to see an ocelot.**

changed and it was donated to the state in 1950. It stands as the only lighthouse on the Texas coast open to the public.

Restaurants and shops are nearby. Vendors along the pier offer pleasure trips out into the Laguna Madre.

South Padre Island is across the Queen Isabella Causeway on Texas Highway 100. The popular resort island has luxury as well as mid-priced hotels, white sandy beaches, dolphin-watching tours, and fishing tours.

Cameron County Park is to the right of the causeway along Padre Boulevard. The park charges an entry fee but gives you access to covered pavilions, restrooms, fishing piers, and plenty of white sandy beaches for strolling, sunbathing, or swimming.

Drive about four miles north on Padre Boulevard to the convention center. A large mural of killer whales by Robert Wyland adorns the side. Notice the row of trees nearby, planted in memory of deceased friends, relatives, and even pets. Walk along the Laguna Madre Nature Trail, a boardwalk that traverses a freshwater marsh, a saltwater marsh, and the shallow waters of the bay.

The South Padre Island Birding and Nature Center is a three-story yellow building next to the convention center and offers a gift shop, informational displays, and another set of boardwalks that cross the marsh. The birding center boardwalks connect with the convention center boardwalks.

Left: **The monument El Cristo de los Pescadores stands at the southern tip of South Padre Island in Isla Blanca Park. The monument is a tribute to people killed while fishing.**

Right: **Old City Cemetery in Brownsville has grave markers going back to the mid-1800s, including this one belonging to Pilar Garcia, who died in 1920. Many of Brownsville's early founders are buried in the cemetery.**

South Padre Island ranks with Miami Beach for drawing large crowds of college students for "fun-in-the-sun" during spring break during March. Keep that in mind if you're visiting the island in mid-March.

After visiting South Padre Island, leave via the causeway and connect with Texas Highway 48 for the drive in to Brownsville.

Head to the Historic Brownsville Museum in the Mitte Cultural District, located at 641 East Madison Street in the former Southern Pacific Depot. Freight service along the line from Edinburg to Brownsville came to the area in 1927, and a year later passenger service was added along with the station. The building is a fine example of Spanish Colonial Revival architecture. Walk around the exterior of the building and notice the elaborate carved stone and ironwork. Be sure to find the sign above the baggage room door and the Southern Pacific Line logo surrounded by ornately carved stonework next to the parking area. The inside of the museum is cool and inviting. Historic furniture fills one room and a variety of displays fill other spaces.

Tourists and locals love the wide sandy beaches at Isla Blanca Park on South Padre Island.

Walk or drive to the Old City Cemetery on East Madison between Second and Fifth Streets. The cemetery was established in 1853 and contains the graves of the founding families, merchants, and travelers. The words on the gravestones tell the history of Brownsville. Examples include a merchant who was born in Scotland, married a lady from Monterey, and eventually died in Brownsville.

The Brownsville Historical Association manages the Old City Cemetery Center at 1004 East Sixth Street. This is a great place to learn more about the history, art, and culture of Brownsville. It's fitting to visit the center before or after your visit to the cemetery. People interested in genealogy and history will love both locations.

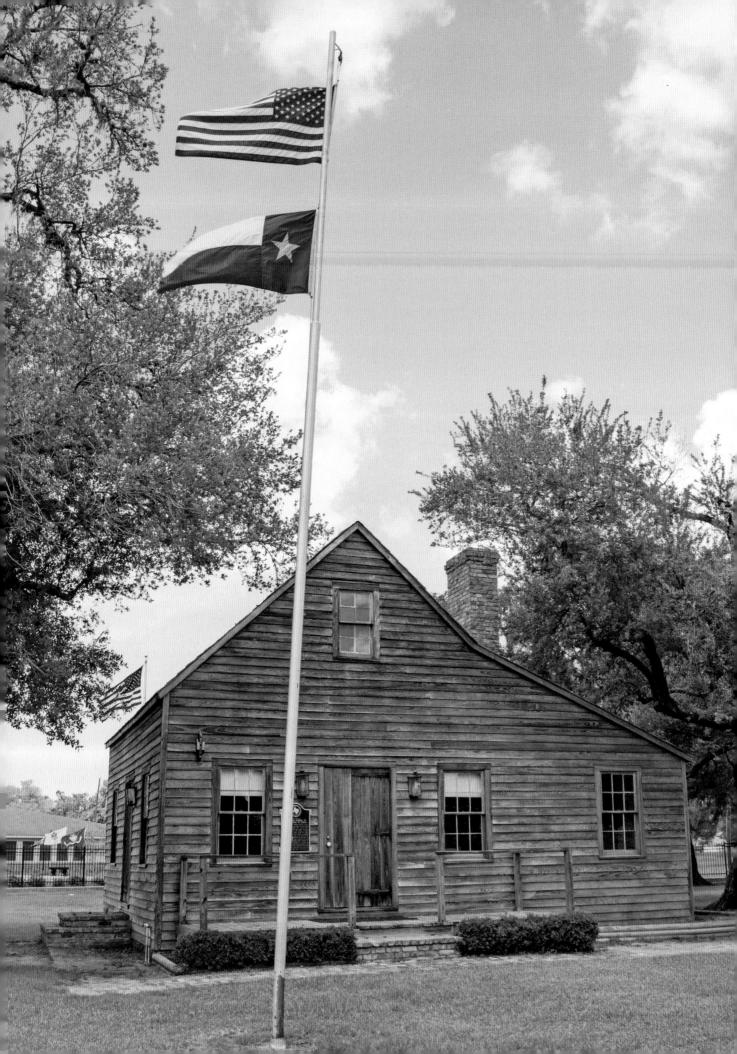

Above: **Moccasin Pond is a freshwater marsh preserved on the San Bernard National Wildlife Refuge in Brazoria County.**

Opposite: **West Columbia hosts a replica of the cabin that served as the first capitol of the Republic of Texas from September 1836 to December 1836.**

— **18** —

GEORGE RANCH to SAN BERNARD

From George Ranch Historical Park, follow Farm to Market Road 762 south until it turns into Farm to Market Road 1994 and continue 4 miles to Texas Highway 36. Drive south on Texas Highway 36 for 16 miles to West Columbia. Continue on Texas Highway 36 south for 17 miles to Jones Creek. Backtrack on Texas Highway 36 and turn west on Farm to Market Road 2611. Drive 4 miles to Farm to Market Road 2918 and then turn left on County Road 306. Approximately 90 total miles.

Four generations of Texans lived and worked on George ranch from the 1830s to the 1930s. It is now a living history park, which is a project of the Fort Bend County Museum Association and The George Foundation. Demonstrations are held four times a day (weather permitting) showing how cattle were herded, sorted, and roped. Walk through the historic homes and buildings and talk with docents in period costumes. Check the George Ranch website for events such as historical reenactments and holiday celebrations.

Leave the George Ranch on Farm to Market Road 762 heading southwest to Farm to Market Road 1994. Wind through rural Texas on Farm to Market Road 1994 until you reach Texas Highway 36. In a little more than fifteen miles, you'll reach Texas Highway 35 and West Columbia.

On October 3, 1836, the first congress of the Republic of Texas was convened in Columbia, now called West Columbia. The town sits between the Brazos River and the San Bernard River, which were major transportation arteries for early Texans. Josiah Bell founded the town in

Gulf Prairie Pioneer Cemetery, on Texas Highway 36 in Brazoria County, holds the graves of members of Stephen F. Austin's original colony. Austin himself was buried here, but his body was later moved to Austin. The cemetery was once part of the Peach Point Plantation and has the graves of the Perry family, Austin's sister's family, and other important people from the Texas Republic and Revolution.

1823. Look for the historical marker on the site of Bell's Landing on County Road 705 off Texas Highway 35 along the Brazos River where paddle-wheel boats used to land, unload cargo, and transport people.

During the fall of 1836, Sam Houston was inaugurated president of the Republic of Texas and both houses of the congress met in Columbia. A replica of the wooden building used by the congress is at the corner of Seventeenth Street and Bernard in the heart of town.

Prior to the founding of the Republic of Texas, the founding father of Texas settlements, Stephen F. Austin, worked many hours in the building at Seventeenth Street and Bernard. Austin died in December 1826 after catching a cold that turned into pneumonia. Mourners carried

his body to Peach Point to be buried in the local cemetery where Austin's sister lived. The Peach Point Cemetery is now called the Gulf Prairie Presbyterian Cemetery and can be reached by taking Highway 36 south out of West Columbia and turning right on County Road 304 before the community of Jones Creek.

The cemetery is the final resting place of many members of the Old Three Hundred, which were the settlers Stephen F. Austin brought with him to Texas. Ancient live oaks shade the graves and give the locations a serene and tranquil feeling.

Another example of historic settlements in this area is the Varner-Hogg Plantation on North Thirteenth Street back in West Columbia. The plantation combines the

Locals and visitors enjoy a meal at Dido's Seafood and Steaks on the San Bernard River. Dido's is well-known for its food and stunning view of the river.

history of three prominent Texas families—Martin Varner, an original member of the Old Three Hundred; Columbus Patton, a man made wealthy by sugar cane; and Texas Governor James Hogg.

Tour the grounds to see an antebellum mansion built with handmade bricks from local river mud. Governor Hogg's daughter, Ima Hogg, furnished the house before she donated the property to the State of Texas in the 1950s. (An old Texas joke that some took as truth was that Governor Hogg had two daughters that he puckishly named Ima Hogg and Ura Hogg. He actually had one daughter, Ima, and three sons, Will, Mike, and Tom. Ima became a Texas legend in her own right and died at the age of ninety-three in 1975.)

Return to Highway 36 south and turn right on FM 2611 at the large correctional facility. Travel approximately four miles to FM 2918. Turn left and go to County Road 306. Turn right and drive one mile to the entrance to San Bernard Wildlife Refuge.

The forty-five-thousand-acre refuge is not only remote from city life; it's also a reminder of the expansive marshlands and creekside woodlands that stretched along the coast before modern times. It's a land both harsh and serene. Harsh because of boiling summer sun, chilling winter winds, and never-ending mosquitoes. Serene because of the breathtaking view of marshes, grasslands, woodlots, and the constant array of birds and other wildlife.

Birds are abundant, particularly in spring during songbird migration and in winter when scores of hawks and thousands of ducks and geese have migrated to the refuge from northern climes. No matter the season, head along the refuge entrance road as it parallels Cocklebur Slough. You may find a bald eagle perched in one of the trees.

At just under 2 miles, you'll reach the junction for the tour loop of Moccasin Pond. Along the 3.8-mile loop, you'll find zillions of water birds, including white-faced and white ibises, black-necked stilts, great egrets and snowy egrets, common moorhens, and pied-billed grebes. Crested caracaras—nicknamed Mexican Eagles—perch in the trees bordering the marsh before making a foray to attack snakes, frogs, and small mammals.

After driving the tour loop, head to Bobcat Woods Trail about a tenth of a mile on a road opposite Moccasin Loop. The boardwalk and 1.5-mile trail through the woods along Cocklebur Slough make for a delightful stroll, but only in fall, winter, and spring. In summer, the trail requires an immense tolerance for muggy heat and hordes of mosquitoes.

The capstone experience after touring the refuge is seafood dining. Two nearby restaurants merit a visit. Dido's at 2922 County Road 519 offers dining on the patio or indoors along the San Bernard River. Fried fish and shrimp are a local favorite.

Another good food spot, 2 J's Café & Marina at 5070 County Road 469, offers down-home authentic country cooking. The outside may not be fancy, but the fried oysters and shrimp po'boys are among the best.

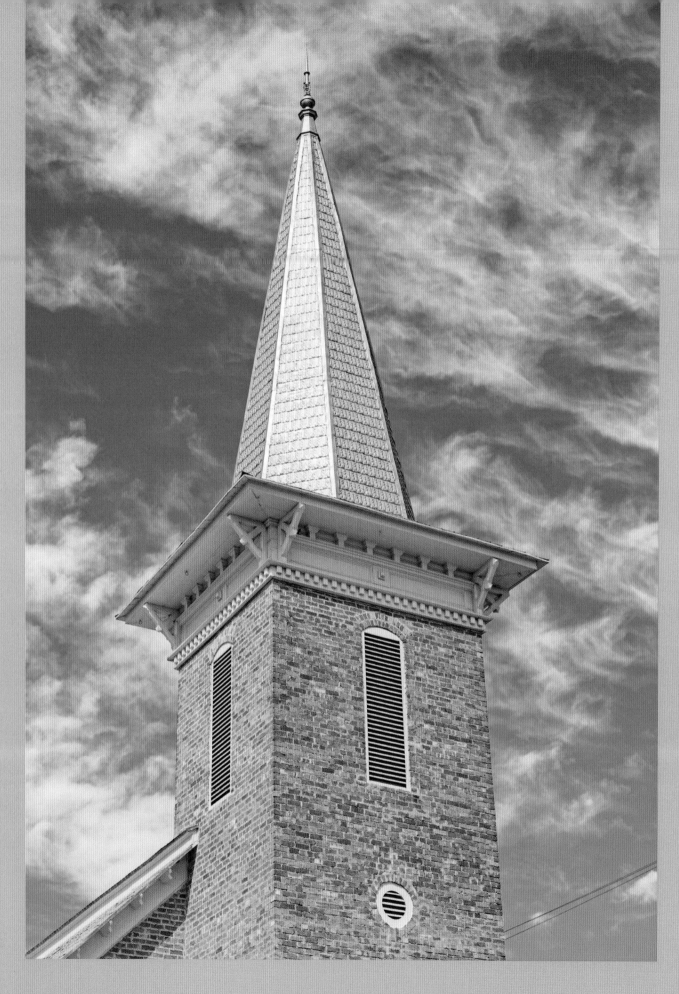

LAREDO to CARRIZO SPRINGS

From Laredo, follow Texas Highway 20 Loop for 7 miles to Lake Casa Blanca. Return to Texas Highway 20 Loop north and merge with Interstate 35/US Highway 83 north for 10 miles. Continue on US Highway 83 north for 61 miles to Catarina, then Asherton, and Carrizo Springs. Return to Catalina and drive 14 miles east on Farm to Market Road 133 to Chaparral Wildlife Management Area. Approximately 140 total miles.

In 1755, the Spanish government in Mexico granted permission for Captain Tomás Sánchez and three families to settle property near a crossing used by bands of Indians collectively called the Coahuiltecan and the Carrizo on the Rio Grande River. The Sánchez colony had cattle, sheep, goats, horses, and other farm animals. In 1767, the colony laid out the settlement for Laredo.

Cattle drives from Saltillo in central Mexico passed through Laredo the way to San Antonio and Los Adaes in modern-day Louisiana. Laredo and Eagle Pass were lucky to find themselves on the Camino Real, or Royal Road.

After Texas gained its independence from Mexico in 1836 and formed a republic, people in Laredo felt continued allegiance to Mexico and tried to resolve their dilemma by forming the Republic of Laredo, combining that part of Texas with the Mexican states of Tamaulipas and Nuevo Leon with Laredo as the capital. But the new—and probably hastily formed—republic fell apart within 283 days, and its citizens tacitly went back under Texan or Mexican rule. After Texas was annexed by the United States in 1845, Laredo officially became part of Texas under the Treaty of Guadalupe Hidalgo. Residents remaining loyal to Mexico moved across the river to form Nuevo Laredo in 1848.

Today, Laredo is a vibrant city. Four international bridges connect the city to Nuevo Laredo and Mexico. The Gateway to the Americas Bridge at Water and Convent Streets is a pedestrian bridge accommodating noncommercial vehicles. The Juarez/Lincoln Bridge at the end of Interstate 35 or San Dario Avenue is open to noncommercial vehicles.

Zaragoza Street on the west side of the Juarez-Lincoln Bridge is a good starting point for exploring historic Laredo. San Agustin Plaza offers a place to sit, enjoy the shade, and watch the world go by. Limited street parking is available along San Agustin Avenue and Flores Avenue. Webb County Heritage Foundation offers daily guided walking tours through the area.

Opposite: **First Baptist Church in Carrizo Springs, Texas, has been lovingly restored by its membership.**

THE CAMINO REAL

The Camino Real or Royal Road was in reality a series of trails as opposed to an actual road or highway. The trails connected important mining areas or sources of revenue for the Spanish crown. They changed and shifted as springs dried up or as floods washed away river crossings. Nonetheless, royal protection from the Spanish crown made the trails relatively safe for travel.

The Camino Real in Texas, a.k.a. Camino Real de los Tejas, crossed the Rio Grande at present-day Eagle Pass and Laredo. The road split and then reconnected in San Antonio. It split again outside San Antonio near Mission San Francisco de los Tejas and split again at Nacogdoches in the east Texas Piney Woods.

Spanish explorers and settlers navigated along trails originally cut by American Indians, who in turn had followed animal trails. Wagons and cattle drives eventually widened the trails, making the surface harder and more durable. In the early twentieth century, those surfaces were paved for traffic from automobiles and trucks. The Camino Real lives on today in street names such as Old Spanish Trail and Old San Antonio Road.

Left: **Pumpjack, Asherton, Texas.**

Right: **Cacti grow on top of buildings that remain from the old Fort McIntosh. The fort was deactivated in 1946, and today the buildings are part of Laredo Community College.**

Opposite: **Sunset can be stunning over the waters of Lake Casa Blanca State Park outside Laredo, Texas.**

The Republic of the Rio Grande Museum at 1005 Zaragoza is housed in one of the oldest buildings in Laredo. The structure was the capitol building for the nine-month tenure of the Laredo republic. Rooms in the museum are furnished in period furniture. Displays are filled with photos, drawings, and artifacts that bring the history of Laredo to life.

San Agustin Catholic Cathedral is across the street from the museum. The stately modern building dates back to 1872 with a steeple that towers above the surrounding trees and buildings. La Posada Hotel is within steps of the church. The hotel resembles a luxurious Spanish hacienda and is Laredo's only four-diamond hotel. The main building started as a high school in 1916 before it became a hotel. A convent standing nearby was later converted to ballroom spaces for the hotel. Stop for a meal in the dining room or use the hotel as your base while visiting Laredo. The ambiance at La Posada is outstanding.

Fort McIntosh is on the campus of Laredo Community College on Washington Street. The fort sits on the Rio Grande at the border between the United States and Mexico. It was established in 1853 to protect the border and was decommissioned only after World War II. Park in a visitor's parking space along Sheridan Road. A pedestrian promenade is in front of the old commander's quarters, used today by the president of Laredo Community College. The noncommissioned officers' quarters, built in 1925, serve as campus housing for students. In fact, many of the

buildings from the days when this was an active fort have been turned into buildings for college space. Although the campus is quite active, parking space is generally available. If you're visiting when the classes are not in session, listen to the sounds of everyday life coming from Nuevo Laredo on the other side of the river. The two cities are closely tied by family life as well as commerce.

Lake Casa Blanca International State Park is on the eastern edge of Laredo at 5102 Bob Bullock Loop. The shallow lake offers a place to watch birds, fish, boat, walk, or just enjoy the view. Regular bird walks are offered and include a chance from May to September to see white-collared seedeaters, extremely rare in the United States. It's also possible to see Texas horned lizards, or "horny toads," black-tailed jackrabbits, and Mexican ground squirrels.

Exit the park and connect on US Highway 83 to Catarina. The two-lane highway has wide shoulders and passes through south Texas brush country. The dense mass of mesquite, wild olive, and desert yaupon seems to extend to the horizon. The highway crests an occasional hill that gives an uninterrupted view in all directions.

Have your passports ready if you are a non-US resident as you approach the US immigration checkpoint on this highway. US citizens only have to answer a few questions and are then allowed to travel on their way.

In the winter, it's common to see red-tailed hawks and American kestrels on the power lines along US 83. These are winter migrants that come to Texas to feed on rodents and

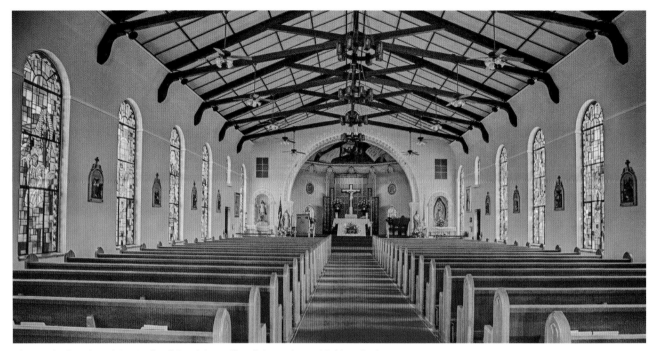

Above: **The interior of Our Lady of Guadalupe Church is modern with historical accents.**

Opposite: **Our Lady of Guadalupe Church stands on a hill at the top of Sixth Street in Carrizo Spring, Texas. The church was built in 1949.**

small birds. In the summer, look for scissor-tailed flycatchers. Roadrunners are common anytime of the year along the grassy shoulder of the road. Watch for a large, messy nest in one of the smaller roadside trees in early spring. The nest might have great horned owls raising young.

Catarina was a stop on the Asherton & Gulf Railway in 1910 that gave area ranchers a way to ship their cattle to market. An expansive mansion-turned-hotel, built by the brother of President William Howard Taft, once stood in town. Today the community has two service stations, each carrying food that is typical of convenience stores. Palm Suite and Inn on the edge of town makes a popular hamburger.

Asherton is the next community along US 83. The town once had one thousand people, thanks to the Asherton & Gulf Railway. Before the Great Depression, it was famous for onion agriculture. The Asher Richardson House is an example of the prosperity that once defined the community. The house is a private residence, so please respect the owner's solitude.

Once you reach Carrizo Springs, stop in at the Dimmit County Chamber of Commerce that's located in the historic jail building at 103 North Sixth Street. The friendly staff can point you to restaurants or lodging in the area.

The historic First Baptist Church is nearby at North Seventh and Houston Streets. The red brick building with a towering silver steeple has been lovingly restored.

Our Lady of Guadalupe Catholic Church crowns the top of Sixth Street. The building has two red domes. Each dome has a cross on top. The church was built in 1949. Windows inside the sanctuary depict the appearances of the Virgin Mary to Mexican peasant Juan Diego in 1531. Nuestra Señora de Guadalupe, or Our Lady of Guadalupe, is a popular symbol for Mexican Catholics.

Return to US 83 and drive south to the intersection with Farm to Market Road 133. Turn on Farm to Market Road 133 and enjoy the drive to the Chaparral Wildlife Management Area.

The gates to the Wildlife Management Area have beautiful ornamentation with iron animals and birds across the top. The 15,200-acre reserve is a research facility monitoring wildlife habitat as it grows back from a history of farming and ranching.

College students and scientists conduct research on the property. School children visit to learn about nature in their backyard. The public is allowed to visit from April to August. Events and additional open dates happen throughout the year. Information about access is available on the website.

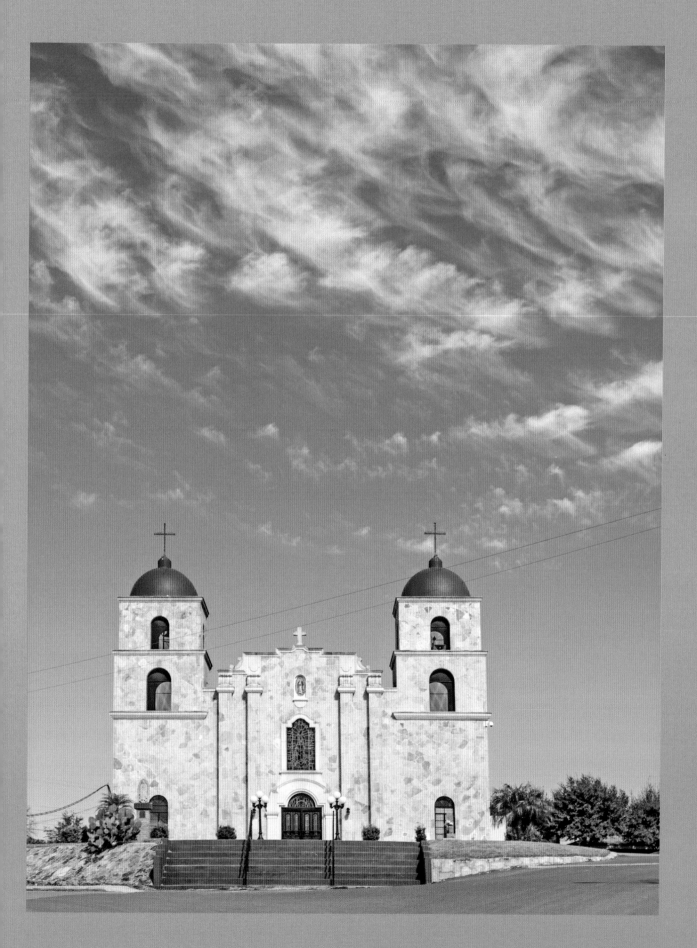

PART VI

SOUTH TEXAS PLAINS

Mile markers to cities such as Seattle and Mexico City decorate a windmill outside the Outback Oasis Motel in Sanderson, Texas.

Alternatively called the Rio Grande Plains and Tamaulipan Brushland, the South Texas Plains blanket roughly twenty million acres south of the Hill Country to the border with Mexico and along the Gulf of Mexico. The rolling terrain of grasslands and thorn bushes, such as mesquite and acacia, extends into the diverse plant communities of the Rio Grande Valley, which is a river delta extending a hundred miles from Laredo to Brownsville. Land elevation goes from sea level to about one thousand feet, with Gulf of Mexico breezes wafting over the semi-arid to semi-tropical terrain. Prior to the twentieth century, the land abutting the river delta was an expansive savannah of incomparable grasslands that attracted cattle ranches such as the legendary King Ranch. Due to decades of cattle grazing, the vast savannahs are no more. But vast vistas still dominate the region.

It's a land of abundant wildlife, from white-tailed deer to javelinas (actually, peccaries that look like hogs), bobwhite quail, white-winged doves, and the endangered Texas horned lizard (often called a horny toad.) Ocelots once were common prowlers among the brushland, but now they are rare.

The Rio Grande Valley is a subtropical, humid, ecological wonderland unlike any other place in North America and reaching farther south than any other place in the continental United States save for parts of Florida.

When the Spanish explorer Alonso Àlvarez de Pineda arrived on the scene in 1519, he named the region Rio de las Palmas, meaning River of Palms, because a grand palm forest stretched upriver from the mouth of the Rio Grande. Specifically, the trees are now known as Texas sabal palms and they once stretched about seventy miles upriver from the mouth of the Rio Grande. But the palms succumbed to the plow because the fertile soil and long growing season ultimately gave rise to crops, especially citrus crops. The last grove of Texas sabal palms is at the Audubon Society's Sabal Palm Grove near Brownsville. (Note: the tall Washingtonian palm trees, an imported palm, are what line avenues and neighborhoods instead of sabal palms.)

Nonetheless, the Rio Grande Valley is a diverse biological system with trees such as palo verde, ebony, bald cypress, pecan, and Rio Grande ash accenting the river plain. With such plant diversity comes diverse birds, some of them like the resplendently colorful green jay occurring nowhere else in North America. Birds such as the raucous and bright brown-and-yellow greater kiskadees are common. Bird-watchers across North America flock, pardon the pun, to the valley for its unparalleled bird life.

Towns along the valley reach deep into Texas legends and history and brim with the joyfulness of Hispanic culture. The towns are eminently safe and friendly.

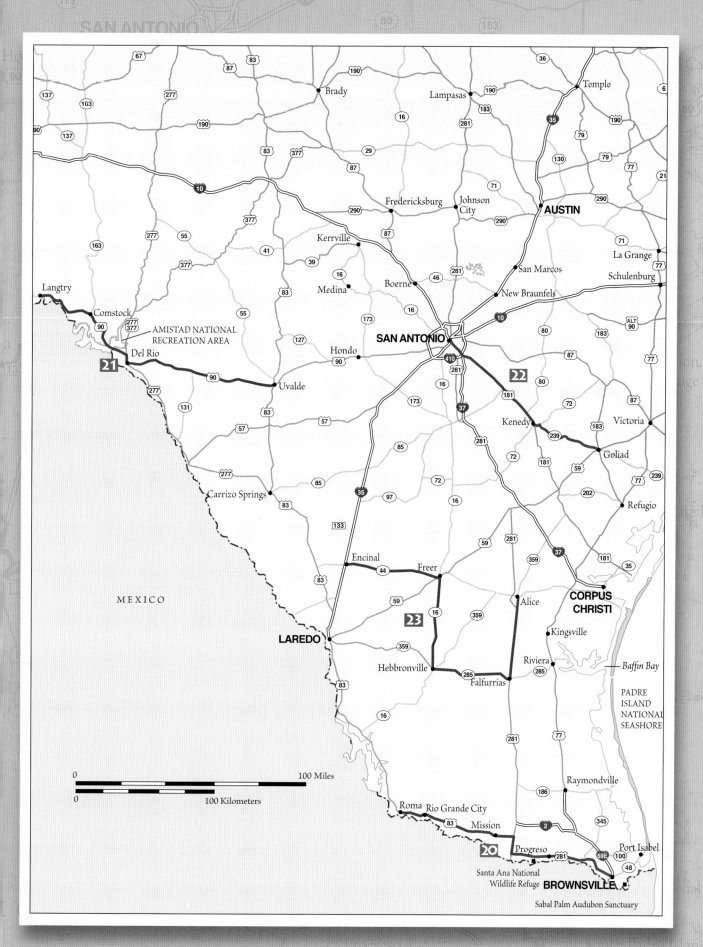

Above: **Queen butterfly (*Danaus plexippus*) on Mexican milkweed.**

Opposite: **Citrus is an important part of the economy in the Rio Grande Valley. A roadside vendor offers a look at a ruby red grapefruit.**

20

BROWNSVILLE to ROMA

From Sabal Palm Audubon Sanctuary, navigate through Brownsville to US Highway 281 north. Drive on US Highway 281 for 45 miles to Santa Ana National Wildlife Refuge. Backtrack on US Highway 281 east for 10 miles to Farm to Market Road 88. Drive north 5 miles to US Highway 83 Business for less than a mile to South Border Avenue. Return to US Highway 83 Business and drive west to North Raul Longoria Road. Drive 7 miles north on Raul Longoria to the Edinburg Nature Center. Navigate to Interstate 69C and drive south to Interstate 2 west then continue to Texas Highway 336/South Tenth Street. Exit on Texas Highway 336/South Tenth Street and drive south less than a mile to Quinta Mazatlan. Return to Texas Highway 336 and drive south 5 miles to US Highway 281 spur, turning left on North First Street, then left onto South Second Street. Return to US Highway 281 and west to South Twenty-Third. Drive north on South Twenty-Third for 5 miles to Interstate 2 west/ US Highway 83. Drive 6 miles and exit US Highway 83 Business. Drive west for less than 2 miles then turn south on Farm to Market Road 2062. Bentsen is 2.5 miles ahead. Return to US Highway 83 west. Drive west 30 miles to Rio Grande City. Continue west on US Highway 83 for 13 miles to Roma. Approximately 170 total miles.

The last one hundred miles of the Rio Grande River slowly meanders through a lush tropical plain. Texans call this region the Rio Grande Valley, or the Valley for short. The term defines a vast river plain that slopes toward the Gulf of Mexico from the rolling hills of Laredo. The fertile soil in the valley once produced some of the largest and

Above: **The Old Hidalgo Pumphouse is owned by the city of Hidalgo. The Pumphouse was opened as a museum and nature center in 1999.**

Opposite: **Washingtonian palms tower above Quinta Mazatlan in McAllen, Texas. The home and grounds date back to the late 1930s. Today the home is a museum and event space.**

finest citrus crops in the nation, but a devastating freeze in 1983 killed more than 50 percent of the citrus trees. Another damaging freeze in 1989 left most valley citrus crops in ruin, and only a fraction of the former citrus groves remains with much of the once-fertile cropland having been replaced by urban development in a now-burgeoning and diverse economy.

Tropical breezes from the Gulf of Mexico bathe the valley in warm moisture, creating an area of diverse tropical vegetation such as honey mesquite, ebony, acacia, and huisache. Along the river, the valley's remnant stands of tropical jungle are home to an array of unique birds and butterflies that in turn attract naturalists and tourists from all over the world.

Bird-watching and butterfly watching are big sports in the valley. No wonder, because even the casual tourist will be enchanted by birds such as the ostentatious green jay and the raucous chachalaca. And who can resist the charm

of gorgeous butterflies such as the zebra longwing and white peacock feeding on mistflower. Avid bird-watchers and butterfly watchers come to the valley for the thrill of finding a rare species in the United States. The valley is therefore a place of high adventure for naturalists but equally great fun for average tourists in search of wildlife quite different from what they normally see in their local city and state parks.

Places to enjoy the valley's unique natural wonders include the Sabal Palm Audubon Center and Sanctuary near Brownsville. This 527-acre refuge protects a remnant forest of native sabal palms. The sanctuary's new educational facility is housed in the historic Rabb Plantation House. A resaca meanders beneath a dense canopy of sabal palms and tangled vines. Throughout this lush arena, you'll find a multitude of birds, butterflies, and tropical plants throughout the year. Guided tours are offered.

BENTSEN-RIO GRANDE VALLEY STATE PARK

Years ago, the park was a favorite location for what are called "winter Texans," people traveling from northern states in recreational vehicles to hook up at trailer sites and stay for weeks at a time. Bird-watchers from around the world arrived and drove round and round through the park looking for unusual birds. However, intense vehicular traffic and visitor pressure in the park contributed to the deterioration of trees and vegetation. Dams along the river deprived the park of life-sustaining water from natural floods.

So the Texas Parks and Wildlife Department closed the park to vehicular traffic and camping, but built a beautiful facility just outside the park from which people may walk into the lush forest or take a tram.

Numerous woodland trails, as well as original vehicular roads, meander through the park, and a two-story observation tower provides a bird's-eye view of the forest and a large resaca (an oxbow from the Rio Grande River).

The Santa Ana National Wildlife Refuge is seven miles south of the Alamo on Farm to Market Road 907. It's a two-thousand-acre subtropical forest bordering the Rio Grande and surrounded by agricultural fields. The refuge is home to an abundance of birds, butterflies, and mammals. You could spend hours walking the trails in the forest. Watch for hummingbirds at the feeders by the visitor's center. The refuge is home to rare North American mammals such as the ocelot and jaguarundi. If you walk quietly in the early morning or late afternoon, you might catch a glimpse of one of these princely creatures.

The Valley Nature Center at 301 South Border Avenue in Weslaco is a forested oasis in a suburban neighborhood. It's a small, six-acre park with sabal palms and other trees and shrubs native to the area. It has a new state-of-the-art visitor's center. Great kiskadees abound in the park, along with other valley specialties such as green jays and Altamira orioles. Look along the ground for the Texas tortoise.

The Edinburg Scenic Wetlands Center located at 714 Raul Longoria in Edinburg has a stunningly designed building that houses computer-aided bird and butterfly instruction, a gift shop, and a lecture hall. The surrounding forty acres are landscaped for butterflies such as the white peacock and for water birds such as least grebes and green kingfishers. Watch for directional signs because vegetation in the parking lot can get thick.

Quinta Mazatlan center is a restored 1935 Spanish Revival–style mansion in the heart of McAllen at 600 Sunset Drive that offers ten acres of walking trails through a forest of trees such as palm, Texas ebony, and wild olive. Sculptures of native wildlife adorn the trails. White-tipped doves abound, as do golden-fronted woodpeckers and an occasional flock of red-crowned parrots.

The Old Hidalgo Pumphouse at 902 South Second Street in Hidalgo is an innovative attraction. The pumphouse was instrumental in bringing irrigation to agriculture of the area in the early twentieth century. The building aged along with the machinery in it. Rather than let the building rot, the community decided to turn the old facility into a museum and the grounds into gardens. Enjoy the native plants around the parking lot and walkways. Then head inside for a tour of the building. Organized tours include a movie about the history of the pumphouse and a walk around the old boilers and pumps. Longer tours include a trip to the Rio Grande for a view of the modern intake pipes and pumps. History fans and gadget lovers will enjoy the pumphouse and the tours.

The headquarters at Bentsen-Rio Grande Valley State Park in Mission, Texas, are modeled on the classic Texas farm concept with tin silos; elongated, arched-roofed buildings surrounded by water ponds; butterfly gardens; native shrubs and trees; and, of course, bird feeders. Inside

Opposite: **La Borde House Hotel on US 83 in Rio Grande City, Texas, offers a chance to stay in a historic hotel with antique furnishings.**

A mural on Convent Street in historic Roma, Texas, pays tribute to the Caballeria de Cristo, or Cavalry of Christ, who rode on horseback through the Rio Grande Valley in the early 1900s. The mural is based on a photo taken in 1911.

the buildings are lecture halls, exhibit halls, and even a coffee bar and gift shop. Nature's architecture in the park is a lush Tamaulipan forest of cedar elm, Rio Grande ash, Texas ebony, and other native plants that once spread all across the valley.

More than five hundred species of birds have been recorded in the valley, more than half of all the species in North America. Some of those birds with tropical colors, such as the green jay, great kiskadee, and ringed kingfisher, characterize the entire area, but you may easily see them here at the 760-acre state park.

Drive upriver on US Highway 83 to Rio Grande City. The journey travels through one little community after another with Spanish names. Stop and eat some enchiladas or fresh tortillas. Buy some locally grown citrus from a roadside vendor. The people of the Rio Grande Valley are among the friendliest you could meet. Rio Grande City has all the comforts of a large city and in the middle of town is a historic fort. From US 83, turn on Lee Circle behind Ringgold Elementary School where you'll find Fort Ringgold. Tell the guard that you want to visit the fort, and you'll be waved through.

The Rio Grande School District bought the fort property in 1949, so you may notice educational activities. Park your car in the area of Lee House at the fort.

General Robert E. Lee spent some time in this house, as did General John J. Pershing. From the porch of the Lee House, the generals could see into Mexico. The fort

was built in 1848, two years after Texas joined the United States, to protect the border from Mexican raiders. The Rio Grande City Tourism and Heritage office offers twice-daily tours of historic Rio Grande City and Fort Ringgold Monday through Friday. The guides on these trips are knowledgeable and offer a good opportunity to learn about the city.

La Borde House is a restored hotel at 601 East Main in the historic heart of Rio Grande City. Rooms in the hotel are filled with historic antiques offering a chance to see what it felt like to stay in this hotel when it was built in 1899.

For a good meal, stop at Che's Mexican Cuisine that shares space with the hotel.

At the top of Britton and Fourth Streets is the Starr County Courthouse as well as a linear plaza that extends four blocks along Britton Avenue. Sit on one of the benches in the plaza and enjoy the view.

After your visit to Rio Grande City, continue on US 83 toward Roma.

In Roma, turn on Lincoln Avenue in the heart of the town's historic district. Lincoln ends at a brightly colored building that offers a viewing platform in back. From the platform, you can see the Rio Grande from horizon to horizon. The international bridge is in view as is Ciudad Miguel Alemán on the Mexican side of the border. Don't be alarmed if fishermen or locals on the other side yell "Hello." Yell "Hello" back!

Around the block is Convent Avenue. Historic buildings line the street. Notice that the wrought-iron balconies are similar to what you might see in New Orleans. River trade was common between the two cities in the past.

Our Lady of Refuge church sits at the top of the street, and city hall is at the bottom. If the birding center is open, stop in and say hello.

21

UVALDE to LANGTRY

From Uvalde, follow US Highway 90 west for 40 miles to Historic Fort Clark. Drive 31 miles on US Highway 90 west to Del Rio and another 9 miles to Amistad National Recreation Area. Continue on US Highway 90 west for 22 miles to Comstock. Drive another 28 miles on US Highway 90 west to Langtry. Approximately 132 total miles.

The people of Uvalde want everyone to know that their community is the "City of Trees," an evident fact as travelers approach the center of town on US Highway 90. Pecan and oak trees tower over the highway, creating a tranquil atmosphere to the town. All roads in Uvalde lead to the old town plaza. Historic buildings surround the plaza dominated by the Uvalde County Courthouse, a showcase of Texas Renaissance–style architecture built in 1927. The Grande Opera House on the northeast corner dates to 1891. Theatrical and musical productions are still hosted in the theater that has an ornate metal

Right: **Fort Clark Springs in Bracketville, Texas, was established by the US Army in the early 1850s. Today visitors can stay in restored officer's quarters and troop barracks.**

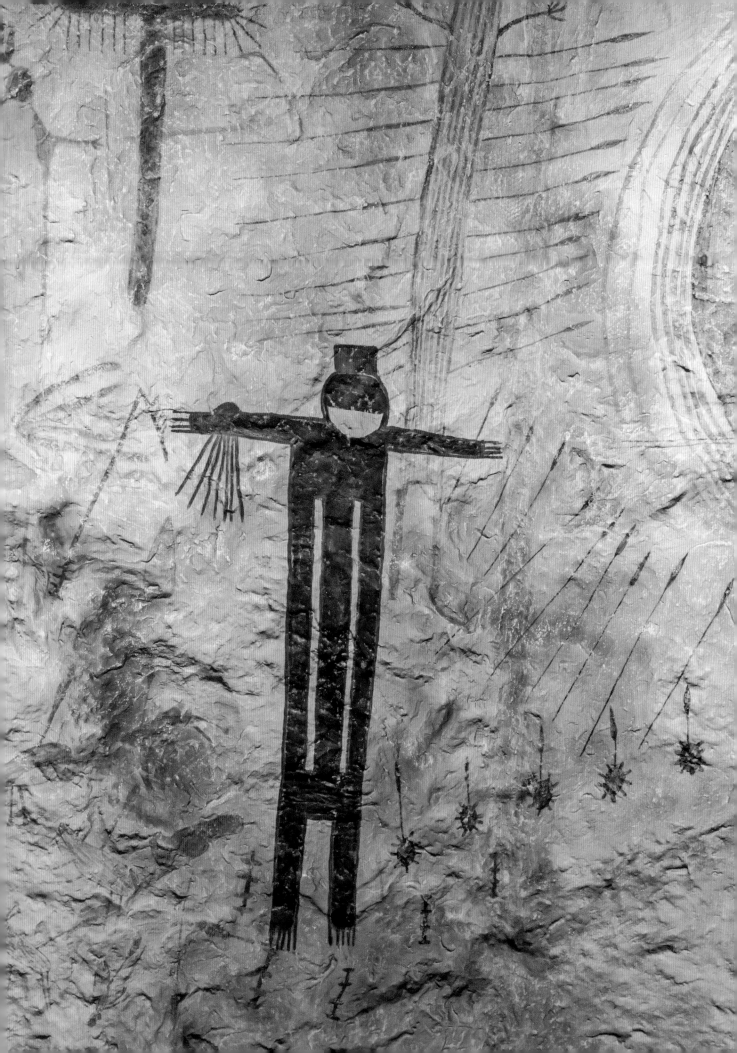

Above: **Lake Amistad, west of Del Rio, is a lake shared by Texas and Mexico.**

Opposite: **The displays inside Seminole Canyon State Park explain and illustrate how people lived in the area hundreds of years ago. Cave art from deep in the canyon is recreated inside the park's visitor center.**

roof and dragon on top of the steeple. Stop in and have a look at the historic photos lining the walls.

No visit to Uvalde is complete without a driving tour through the historic district where all the early streets were laid out in a grid pattern with four plazas. Stately homes on Park, High, Getty, and Main Streets, built in the late 1800s and early 1900s, are an indication of the wealthy farming and ranching families that settled in this area. The home owned by John Nance Garner, Franklin D. Roosevelt's first vice president, now houses the Briscoe-Garner Museum on 333 North Park Street.

Water has sustained Uvalde and the surrounding county throughout its history. Because of the abundant water, people have farmed pecan trees and vegetable crops and raised beef and goats for more than 150 years.

Continue along US 90 to Brackettville and Historic Fort Clark. At the guard station, the attendant will ask if you're a resident or visitor. People who visit the fort include community residents and those entering for the golf course.

Pay the small entrance fee and drive to the visitor's center on the right to begin a walking or driving tour of the fort.

Hundreds of years ago, Comanches were drawn to this area by water gushing from a natural spring. Anglo settlers displaced the Comanches and established ranches. In 1852, the US military leased land from one of the ranchers and built the fort, which included a hospital. The town of Brackettville, named for Oscar Brackett, developed around the fort.

Seminole–African American scouts, who once protected the border for Mexico, came to the fort in 1872 to scout for the US Army. Thanks to the knowledge of these scouts, raids by Comanches, Kickapoos, and Lipans ended in 1881. The Ninth and Tenth units of African American soldiers, called "Buffalo Soldiers," were stationed at the fort.

Fort Clark was decommissioned in 1944 when a modern, mechanized army replaced the need for the fort and its once-glorious horse cavalry. The government sold the fort to Brown and Root Company of Houston that used the

property as a guest ranch. In 1971, the fort was purchased by a development company and turned into a private resort.

Today, people visit Fort Clark for amenities such as its swimming pool that stays at 68°F throughout the year. There's golfing, nature trails, and lodging.

Ask for a walking tour map at the visitor's center. Highlights include a log house built in 1854 and eight duplexes built in 1874 that make up the officers' row quarters. General Patton lived in the staff officers' quarters when he was a colonel at Fort Clark in 1938.

Return to US 90 and drive to Del Rio. Del Rio is home to Laughlin Air Force Base and is a bustling city with a variety of hotels, restaurants, and stores.

Continue through Del Rio to Lake Amistad and the Amistad National Recreation Area.

Amistad means "friendship" in Spanish. The lake was created to bring a steady supply of water to residents on both sides of the border, plus watersports, camping, hiking, and bird-watching.

Boaters can access an amazing seventy-four miles of the Rio Grande, plus the Devil's River and Pecos River. Fishing from the lake banks is allowed with a valid fishing license. Fishing, scuba, and river guides are licensed through the park service and authorized to operate on the lake. Paddlers have a series of water trails around the lake.

Whatever your passion, there is something of interest at Lake Amistad. The National Park Service provides information about the sixty-thousand-surface-acre park through a headquarters building at 9685 US 90 West.

Seminole Canyon State Park is on US 90 after the small town of Comstock. The park preserves some of the best remnants of rock art produced by wandering tribes as far back as seven thousand years ago. The park is the guardian of these works of art and offers guided tours daily. For those not physically able to make the hikes, re-creations of the ancient rock art are featured in the visitor's center. The center is filled with displays about Mexican and European

The Uvalde County Courthouse, in Uvalde, was built in 1927.

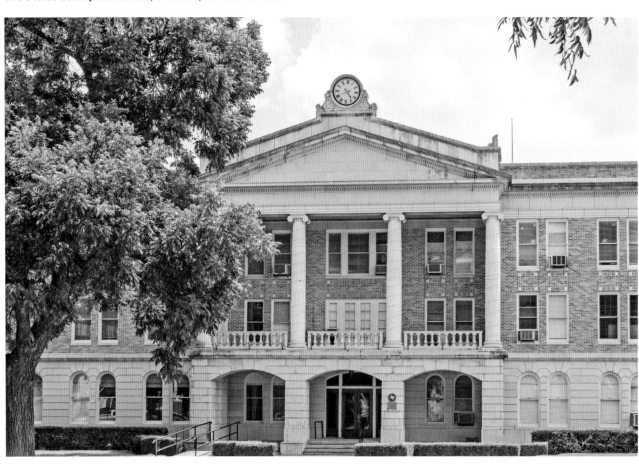

Left: **The Pecos River Bridge spans the Pecos River along US 90 west of Del Rio, Texas.**

Right: **The Judge Roy Bean Visitor Center in Langtry, Texas, is an educational and fun place to visit along US 90 between Del Rio and Sanderson.**

settlers to the area, as well as the natural history. A gift shop offers plenty of incentives to spend money. The park offers camping and picnicking.

Continue along US 90 to the Pecos River Bridge. An overlook is available from a high bluff on the northeast end of the bridge. There's also a parking area at the foot of the bridge before it spans the river.

The Pecos River has cut a deep channel through layers of limestone at this location. Travelers once crossed the wide river via a bridge built in 1923 that was near the water level. Floods frequently washed away the bridges, leading to construction of the current bridge in 1954. The bridge is 1,310 feet long and stands 273 feet above the river.

Park your car on the high overlook above the Pecos. Look downriver to see the Rio Grande where the two rivers meet. Notice the silence, save for an occasional vehicle on the highway or a bleating goat.

Continue the journey along US 90 West and enjoy some of the most spectacular road cuts in the country. To make the highway, workers sliced through layers of limestone and clay laid down during the Upper and Lower Cretaceous period when the land was an inland sea. Marvel as layers laid down by calm seas, shown in russet, abruptly change into layers laid down by turbulent seas, shown in white. What a snapshot of Earth's geologic history so close in view.

Pull into Langtry and stop at the Judge Roy Bean Visitor's Center operated by the Texas Department of Transportation. Helpful staff will talk to you about things to see in the area. Restrooms are in the building. Outside, you'll find gardens with native plants labeled as to the names.

A replica of Judge Roy Bean's courthouse and Jersey Lilly Saloon stand in the gardens. Roy Bean was one of those larger-than-life characters who found a place in the booming and lawless desert Southwest. His life is told more in myth than in fact, but he was certainly a colorful character. He lived in Mexico, California, and New Mexico before settling in San Antonio, Texas. Probably avoiding a creditor or some other kind of mischief, he crossed the Pecos and settled in this small community that was coming to life thanks to the railroad.

Bean got himself elected justice of the peace and established his "law west of the Pecos." The English singer Lillian Langtry was a long-distance and one-sided love affair for Bean, so he named his saloon and opera house the Jersey Lilly. Inside the visitor's center are artifacts from Bean's day, including his law book and a letter from Lillian Langtry.

A shop across the street from the visitor's center serves ice cream, much welcomed on summer days.

ALAMO to GOLIAD

From the Alamo, follow the Mission Trail for 3 miles to Mission Concepcion. Drive on Stevens Avenue and then south on South Presa Street to Mission San Juan. Drive south along Villamain Road to Mission San Francisco de la Espada. Navigate to Interstate 410 east and turn south on Interstate 37. Drive 1.5 miles and exit to US Highway 181 east. Drive 47 miles to Kenedy, connecting with Texas Highway 72 east and then Texas Highway 239 south. Drive 31 miles to Goliad. Approximately 100 total miles.

This tour starts at the Alamo on Alamo Street in downtown San Antonio and ends at Goliad State Park in Goliad. In between are historical buildings, green spaces, residential neighborhoods, and open roads.

Spain established missions in the 1700s in the land north of the Rio Grande River. The missions, with the church as the main focus, were actually settlements lining the trade route from Mexico City to the northern frontier in Texas. Settlers planning to become citizens of Spain were required to convert to Catholicism, and the missions therefore served religious conversion needs of prospective citizens, as well as serving as way stations for commercial trade.

The building we call the Alamo began its life back in 1744 as a mission when the cornerstone was laid for a church at San Antonio de Valero. However, the mission was secularized in 1793 and became a Spanish military post called the Alamo ten years later. The Mexican independence movement began a tumultuous time in 1811 up until Mexico gained independence from Spain in 1821. Mexico's citizens in Texas of both Anglo and Mexican descent called "Texians" grew weary and angry under Mexico's rule in the years leading up to 1836 when they engaged the Mexican Army in a series of skirmishes.

The Mexican Army under General Santa Ana arrived in San Antonio in early 1836 to squelch the uprising. The Texians retreated inside the protective walls of the Alamo in late February of 1836. Texas declared its independence from Mexico on March 2, 1836. Four days later, the Mexican Army laid siege to the Alamo. At dawn thirteen days later on March 6, the army broke through the Alamo walls, killing about two hundred Texian fighters but sparing the women, children, and two African American slaves. The Mexican Army lost at least six hundred men during the siege and subsequent sacking of the Alamo.

The Mexican Army moved on to the east, leaving the Alamo behind, but not its legacy. "Remember the Alamo"

became a battle cry for Texas independence and a symbol of a Texas spirit that would live on.

The Texians defeated the Mexican army at the Battle of San Jacinto in 1836, and the Republic of Texas became an official independent nation. The new Republic donated the Alamo mission buildings to the Catholic Church in 1841. But after Texas became part of the United States, the US military leased the buildings from the church,

Mission Concepción, part of the San Antonio Missions National Historical Park, displays a simple interior. The mission was dedicated in 1755.

The Alamo, a symbol of Texans' spirit and determination, is dwarfed by the buildings of downtown San Antonio. The building that began life in 1744 is now a major tourist attraction administered by the Texas General Land Office.

made repairs, and added the façade that we see today on the outside of the Alamo. The military, Catholic Church, and local community battled over ownership of the Alamo until the Daughters of the Republic of Texas became custodians in 1905. In 2015, UNESCO named the Alamo a World Heritage Site. The Alamo is now under the control of the General Land Office of Texas.

Walk around the Alamo, touch the walls, and sit in the quiet sanctuary of the chapel. Tour the gardens and view the displays to learn about this icon in Texas history.

The Mission Trail driving tour leaves the Alamo and heads south toward more history and stunning architecture. The route along Alamo Street to South St. Mary's Street and to Mission Road is clearly marked. (If you lose your way, look for street signs with the words "Mission Trail" written across the bottom edge.)

Mission Concepción was dedicated in 1755. The building hasn't undergone extensive restoration, but it still has a commanding presence. Notice how local citizens use the expansive grassy lawn around the church for picnics or playgrounds for their children. The National Park Service has a small visitor's center on the grounds.

Continuing along the mission trail, you'll find a larger visitor's center at Mission San José. The mission, named for Saint Joseph, was completed in 1782. It is the largest mission on the trail and is the best-restored with a breathtaking façade around the main entry to the sanctuary. Services are still held in the church.

Mission San Juan, the next stop on the mission trail, was completed in 1756. The tower, called an *espadaña*, houses three bells and overlooks the surrounding parkland and residential houses. Some buildings around the church have been restored, but many have been left unfinished. It's interesting to be able to walk inside the buildings to see how they were constructed more than two hundred years ago.

Mission Espada is the next on the mission trail. The church was finished in 1756 and displays another three-bell *espadaña*. Nearby, the Espada Aqueduct carries water from the San Antonio River to nearby agricultural fields. This aqueduct brought life-giving waters to the arid fields

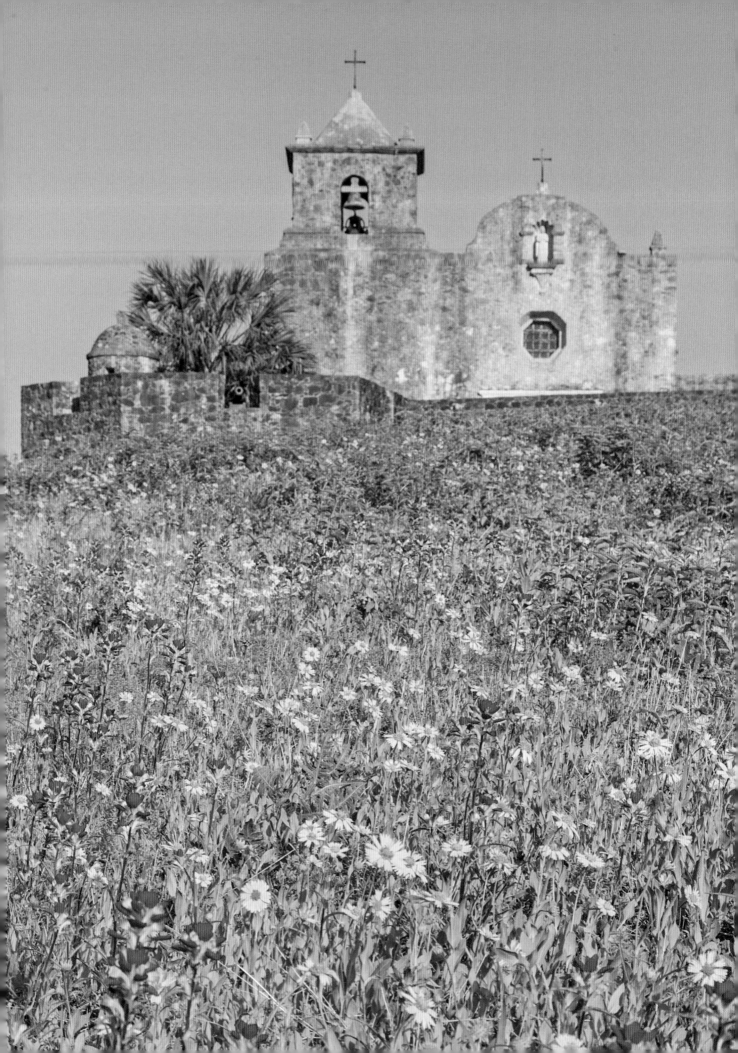

Above: **The Brooks County Courthouse in Falfurrias, Texas, was designed by Alfred Giles in 1914 in the Classic Revival style.**

Top left: **The Mission Espíritu Santo is located at Goliad State Park and Historic Site near Goliad, Texas. Also called Mission Nuestra Señora Del Espíritu Santo de Zuñiga, the mission was founded in 1722 to protect Spanish holdings. The buildings were restored between 1936 and 1939.**

Top right: **Mission San Juan was completed in 1756. The three bell tower, or** *espadaña*, **towers over the surrounding park land and residential houses. Buildings around the church have been restored, but many have been left unfinished.**

Opposite: **The Presidio La Bahía at Goliad State Park and Historic Site was built in 1749 to protect Spanish missions in the area.**

around the mission in the 1730s and has been in continuous use ever since.

To reach Goliad, leave San Antonio on US Highway 181 south and connect with Texas Highway 239 in Kenedy.

The Presidio Nuestra Señora de Loreto de la Bahía is located on US Highway 183 on the outskirts of Goliad. Spain, Mexico, the Republic of Texas, and the United States have used the presidio, or fort. It was constructed in 1749 and is a well-preserved example of a Spanish military outpost.

Park your car and walk around the fort. This facility anchored surrounding settlements in the eighteenth century offering protection as well as stability. Battles were fought here as Mexico fought for independence from Spain from 1810 to 1821. More skirmishes occurred when the Texians tried to gain their independence from Mexico in 1836.

The National Park Service manages the presidio. Events including historic reenactments are held throughout the year by a group of dedicated volunteers. The museum inside the Presidio has artifacts as well as informative displays.

Goliad State Park is a block away on US 183. The Mission of Nuestra Señora del Espíritu Santo de Zuñiga is a replica of the building that stood here in 1749 and was built by the Civilian Conservation Corps in the 1930s. It was a religious outpost in the mid-1700s but also an important cattle ranch. People up and down the mission trail needed food, and the mission was a major supplier. The famous Mexican general Ignacio Zaragoza was born nearby in 1829. A replica of his birth home stands nearby on the banks of the San Antonio River.

Excellent historical information is provided throughout the park. Bluebonnets, the state flower of Texas, are common throughout the grounds in March and early April.

23

ENCINAL to ALICE

From Encinal, follow Texas Highway 44 east for 47 miles to Freer. Drive 40 miles south on Texas Highway 16 to Hebbronville. Drive on Texas Highway 285 east for 35 miles to Falfurrias. Drive on US Highway 281 north for 38 miles to Alice. Approximately 160 total miles.

This route begins in Encinal along Interstate 35 north of Laredo and south of San Antonio. The country is Texas brushland mixed with farmland.

Leave the interstate and travel east on Texas Highway 44. Right before the Webb County line, notice a decorative iron fence stretching for about a mile. The fence is old and rusted, but it is decorated with golden crosses, horseshoes, and Texas stars. A large ranch gate along the fence has the same adornments plus a large Our Lady of Guadalupe symbol.

Enjoy the driving along Highway 44 to Freer. Traffic is sparse on the two-lane road with a mowed shoulder to make driving fun and easy.

Freer sits in Duval County. The commerce of Freer centered on ranching and farming until oil was discovered in 1928. The town boomed but had no paved streets, potable water, or sewage system even ten years later. Today, there are hotels and places to eat.

Exit Freer on Texas Highway 16 and once again enjoy a drive along the open highway through brushland.

Stop at Hebbronville, the county seat of Jim Hogg County. The county was named for Texas Governor James Stephen Hogg. Hebbronville was named for ranch owner James R. Hebbron. In 1883, the Texas Mexican Railroad came through the area.

Our Lady of Guadalupe Church is located at 504 East Santa Clara. The church is covered with a pink stone façade and topped with two bell towers. The rest of the building is lime green with a copper-covered dome over the church altar. Inside, leaded glass windows are modern and striking in their intense colors of green and blue.

Scotus College is adjacent to the church on grounds that are quiet and peaceful. The college moved to Hebbronville from Mexico in 1926 as a preparatory college for the priesthood. The college is no longer in operation, but the building is used for church classrooms. Visiting

Above: **The sky is filled with colors as the sun goes down over the prairies outside Alice, Texas.**

Left: **Our Lady of Guadalupe Church is located on East Santa Clara Street in Hebbronville, Texas.**

priests are allowed to stay in the guest quarters and use the second story open-air walkway for religious contemplation.

Our Lady of Guadalupe Cemetery is about a mile outside of Hebbronville on Texas Highway 285. Notice that the graves in this cemetery are elaborately decorated. Mexican American families have decorated the graves of their loved ones throughout the twentieth century. Historically, this was women's work; however, as we move into the twenty-first century, men and women share the duties. At certain times of the year, such as Dia de los Muertos or Day of the Dead on November 1, the cemetery will be festooned with colored ribbons and flowers.

Continue along Highway 285 for thirty-five miles to Falfurrias. Deciduous brush about ten-feet high lines the road along with a scattering of cactus and yucca. Wide-open stretches of pastureland become more common as you approach Falfurrias.

Falfurrias is the county seat of Brooks County. The town is named for the Falfurrias Ranch, owned by pioneer

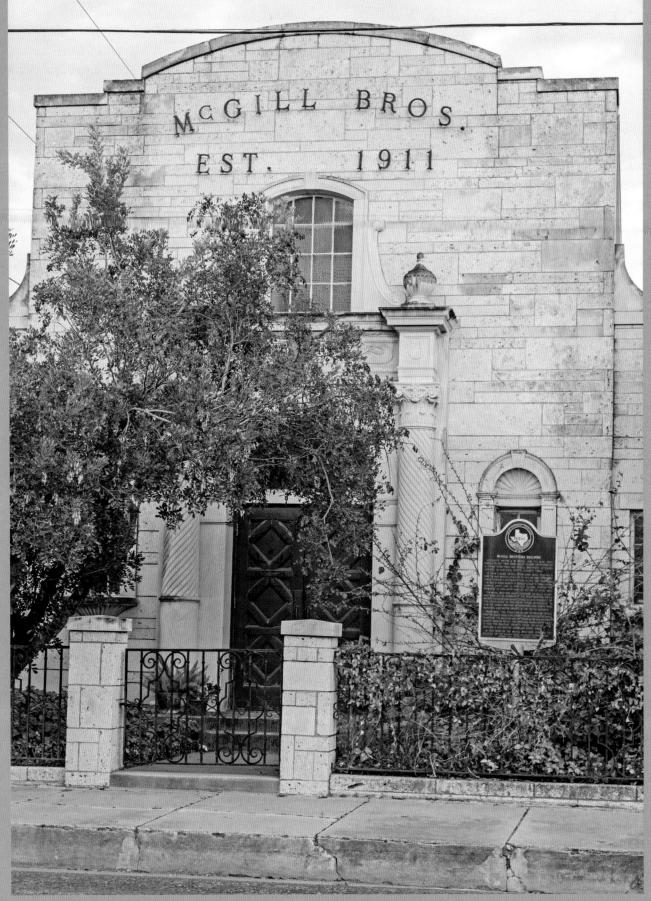

The South Texas Museum in Alice sits in the old McGill Brothers building. The building was built by the McGills in 1941 as an office for their ranching business.

Edward Lasater, who was instrumental in getting the railroad to pass through the area. That led to the establishment of a post office and newspaper.

Lasater imported Jersey dairy cows to his ranch and began a butter production tradition that continues to this day, except that Falfurrias butter no longer comes from Falfurrias but is made in Winnsboro.

The historic center of Falfurrias centers around St. Mary's Street and Highway 285. The Fallen Heroes Memorial Park sits on the corner shaded by live oaks and palm trees. The historic Pioneer Theater is next door.

History buffs will like the Heritage Museum of Falfurrias at 415 North Street Mary's. Relics, artifacts, and personal papers of local pioneers are housed in the museum.

Stop by the Star of Texas restaurant at the corner of Highway 285 and US Highway 281 if you're in the mood for a meal. It's hard to miss the place since its menu covers most of the outside of the building.

After your stop in Falfurrias, travel north on US 281 through Premont to the city of Alice.

Alice is a community also built around the railroad. In the mid-1880s, ranchers in the area needed to ship their cattle. A depot called Bandana was established along the railway line, and an application was submitted to name the post office Kleberg. Because the name was already taken, residents sent another application for the name Alice in honor of Alice Gertrudis King Kleberg. Alice was the daughter of Richard King of the King Ranch fame and was married to Robert Justus Kleberg, King's business partner.

The City of Alice received unwanted national notoriety in 1948 when Lyndon Baines Johnson ran against Governor Coke Stevenson in the Democratic Party's primary contest for the US Senate (in those days, a Democratic candidate was a shoo-in to be elected). Federal investigators alleged that the ballot box from Precinct 13 in Alice had been stuffed with fraudulent ballots.

Stop at the South Texas Museum at 66 South Wright Street. The building looks a bit like the historic Alamo in San Antonio and once served as the offices for the McGill Brothers Ranches. Inside you'll find displays including weapons going back to the Civil War, historic household items, dolls, and arrowheads. The archives of the museum hold photographs, documents, and historic maps. Guided tours are available.

WIMB
TE

R
1

TIPS

DBRart

David Richardson
Home Grown Music

Cypress Creek Café
Buzzard Bar

PART VII

HILL COUNTRY

This is one of fifty fiberglass boots around Wimberley, Texas, that have been painted by area artists. The boots were purchased by citizens and business owners and can be seen around the community.

THE HILL COUNTRY rests in the heart of Texas—geographically, historically, and geologically. It stretches east toward the coast until limestone hills cede to coastal prairies, then south toward the floodplains of the Rio Grande, then west toward the Pecos River, and finally north toward the rolling plains. It encompasses lands first occupied twelve thousand years ago by pre-historic Sana and Payaya and later by historic tribes such as the Tonkawa, Comanche, and Apache. Spanish settlers began moving into the region by the 1600s, followed by American Anglo settlers in the early 1800s and German-European settlers in the 1840s. German immigration to Texas followed a virtually direct route from ports of entry such as Galveston toward and into the Hill Country, establishing German-named communities such as Fredericksburg and Boerne (pronounced "burnee").

It's the land of the legendary Battle of the Alamo in 1836. It's the land of a larger-than-life figure named Lyndon Baines Johnson, the thirty-sixth president of the United States, who was born and raised on the rugged landscape.

Part of what makes the land tranquil and rugged is an oblong geologic feature called the Edwards Plateau, a landmass uplifted from a shallow sea between twenty to fifty million years ago. It encompasses the Hill Country between the Colorado River to the east and the Pecos River to the west but is ill-defined at its northern and southern boundary, separated by a mere one hundred miles. Because the land was thrust up from the bed of a shallow sea, it is characterized by rocky hills of layered limestone containing extensive caverns and cut by rivers to form rolling valleys.

The inactive Balcones Fault Zone interrupts the plateau on the east, and the Llano Uplift with rock formations dating back to the Precambrian era some 570 million years ago defines the northwest section.

Sweeping prairies become a palette of colors as they display an array of brilliant spring wildflowers with the Texas bluebonnet stealing the show. It's a place where white-tailed deer are common, as are wild turkeys and armadillos. The arid climate is soothed by cool, refreshing morning and afternoon breezes wafting across rivers and creeks. Greenery, from sprawling grasslands to woodlands holding Ashe juniper, oaks, and cypress trees, enhances the pastoral landscape.

Numerous lakes are actually artificial water reservoirs created by dams on rivers. Texas has no natural lakes because the land was never gouged by glaciation. (Caddo Lake in East Texas was originally formed by a logjam on the Red River and was arguably a natural lake until it, too, was artificially dammed in the early twentieth century.)

Communities and towns along the backroads date back to the predominance of agriculture and ranching, still a major factor in the Hill Country. In nearly every case, the towns have more legends woven into the fabric of authentic history than could fill a university library.

Visit local bakeries, cafés, and restaurants for uniquely delicious food. Shop the stores in the restored "old towns." Chat with local storeowners and residents and be surprised at how many of them may be refugees, so to speak, from big cities.

29

0 50 Miles

0 50 Kilometers

87 16

281

29

130

Johnson City

281

71

AUSTIN

35

Dripping Springs

26

290

Stonewall Hye

Fredericksburg

290

1376 Luckenbach

25

Driftwood

12 150

87

1376

32

Wimberley 150

39

Kerrville

473 Sisterdale

Fischer

473

32

1376

306

306

Canyon Lake

12

16

311

San Marcos

46

281

Medina

Bandera

46

2722 306

24

Boerne

27

Gruene

New Braunfels

173

16

10

35

SAN ANTONIO

410

10

80

87

Hondo Castroville 90

127

90

281

16

35 173

37

181

80

57

Kenedy

85

72

181

Raymondville

CASTROVILLE to CAMP VERDE

From Castroville, follow US 90 west then Texas Highway 173 north to Bandera. Drive 13 miles west along Texas Highway 16 to Medina. Drive east on Ranch Road 2828 for 9 miles to Texas Highway 173. Drive north for 3 miles to Camp Verde General Store. Continue on Texas Highway 173 for 24 miles to Kerrville. Approximately 112 total miles.

Castroville rests on a flat, agricultural plain at the base of the jagged hills that form the Balcones Escarpment, a fault line separating the Edwards Plateau of the Hill Country from the coastal plane. The Medina River flows through

Above: **The Bandera County Courthouse was finished in 1890. Stone came from local quarries and was laid by Russian immigrants.**

Opposite: **The Steinbach House in Castroville, Texas, was originally built in Wahlbach, France, between 1618 and 1648.**

town, and restaurants, cafés, bakeries, shops, and historical attractions line the streets.

American Indians and German and French immigrants have deep roots in Castroville. Comanches and Lipan-Apaches settled the present-day Castroville valley along the Medina River, and in the early 1800s, the Spanish army expanded the paths that tribes traveled between northern Mexico and San Antonio.

Early nineteenth-century settlers to the area, which was then part of Mexico, were called "Texians." They later fought for independence from Mexico and won it in 1836. Newly formed Texas then began attracting European immigrants. One of those immigrants, Baron Henri de Castro, recruited twenty-seven French and German settlers to build a settlement where present-day US Highway 90 crosses the Medina River. On September 12, 1844, the settlers named their community Castroville. On the same day, Bishop Odin stood on the banks of the river under the shade of pecan trees and dedicated the cornerstone of a new church.

The Texas Parks and Wildlife Department preserved the church as part of the Landmark Inn State Historic Park, maintaining the progeny of the historic pecan trees, a gristmill, several outbuildings, and the old Vance Hotel. The main buildings in the park are now a bed-and-breakfast and historic site. The Landmark Inn contains a small museum, gift shop, bookstore, and warm friendly staff willing to answer your questions.

Walk through the grounds and imagine stagecoaches and wagon trains stopping here in the mid-1800s on the way to Mexico and El Paso. Imagine covered wagons passing through in 1849 on the way to California during the legendary gold rush.

September Square is across US 90 from the Landmark Inn. The shaded square is in the center of town and contains a small garden surrounded by cafés and shops offering antiques and crafts.

Historic Castroville begins immediately after crossing the Medina River on US 90. Alamo, Lafayette, and Fiorella Streets border September Square, where monuments to Henri Castro and war veterans have been erected. Notice that the Castroville Café on Lafayette Street used brick from nearby D'Hanis to pave the patio—you can see the name "D'Hanis" clearly stamped on each brick. The café next door to Castroville Café is housed in an old Magnolia Gasoline station. See an original gas pump sitting under the quaint porch.

Download a copy of the historic walking tour from the Castroville Chamber of Commerce website. The history and story behind over fifty locations around Castroville are on the walking tour map.

Continue on US 90 to the Steinbach House. Originally built in Wahlbach, France, between 1618 and 1648, the house was disassembled and shipped to the United States in 1998. The two-and-a-half story home is framed in timbers, bricks, and plaster. The project was finished in 2002. Alsatian furniture can be seen inside the house.

Any visit in Castroville must include a stop at Haby's Alsatian Bakery on US 90. The fresh-baked bread, pastries, and cookies are *bonne bouches*. Heading west out of Castroville, US 90 climbs up the ancient banks of the Medina River. Pull into the roadside park at the top of the bluff to enjoy the panoramic view of Castroville in the valley below. Hundreds of tiny Farm to Market roads will get you from Castroville to Bandera.

OLD SPANISH TRAIL

The Old Spanish Trail, nicknamed OST, served as a caravan trading route between Santa Fe and Los Angeles from 1829 to 1848. A transcontinental highway built in the 1920s between San Augustine, Florida, and San Diego, California, was marketed as the Old Spanish Trail and crossed Texas from Beaumont to San Antonio and El Paso. Although Bandera was not specifically on the "trail," it successfully marketed itself as a stopover with the opening of the OST Restaurant in 1921.

The roads skirt around pasturelands, farm fields, and over and around verdant limestone hills. Plot a route on your GPS or smartphone from Castroville to Bandera. For the quickest route, take US 90 west to Texas Highway 173 north to Bandera. Even the "quick" route is a scenic forty-two miles.

In Bandera, eat breakfast at the Old Spanish Trail (OST) Restaurant for one of life's more memorable experiences. Enjoy a plate of fried eggs, bacon, and gravy-soaked biscuits, not unlike a breakfast eaten by ranch hands of old. Since the 1920s, the raucous but amazingly organized eatery has hosted everyone from working cowboys to local merchants and out-of-town, out-of-state, or out-of-country tourists.

The town derives its name from a natural cut in a ridge of limestone called Bandera Pass. Origins of the word *bandera* remain the stuff of legends, one of which claims the name referred to a red flag at the pass where original Mexican settlers marked the boundary between their hunting territory and that of American Indians. The town of Bandera began as a lumber mill in 1853 and became the embarkation point for western cattle drives after the Civil War.

Its cattle-driving history gives Bandera the honor of being called the "Cowboy Capital of Texas." Accordingly, sidewalk shops are filled with western clothes, antiques, decorative items, and crafts. Downtown's three-story Bandera County Courthouse, featuring a cupola and clock tower, was built in 1890. Markers around the courthouse commemorate American war veterans and, of course, there's a monument to Texas cowboys that lists names of champion cowboys.

Medina is thirteen miles northwest of Bandera on Texas Highway 16. Beginning with a sawmill in 1865, the town eventually became a hub for raising livestock. But since the 1980s, the community has become famous for apple farming using dwarf apple trees that grow an unusually sweet variety of apples. Visit the Love Creek Apple Store for sumptuous apple butter, apple pies, and fresh apples. You might want to get there early before fresh supplies run out. Eat lunch at the Patio Café and enjoy a slice of apple pie with ice cream. Tour Love Creek Orchards to pick your own fruits, including peaches and figs.

Travel east out of Medina on Ranch Road 2828. Enjoy this nine-mile stretch of winding road that weaves across low, rolling hills. Turn north at Texas Highway 173 for

Food at the Camp Verde General Store and Restaurant is served up with a smile by waitress Destiny Jannell.

three miles and turn into the Camp Verde General Store and Restaurant. The store was originally constructed in 1857 to supply goods to US Army soldiers at nearby Fort Camp Verde. A flood destroyed the building at the turn of the twentieth century and it was subsequently rebuilt. Recent renovations include a restaurant. Eat, shop, and then walk over to Verde Creek. Enjoy the shade of the towering cypress trees and listen to the water as it tumbles over a small waterfall.

Fort Camp Verde is where camels were brought from the Middle East during the 1850s in an army experiment to see if the two-humped desert animals could carry supplies and equipment across rugged, arid Texas terrain better than horses. The camels met the challenge, but the fort was deactivated in 1869, with the camels being sold to circuses or used to tote mail to Mexico. The last captive offspring of "Texas Camels" died in 1934.

Kerrville is fifteen minutes north of Camp Verde on Highway 173, with access to Interstate 10 and the city's hotels, museums, and restaurants. Comfort is an alternate smaller community along I-10 that can be reached by traveling along Highway 173 to Farm to Market Road 480 and then Texas Highway 27 east.

JOHNSON CITY to FREDERICKSBURG

From Johnson City, follow US Highway 290 west for 10 miles to Hye. Drive 6 miles along US Highway 290 west to Stonewall. Drive 8 miles west to Ranch Road 1376 and continue for 5 miles south to Luckenbach. Drive on Ranch Road 1376 south for 15 miles to Sisterdale. Drive on Ranch Road 473 west for 8 miles to Old San Antonio Road. Drive north to Old Tunnel State Park. Continue north on Old San Antonio Road to US Highway 290 west. Drive 4 miles to Fredericksburg. Approximately 76 total miles.

Rocks west of Johnson City show features carved here during the Precambrian era about 570 million years ago. The Texas Hill Country's land mass occurred between twenty and fifty million years ago when the Edwards Plateau was uplifted out of a shallow sea, and humans occupied the region beginning about twelve thousand years ago. Apache and Comanche peoples ruled the land in the early 1800s but were gradually driven out by Mexican and Anglo settlers after Texas won its independence from Mexico in 1836. Texas then became the twenty-eighth state of the United States in 1845.

Johnson City is the county seat of Blanco County, named appropriately for the Blanco River coursing through the county and fed by clear water springs.

Pecan Street Brewing in Johnson City sits across the street from the Blanco County Courthouse and is a

Opposite: **The Sauer Beckmann Living History Farm, on the grounds of the Lyndon Baines Johnson State Park, is a true working farm with chickens, turkeys, pigs, and cows.**

popular lunch spot. Friendly staff members serve a variety of meals, including delicious hamburgers, pizzas, and soups, in the homey atmosphere. Craft beers have rousing names such as Landbird's Wit, Road Devil Red Ale, and Ten Penny Nail.

Go over to Taste Wine + Art, a block from Pecan Street Brewing, to enjoy works by local artists while sipping a glass of wine from Texas wineries or from wineries around the world. Sit on the screened-in porch for a view of a sculpture garden.

Travel west on US Highway 290 to the small town of Hye. Stop at the historic Hye Market and Post Office where Lyndon Johnson as a four-year-old boy mailed letters and where, as president in 1965, he announced the appointment of Lawrence O'Brien to be postmaster general. Inside the quaint old store are historical artifacts along with craft beers and Texas wines, not to mention soft drink coolers plus a gift shop. Hye Meadow Winery is a short walk away along US 290. Stop in for a wine tasting on its shaded back porch.

PEDERNALES FALLS STATE PARK

Pedernales Falls State Park on Park Road 6026 is a byway that takes you back through geologic time for a glimpse of 500-million-year-old rocks from the Ordovician Period. The park headquarters overlooks the Pedernales River Valley with a terrain that drops away in a series of low-lying hills of limestone, pushed up at an incline during the Ouachita Mountain building episode near the end of the Paleozoic era, more than 250 million years ago.

The inclined limestone layers were eroded by wind, rain, and the flowing Pedernales River, named by the Spanish for its bed of flint-like rock. The main waterfall is a torrent of water racing over jagged limestone shelves, not a veil of water pouring off the edge of a mountain.

The park has designated areas for swimming, camping, hiking, and mountain biking. You may also enjoy activities as diverse as horseback riding on the equestrian trail (although you must provide your own horse) and photographing or watching birds at a bird-photography blind secluded deep in the woods.

TEXAS WINES

My son Michael J. Clark and his wife, Robin, who has a certificate in viticulture, are experts on Texas wines. Michael says, "Texas is currently the fifth-largest wine producer in the United States, and with a state this size, there is still ample room to grow. The grapes, the climate, the soil, and the people are the essential ingredients. For the grapes, it's about the right varietals [wines] for the right climate and soils.

"The focus on warm climate varietals has proven best for Texas. Tempranillo has certainly been the shining star for Texas wines, and most red wine lovers are familiar with this grape used in many Spanish Rioja–style wines. The rich, bold, and intense flavors of this red grape have not only found a new and bigger home in the Texas wine world, but may have just found the right region to bring out the best qualities of the grape. Mourvedre and Tannat red grapes have shown to be ideal in taking advantage of the clay and limestone soils of much of the Hill Country. The results are great single or blending varietals that bring out both character and structure for making good wines.

"For the white grapes, Roussanne and Viognier have put Texas on the map as a quality white wine producer. The Roussanne has that buttery-like feel of a Chardonnay but more depth and heavier mouthfeel than most whites. The Viognier wines have shown to be the ideal extra-crisp, clean, and refreshing white with mineral character that you want for the Texas summer heat.

"The quality of the Texas wine continues to gain regard, with more wines winning awards and recognition across the globe. The Texas Hill Country is the largest, best-known, and fastest-growing American viticultural area in the state, sitting on the Edwards Plateau and Llano Uplift."

Above: **Bats roost in the tunnel during the day at Old Tunnel State Park. The tunnel was originally built for a train that traveled from Fredericksburg to San Antonio. Construction on the tunnel began in 1913 and was in service for thirty years. Automobiles and highways made the railroad obsolete, and by 1942 the railroad was history. Bats moved into the tunnel and have now produced a large population.**

Right: **Friendly service and good food await visitors at Pecan Street Brewing in Johnson City, Texas.**

West of Hye along US 290 is Stonewall, the birthplace of the thirty-sixth president of the United States, Lyndon Baines Johnson.

Visit the Lyndon B. Johnson State Park, where you'll find historical displays of early German settlers and reproductions of their homes at the Pioneer Museum. Nearby is the Sauer-Beckmann Farmstead, an active working farm that raises chickens, turkeys, pigs, and cows. Bacon could be frying in pans in the morning as docents dressed in period costumes prepare the breakfasts that farmers ate in the late nineteenth and early twentieth centuries. The home also indicates living accommodations of the period and how food items such as jars of fruit preserves were stored.

Going west from Stonewall on US 290, turn at the large sign for Becker Vineyards. Stretching over the rolling landscape, the picturesque vineyards could be taken for a scene from an Italian vineyard in Tuscany.

Lush gardens and an expansive lawn surround the vineyard's main buildings of limestone blocks. A tasting room and gift shop adjoins outside patios, where visitors may sit and relax while breathing fresh air and gazing over the beauteous landscape.

Names of German towns adorn the walls of the Altdorf Biergarten in Fredericksburg, Texas.

Drive west on US 290 and then south on Ranch Road 1376 to Luckenbach, made famous in the 1978 country-western hit song "Luckenbach, Texas," recorded by Waylon Jennings and Willie Nelson. The song says, "Let's go to Lukenbach, Texas, with Waylon and Willie and the boys . . ." The Luckenbach Store was actually a post office from 1850 to 1971, but largely due to the song, it has become a pop-culture mecca visited by tourists and celebrities from around the world. Shop the store for T-shirts, cowboy hats, toddler clothes, handmade jewelry, and snacks. A bar in the back serves cold beer.

Sister Creek Vineyards, another Hill Country winery, is located in Sisterdale, fifteen miles south along Ranch Road 1376 and housed in a restored nineteenth-century cotton gin. A wine-tasting room and gift shop inside display Texas antiques such as a horse-drawn buggy.

Travel west on Ranch Road 473 and then turn right on Old San Antonio Road. Continue for roughly four miles to Old Tunnel State Park for the Old Tunnel bat cave and nature trails. A viewing platform with restrooms sits above the tunnel where visitors can watch a nightly emergence

ENCHANTED ROCK STATE NATURAL AREA

The Enchanted Rock State Natural Area is situated eighteen miles north of Fredericksburg on Ranch Road 965. The geologic feature known as Enchanted Rock is the second-largest granite dome in the country and rises 1,825 feet above sea level. Geologically, it's a batholith that pushed up from bedrock around one billion years ago.

of around three million Mexican free-tailed bats from their daytime roosts inside the tunnel. The nocturnal bats swoop over the Hill Country, consuming more than twenty-five tons of crop-destroying insects and beetles.

The tunnel originally sheltered a railroad track for a train traveling between Fredericksburg and San Antonio from 1913 to 1942, until roadways with faster and more efficient

vehicular transportation made the rail line obsolete. Bats took over the tunnel as a roosting and breeding home.

Continue north on Old San Antonio Road to Luckenbach-Cain City Road and less than five miles to US 290. Be careful, as the US 290 intersection will sneak up on you.

Wildseed Farms is 2.5 miles to the east with a sweeping view of Texas native wildflowers and seed crops. Depending on the time of year, visitors will see expansive fields of bluebonnets, poppies, or zinnias. Native plants, perennials, and annuals are for sale in the plant nursery, along with yard ornaments and garden furniture. A walk-in butterfly house includes an extensive gift shop.

Fredericksburg is five miles to the west. Texas was a magnet for nineteenth-century German settlers. Beginning in the 1840s, they settled in lands reaching from the fertile soils of the coastal plain across to semi-arid land and limestone hills of New Braunfels and Fredericksburg. Much of the migration was instigated by minor noblemen looking to bring middle-class peasants to a new territory, where the noblemen, of course, would rule. But the diversity of immigrants—from German Methodists to Lutherans, Catholics, and "Freethinkers"—overwhelmed any nobleman's hopes of a homogenous class of Texas Germans.

Fredericksburg is the heart of nineteenth-century German settlement in the Hill Country. Named for Prussia's Prince Fredrick (1794–1863), the town was founded by Baron von Meusebach, who arrived in Texas in May 1845 at the age of thirty-two. He attracted a community of mostly liberal, well-educated Germans who prized a culture of music and art, a culture that continues in the town. On almost any weekend, the town will be hosting festivals, art shows, folk music concerts, and choral concerts. Walk the streets of the town's historical center with its antique shops, restaurants, and bakeries. Don't miss museums such as the Pioneer Museum Complex, and then go to nearby Vereins Kirche (Society Church) Museum to learn the heritage of early German settlers. Also visit the National Museum of the Pacific War in the Nimitz Hotel. The hotel is named in honor of Admiral Chester W. Nimitz, who led the Pacific Fleet during World War II and hailed from Fredericksburg.

Take a side trip to the Marschall-Meusebach Cemetery at Cherry Springs: take US Highway 87 north out of Fredericksburg and drive fifteen miles until you see Cherry Springs Road and go east about one mile to the cemetery, which is the burial ground for the local residents as well as for people killed in frontier skirmishes and veterans of the Civil War and all wars involving our nation.

Look for the Hilltop Café on US 87 halfway between Fredericksburg and Cherry Springs Road. It's a great place to eat and see the old gas pumps of the early twentieth century and the period's decorative signs.

26

DRIPPING SPRINGS to SAN MARCOS

From Dripping Springs, follow Ranch Road 12 south to Ranch to Market Road 150 and Driftwood. Backtrack to Ranch Road 12 or continue on Ranch to Market Road 150 south for 7 miles to Ranch to Market Road 3237 and drive 9 miles to Wimberley. Drive on Ranch to Market Road 2325 west out of Wimberley to Jacobs Well Road then continue for 4 miles to Jacobs Well. Return to Ranch to Market Road 2325 west to Fischer Store Road. Drive 9 miles to Fischer. Drive Farm to Market Road 484 south to Ranch to Market Road 32 to Ranch to Market Road 12 to San Marcos. Approximately 67 total miles.

Dripping Springs calls itself the gateway to the Texas Hill County. A stagecoach between Austin and Fredericksburg once stopped in the town to take advantage of the available water. Tonkawa also depended on the water during their treks across the Hill Country. Settlers came to the area in 1857 when John Moss established a post office and needed a town name. His wife, Nannie, suggested the name Dripping Springs.

Head into town to Rolling in Thyme and Dough, a bakery featuring homemade breads, pastries, organic

Right: **Driftwood Estate Winery, on Elder Hill Road, in Driftwood, Texas.**

Left: **Dick's Classic Garage in San Marcos, Texas, houses the automobile and motorcycle collection of Dick Burdick. The museum was established in 1980.**

Opposite: **The Fischer Store Antique Museum is located on Fischer School Road off FM 484.**

soups, salads, and sandwiches. Then drive to the Solaro Estate Winery, home of award-winning Texas wines in a country estate setting.

Drive south out of Dripping Springs on Ranch Road 12 then turn left onto Ranch to Market Road 150. In Driftwood, take a jog onto Elder Hill Road for a stop at the Driftwood Estate Winery. Enjoy a stunning view of the Texas Hill Country from the grounds.

Return to Ranch Road 12 to reach the serenity of Wimberley, a comforting town along the crystal-clear waters of the Blanco River at the crossroads of Farm to Market Road 2325, Ranch Road 12, and Ranch to Market Road 3237. In the 1850s, the town was called Winter's Mill for the local sawmill. The town changed its name in honor of Pleasant Wimberley after he bought the mill in the 1870s. A massive flood in 2014 disrupted the community, but the town quickly recovered.

Go to the town square for breakfast at the Wimberley Café and then next door for coffee and pastries at Sip! on the Square. During the day, choose from any number of great local eateries such as the Wimberley Pie Company, but do get a taste of Texas wines at nearby Taste Buds market at 13904 Ranch Road 12.

Cross the Blanco River in Wimberley and take River Road to Wayside Drive and Pioneer Town, with a faux

Wild West street along with an Old West saloon and other attractions. Jack Drake's Cowboy Museum is a fun place that also contains amazingly authentic exhibits. Devoted to cowboy and American Indian history, the museum displays old guns, period clothing, and historical documents in a seemingly haphazard distribution throughout its two-story structure. A seven-foot-tall jackalope is a hoot and represents the famed folklore about a jackrabbit with antlers (but oddly more like the antlers of a deer than an antelope). The gift shop offers souvenirs, including antiques and even rattlesnake rattlers.

Take a tour of the 81.5-acre Jacobs Well Natural Area, eleven minutes from downtown Wimberley at 1699 Mount Sharp Road. The well is an opening to an underwater cave fed by a continuously flowing artesian spring that forms the headwaters of Cypress Creek. Shallow water around the well offers opportunities for swimming, and rocks high above the well offer a chance to jump into the cool well water. For bird-watchers and bird photographers, a bird blind is near the parking lot, as is the trailhead for a nature trail.

Take Farm to Market Road 2325 west and then follow Valley View Road to Fischer Store Road and stop at the 129-year-old Fischer Dance Hall, made famous by country and western singers such as Bob Wills and Willie Nelson. Then, return to Farm to Market Road 484 south

until it reaches Ranch to Market Road 32. Called Devil's Backbone, the road runs along the ridge to Ranch to Market Road 12 and back to San Marcos.

San Marcos is home to Texas State University, a bucolic campus that belies its intellectual endeavors. Across from the University on Ranch Road 12 is San Marcos Cemetery with grave markers as far back as the early 1800s. One grave beneath the shaded grounds has a tombstone for Captain Lewis Lawshe, who served in the War of 1812.

A must-see place is Dick's Classic Garage. The spacious modern building harbors restored vintage automobiles from the Model T Ford to Cadillacs, Chevrolets, Packards, Hudsons, and more manufactured from the early twentieth century through the 1950s. A replica of the *Batmobile* from the 1966 television series *Batman* is on display. All the vehicles sitting on spic-and-span clean floors look as though they are shiny new. A gift shop offers multiple items for car buffs, and educational tours may be available

27

BOERNE to NEW BRAUNFELS to SAN ANTONIO

From Boerne, follow Texas Highway 46 east to Farm to Market Road 3159 for 36 miles to Canyon Lake. Drive on Farm to Market Road 2673 to Canyon Lake Gorge. Loop around Canyon Lake on Farm to Market Road 306 north. Drive north on Farm to Market Road 3424, then east on Ranch to Market Road 32 for 25 miles to Purgatory Road. Drive south on Purgatory Road to Farm to Market Road 306. Continue south on Farm to Market Road 306 to Gruene then 2 miles to New Braunfels. Drive south on Interstate 35 to San Antonio. Approximately 109 total miles.

Boerne (pronounced "burnee") was founded in 1849 and originally named Tusculum. It was changed in 1852 to honor the German journalist and political refugee-resident Ludwig Boerne. The settlers were German intellectuals called "Freethinkers." Stay in the historic Ye Kendall Inn and enjoy a leisurely breakfast at Bear Moon Bakery. Head on a morning drive to Cibolo Nature Center that features trails winding through native grasslands, marshlands, and majestic bald cypress trees lining Cibolo Creek. Nestled among tall oak trees, the visitor's center has a wide wooden porch surrounding the building where you can sit in an old-fashioned rocking chair and listen as the chair's rockers creak against wooden planks in synchronization with singing birds and the rhythmic dripping of water from the courtyard fountain.

Drive east along Texas Highway 46 and then Farm to Market Road 3159 to Canyon Lake.

Canyon Lake is a reservoir from a dam on the Guadalupe River. Created by the Army Corps of Engineers in the 1960s, the lake has eighty miles of shoreline and ranks among the deepest of Texas lakes at an average depth of about forty-three feet, depending on droughts. It is a popular fishing destination.

On Farm to Market Road 2673 is Canyon Lake Gorge, where 150-million-year-old dinosaur tracks are traced in the limestone. Dinosaurs roamed Texas when a shallow sea and shallow marshes covered the landscape.

For a scenic route around Canyon Lake, take Farm to Market Road 306 to Scenic View Drive, then Farm to Market Road 3424 north to Ranch to Market Road 32. In eleven miles, turn on Purgatory Road, allegedly haunted at night by ghosts. Entertaining highway signs read "Purgatory/One Way" and "Purgatory/Dead End."

Assuming you survive Purgatory Road, continue to Farm to Market Road 306 and drive into New Braunfels.

Prince Karl Solms of Braunfels, Germany, arrived in Texas in 1844, and in 1845 he established the colony New Braunfels for early German settlers. Positioned along the banks of the Guadalupe River, the colony flourished alongside the river as a trading route between Austin and San Antonio.

The twentieth century saw New Braunfels become a family-oriented river sports recreational center. Parks with tube rentals, golf courses, river accesses, and playgrounds line the river, and its Schlitterbahn Waterpark and Resort is one of the more popular tourist destinations in Texas.w

New Braunfels, Texas, has a quaint historic downtown centered around the courthouse.

Homes along King William Avenue in San Antonio are historic, magnificent, and stately. Some are large mansions and others are more modest. All are well maintained. The broad avenue is lined with cypress, magnolia, and oak trees.

The city's architecturally alluring Romanesque Revival–style Comel County Courthouse is made of limestone and listed in the National Register of Historic Places. It sits by a roundabout circling a small park with an old-fashioned bandstand.

Off Peach Street, south of the town's historic center, is the old cemetery with graves dating from the late 1800s and early 1900s. Names on the graves such as Kupferschmidt, Voigt, and Schroeder are monuments to the town's German heritage.

To the east of New Braunfels is a small town called Gruene (pronounced "Green"). Its founder, Henry D. Gruene, established a cotton farm along with his father and brothers on the location in 1872. The Gruene home stands as the Gruene Mansion Inn and is listed on the National Register of Historic Places.

Look for the tall silver Gruene water tower, looming over tiny Victorian-style cottages, red brick storefronts, antique stores, cafés, and gift shops. Park in one of the convenient parking areas and walk the streets under the shade of pecan trees.

The Gruene Hall at the end of Hunter Road was built in 1878 and stands as a flagship for exciting nightlife in this otherwise-calm rural region. Locals call it the oldest dance hall in Texas, and it has drawn such famous country-western singers as Willie Nelson, George Strait, and Lyle

Lovett. Not just country bands perform in the hall; it's also a venue for gospel singers.

San Antonio is south of New Braunfels on Interstate 35. Head to the old but revitalized location of the Pearl Brewing Company at 303 Pearl Parkway. The iconic Pearl Beer originated here in 1886 and later became known by such slogans as "A bottle of Pearl, please!" and "From the country of 1,100 springs." The area is now a chic market square lined with shops, restaurants, and condominiums, where people can stroll or ride bicycles.

King William Historic District and King William Street is south of downtown San Antonio and situated near Durango and South St. Mary's Streets. The area was originally farmland for a Spanish mission, known today as the Alamo. German immigrants settled the area in the 1840s and eventually became a neighborhood with expansive mansions with European architecture and a main street called King William to honor Prussia's King Wilheim I (1797–1888). The street name changed briefly to Pershing Avenue during World War I in honor of American Army General John J. Pershing (1860–1948) but reverted back to King William Street after the war.

The community fell into disrepair up until the 1950s when people began to restore homes for attractive residences near the downtown business district. The new residents preserved some of the original character of the community, and it once again has become a fashionable neighborhood.

Park on one of the side streets or take a San Antonio Blue Trolley from Alamo Square.

The New Braunfels Cemetery is the last resting place of many of New Braunfels early settlers. The earliest grave dates back to 1845.

INDEX